ROBERT TURNER

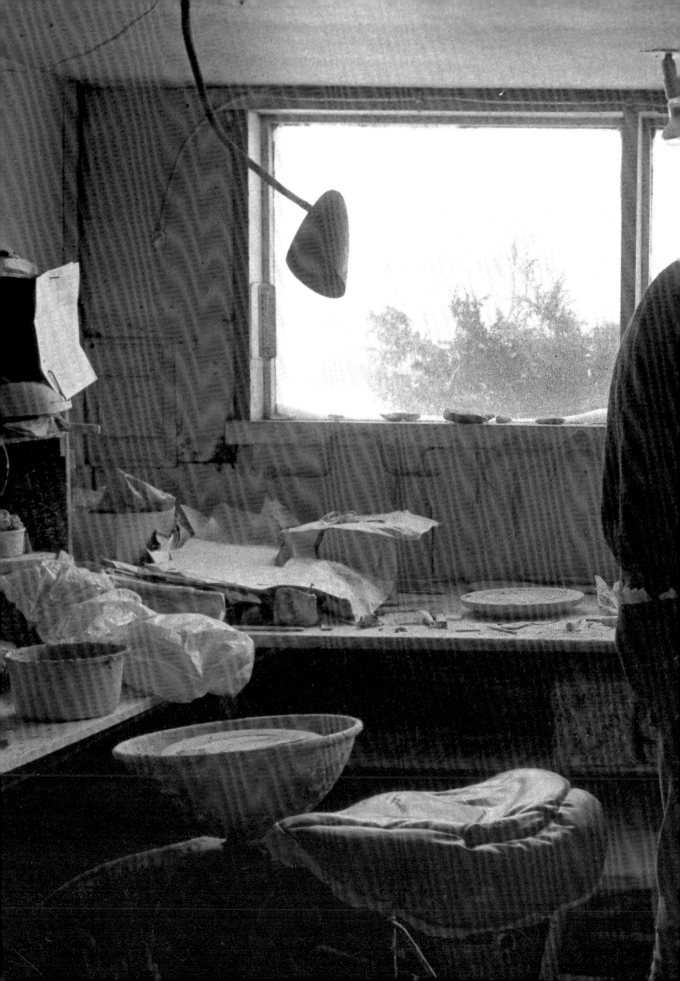

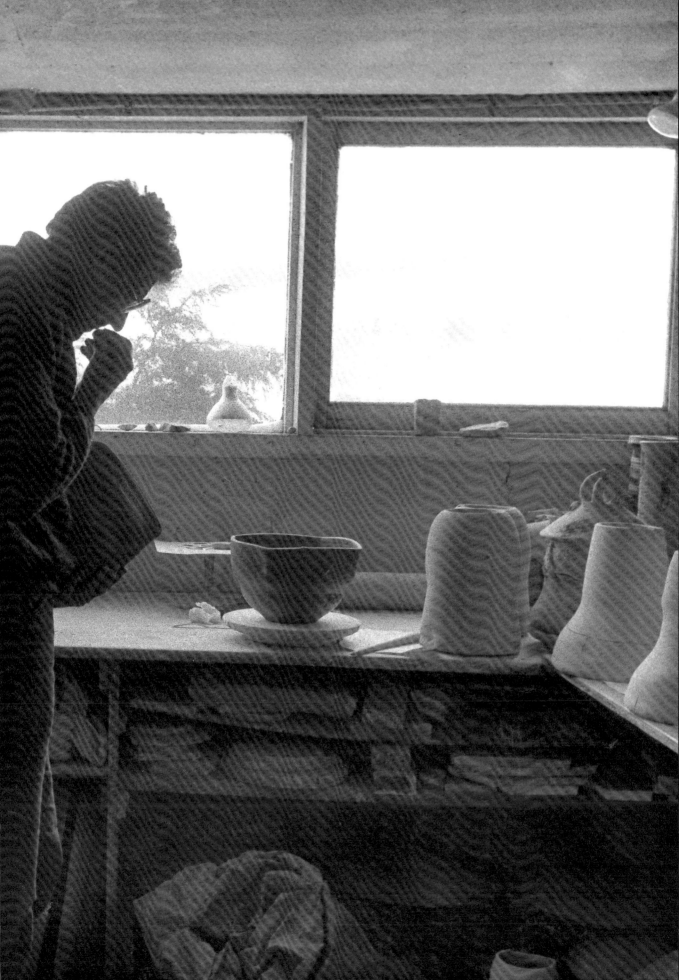

ROBERT TURNER

SHAPING SILENCE
A LIFE IN CLAY

Marsha Miro
Tony Hepburn

INTRODUCTION BY Janet Koplos

KODANSHA INTERNATIONAL
Tokyo • New York • London

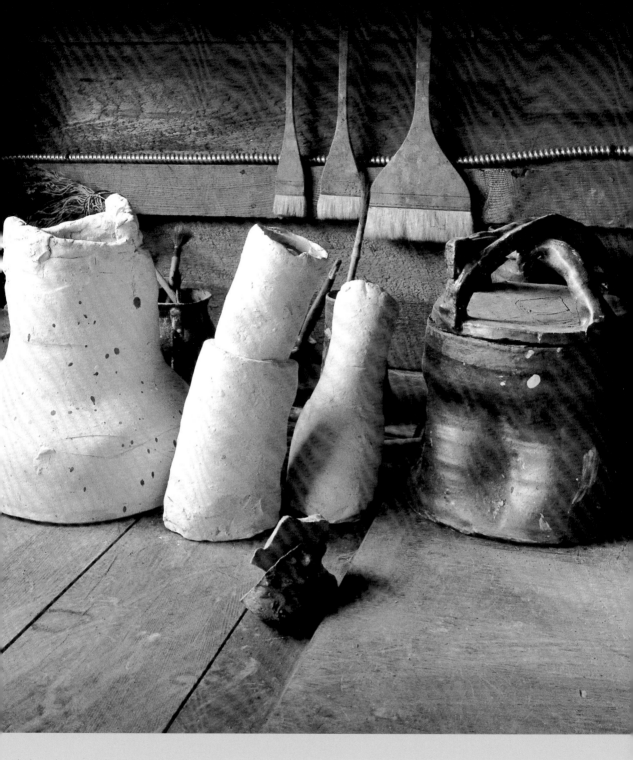

ote: The photograph on page 1 is a detail of the *Dome* on page 25 and has been inten-
onally reversed.

stributed in the United States by Kodansha America, Inc., 575 Lexington Avenue, New
ork, NY 10022, and in the United Kingdom and continental Europe by Kodansha Europe
d., 95 Aldwych, London WC2B 4JF.

ablished by Kodansha International Ltd., 17–14 Otowa 1-chome, Bunkyo-ku, Tokyo
2–8652, and Kodansha America, Inc. Essays and chronology copyright © 2003
dividually by authors: Janet Koplos, Marsha Miro, Tony Hepburn, and Helen Drutt.
l rights reserved. Printed in Japan.

BN 4–7700–2946–2
rst edition, 2003
 04 05 06 07 08 09 10 10 9 8 7 6 5 4 3 2 1

brary of Congress Cataloging-in-Publication Data available

ABOVE: Intrigued by their stance and grouping, Turner left these pots unfinished so he could study them. 1996.

PAGE 2–3: Turner working in his Alfred studio, wetting nubbins of clay, small balls of clay that prevent the pot from touching the kiln shelf during firing. C. 1979.

C O N T E N T S

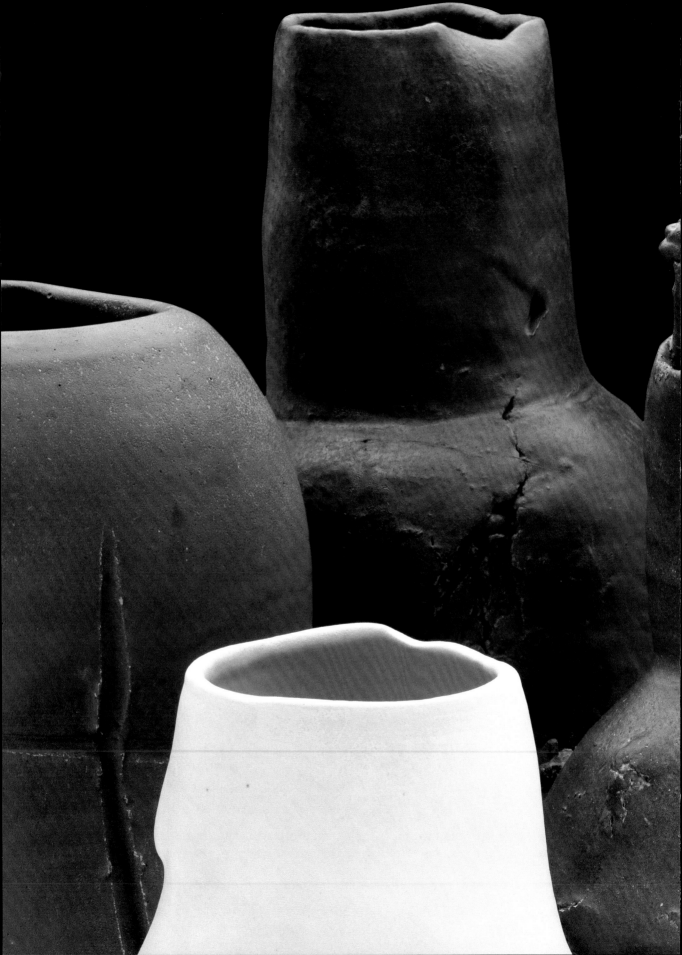

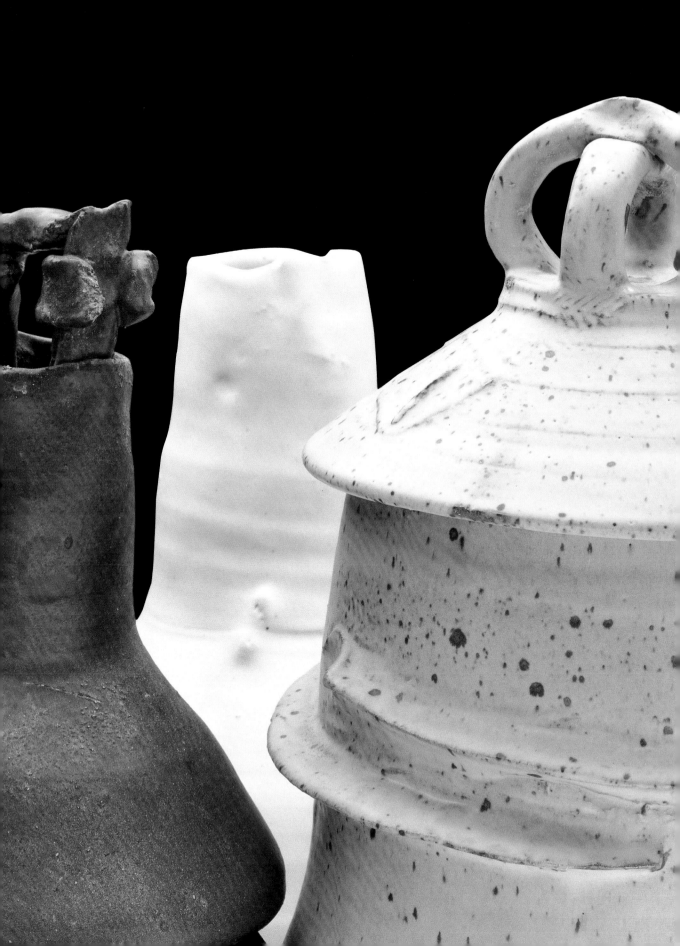

THE PILGRIM IN THE POT SHOP

Robert Turner and Peter Voulkos are at opposite ends of the spectrum of ceramic artists. Voulkos created for himself a notable identity as an intense, flamboyant performer of grand gestures in often amusing extremes. He fashioned extroverted works that can be classified as three-dimensional realizations of abstract expressionism. Yet approximately parallel in time, Robert Turner became a model of another sort: famously reserved and indirect in his commentary and a Quaker and conscientious objector in World War II, he made abstract vessels that are subdued in tone and conducive to meditation. Though both men initially trained as painters and aspired to the same high aspirations of meaning, Voulkos was inspired by the leading fine art of his time, while Turner drew on functional ceramics, sculpture, landscape, architecture, and abstract geometry. Whereas Voulkos's work is distinctive for its mass, vigor, outward orientation, and interaction with space, Turner's forms pull the focus inward, inviting imaginative projections and leading the viewer's attention beyond subtle and sensuous surfaces toward cosmic associations. One artist is active, the other contemplative.

Turner, by temperament, always avoided a "star" turn in his career. He has sought service more than glory. Early on, he abandoned painting in favor of ceramics because pottery is an art that can also be useful. Thus he exemplifies moral motivation in craft, which, at various times in the nineteenth and twentieth centuries, was seen as an alternative to the cold impersonality of mass production and the anomie of modern existence. Even his later nonfunctional ceramic forms have a functional aspect, though of a more abstract nature.

Garth Clark has noted that, unlike most painters who turn to clay, Turner has never been interested in painting his pots. Clark concludes that Turner's primary interest is form. I would argue that while Turner's propensity to create simple and strong abstractions places him in the sculptural lineage of Brancusi and Noguchi, surface is every bit as important as form in his work. Yet his surfaces are not the "glazed paintings" common to ceramics—the colorful and smooth gestural, pictorial, or patterned options that attract many people to the medium. They are instead like sheets of drawing paper on which Turner places a few, very deliberate marks. In such a reductive setting, these isolated and unobtrusive notations are invested with an extraordinary power. Turner seems to have discovered natural sources of Zen aesthetics in the windswept emptiness of the desert and

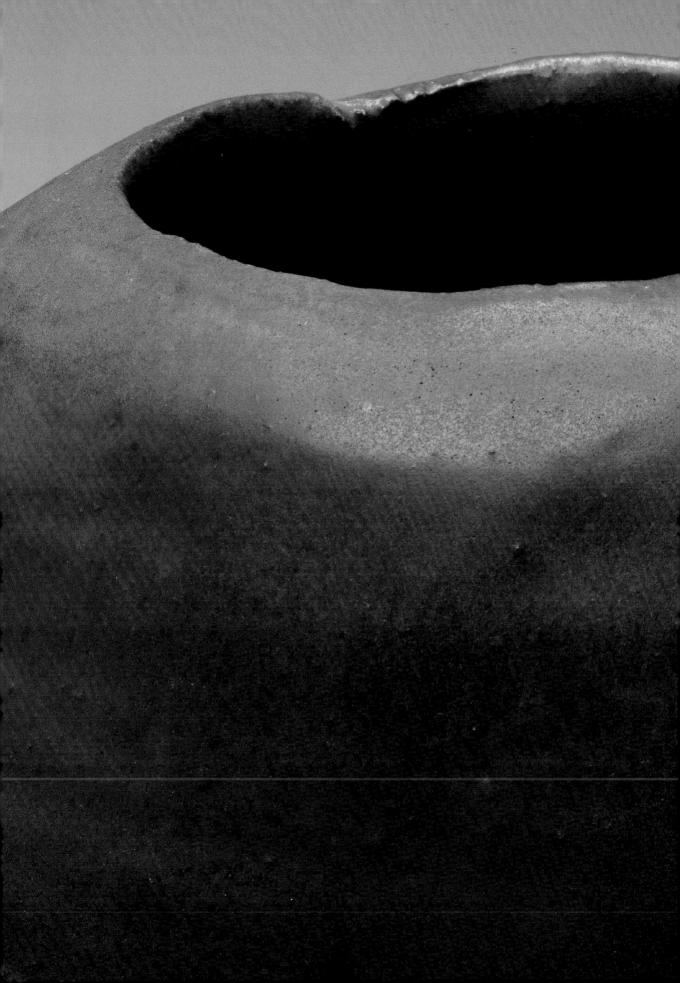

wave-etched emptiness of the shore, his preferred landscape themes. Perhaps because of these choices, his work has been variously described as classicist, austere, and pure, but none of these terms seem quite right to me. I see in his pieces such qualities as serenity, dignity, and tenderness.

Turner has always recognized the value of simplicity and quiet. His manner is modest. Even in the celebrated experimental environment of Black Mountain College, a landmark site for contemporary art, he called his studio a "pot shop." Secure with that humble base, he has opened himself to other influences. Besides landscape, he has responded to African art (religious forms and traditional dwellings, equally) and looked for the ideal through geometry. In fact, Turner's entire career could be regarded as one long pilgrimage, a search for the meaningful and the true. His work is not about himself, although it is his hands that shape the bases, his fingers that push through the clay, his eyes that set a small or large strap on a surface of a piece to change its metaphoric implications as well as its physical dimensions. Rather, it is almost as if Turner were a channel for notions, feelings, and shapes from elsewhere. His gestures are not solely his own but a proxy for larger spirits that perhaps we all share, although we are not all equally sensitive to them. Where he finds this numen, he makes it visible to others.

I have never forgotten my own first exposure to Turner's work. It was a show at Alice Westfall's exemplary Chicago gallery, Exhibit A, in the late seventies. On exhibit were a number of his conical-lidded works inspired by a trip to Africa a few years earlier. As I stood looking at them, seeing the merger of something as prosaic as casseroles with something as exotic as tribal huts, I began to feel that they were alive and coexisted as a family. I was transported by sensations of euphoria and rightness. More than twenty years later, that first encounter still ranks as one of the deepest and most unexpected emotional experiences I have ever had in the presence of art. What the French novelist Stendhal felt and described in the nineteenth century—a feeling of meekness and awe in the presence of great art—is not restricted to paintings of large scale and honored presentation; it can also arise from the recessive forms, taciturn surfaces, and comfortable domestic sizes found in the abstract but richly allusive objects Turner has created from clay.

Turner's works are never explicit. They do not come with a message or a snapshot. They do, however, hold in themselves what the artist intends and what he discovers in his process of creating, and they are open to our conjecture when we study them. We can mentally enter the works. Their combination of receptiveness and mystery is unusual. The best comparison I can find is the work of a sculptor a generation younger than Turner, Martin Puryear. Craftsmanship and a respect for materials—most often, wood—are prominent features of Puryear's large abstract sculptures. Both he and Turner share the qualities of quietness and integrity, and they both create works that communicate a nondogmatic spiritual power, a feeling of something larger not tied to any specific creed or practice.

This book pays tribute to a remarkably understated man, important as an artist, a teacher, and a thoughtful human being. Tony Hepburn's gracious profile of his peer and mentor gives a first-hand portrait of Turner's thinking. As Hepburn himself says, Turner addresses both the material world and the human condition in each pot he makes, and searches for universality. Marsha Miro's intensely focused and minute examination of the objects is a close reading of the formal and metaphoric qualities of artwork, an approach that is extremely rare in ceramics and can serve as a model for critical analysis of ceramic arts in the future. Together they enrich our exposure to Turner's vessels and to Turner himself: a regular person, imperfect and uncertain, who has nevertheless inspired others with what Hepburn calls his "generosity of spirit" and imbued his art with the same remarkable character.

—Janet Koplos

The Turner House at Alfred Station, New York.

Bob Turner and his small gas kiln at the Santa Fe home, 2002. ▶

*I try things and wait for
"it" to ring true—true
to accumulated experience,
to an intuition of how things react
and reveal themselves.*

ROBERT TURNER

COLOR PLATES

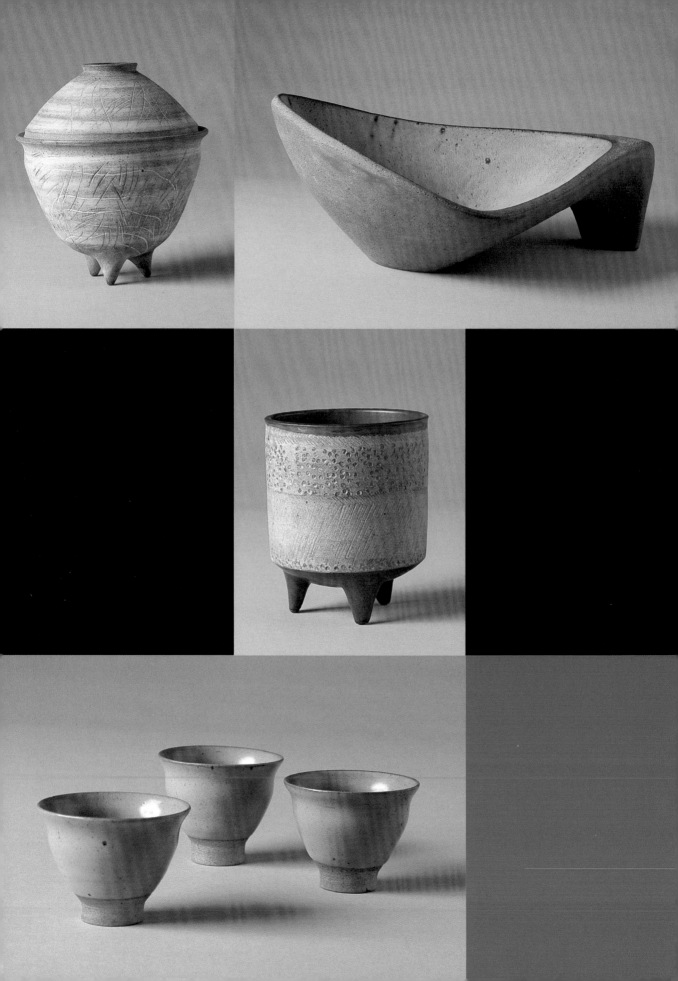

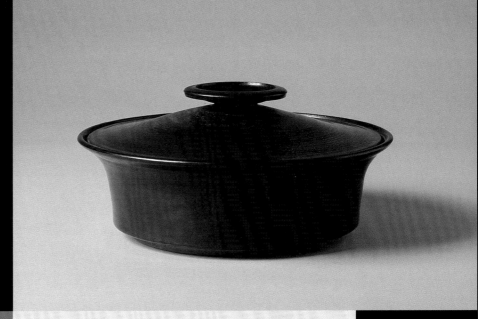

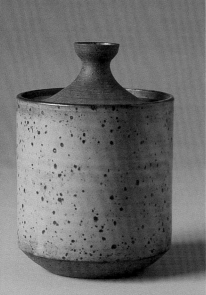

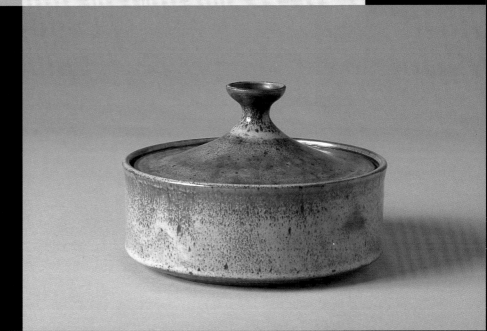

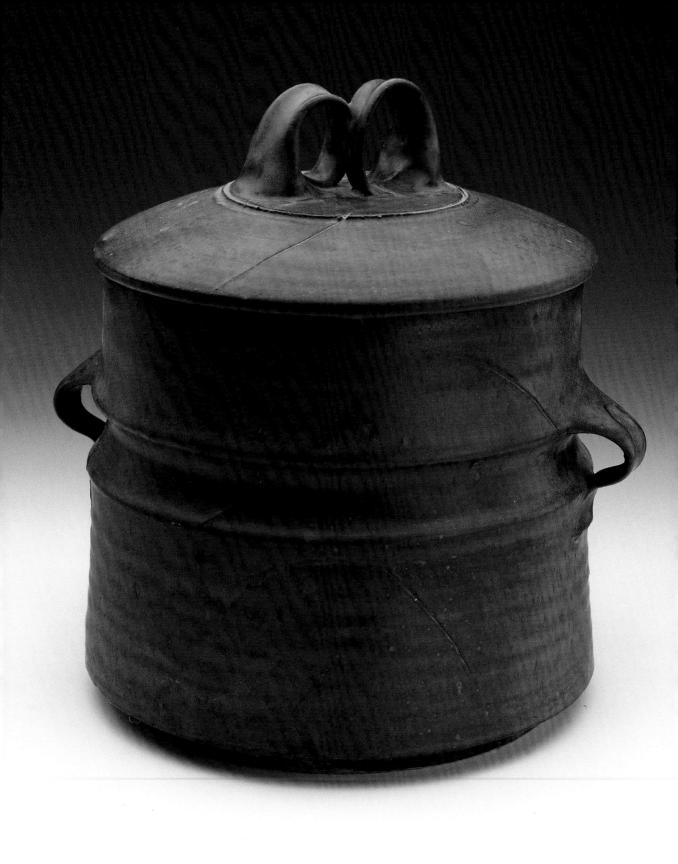

Covered Jar
1967 11⅝ x 8⅝ in. (29.5 x 22 cm.)

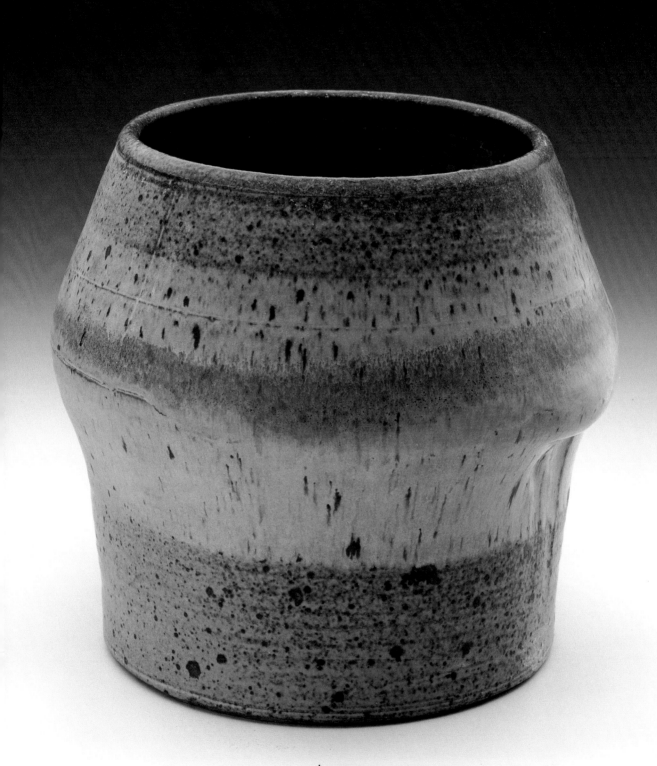

Jar BEIGE

1966 8½ x 9¼ in. (21.5 x 23.5 cm.)

*This jar provided an opening in perception of form for me. The requirement of function—
in this case, that of being able to lift the piece more securely—was implicitly a challenge
to personal and aesthetic decisions. Thus, at the logical place of lifting on each side
of the jar, I easily formed a protrusion with a combined push-out and push-in while
the clay was still plastic. This singular shape seemed to suggest the movement of a living
organism. It also recalled the turtle emerging from the old pre-Columbian pots of Mexico.
The sense of the entire piece was altered for me.*

Landscape Jar

1967 26 x 13 in. (66 x 33 cm.)

In the high desert and mountains of New Mexico, changes in landscape and weather appear to the eye to be larger than the 360 degrees the compass will allow. ■ *This piece was made around 1966–67, when I wanted the challenge of a change of scale. Discovering that a piece I was making could speak its own mind was the beginning of new perceptions for me.*

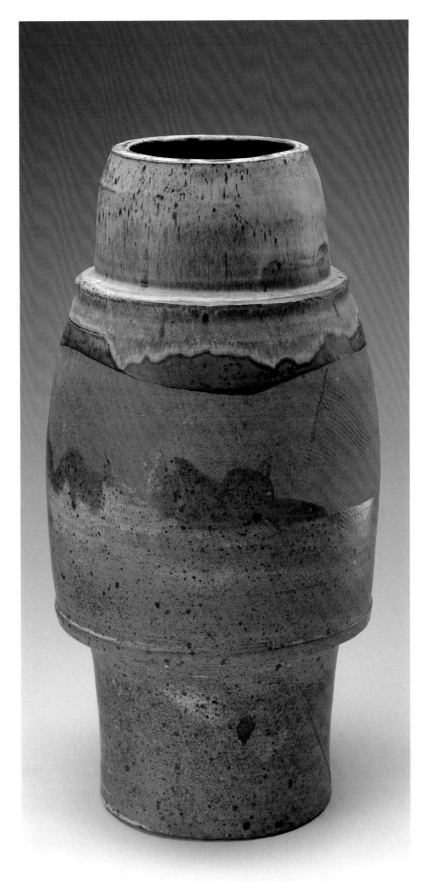

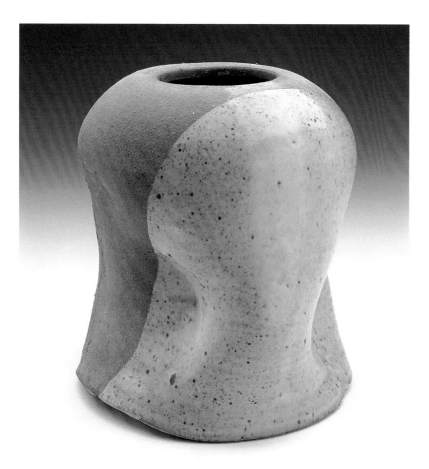

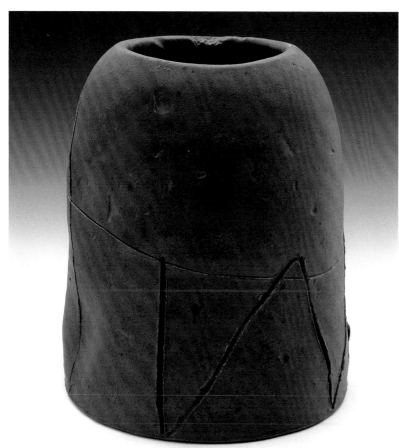

Early Dome EXPERIMENT
1970 8½ x 8¾ in. (21.5 x 22 cm.)

*In the late sixties, after years of constantly
being in control of the shaping and
forming process, I wanted to let the piece
decide. I wanted to be more aware
of the way things form and,
at a certain point in the making,
to get out of the way.* ■ *I had just thrown an
abstract combination (of dome on cylin-
der), and the piece was still wet, responsive.
When cut from the wheel
and then lifted from underneath, the piece
reformed itself into the unity we see.*

Dome ACROBAT
1981 9½ x 8¼ in. (24 x 21 cm.)

*The quietness of the wall accepts
the quick line, the cut.*

Dome
1976 10¼ x 8½ in. (26 x 21.5 cm.)

*Where age and moment combine.
In Yosemite National Park, in 1967,
I saw the rock Half Dome.
It was magnificent in scale—its shape
both surprising and striking as an
inevitable possibility of natural
forces.* ■ *After all the roundness
of the thrown form, "I want to cut through
physically in some way. I pull a line
straight down, then sweep it across,
responsive to the horizontal plane
on which the pot sits. The pot defines how
geometry works. Making connections
with things I know." Clay permits that
to happen. (Material in quotation marks
from "Born Remembering")*

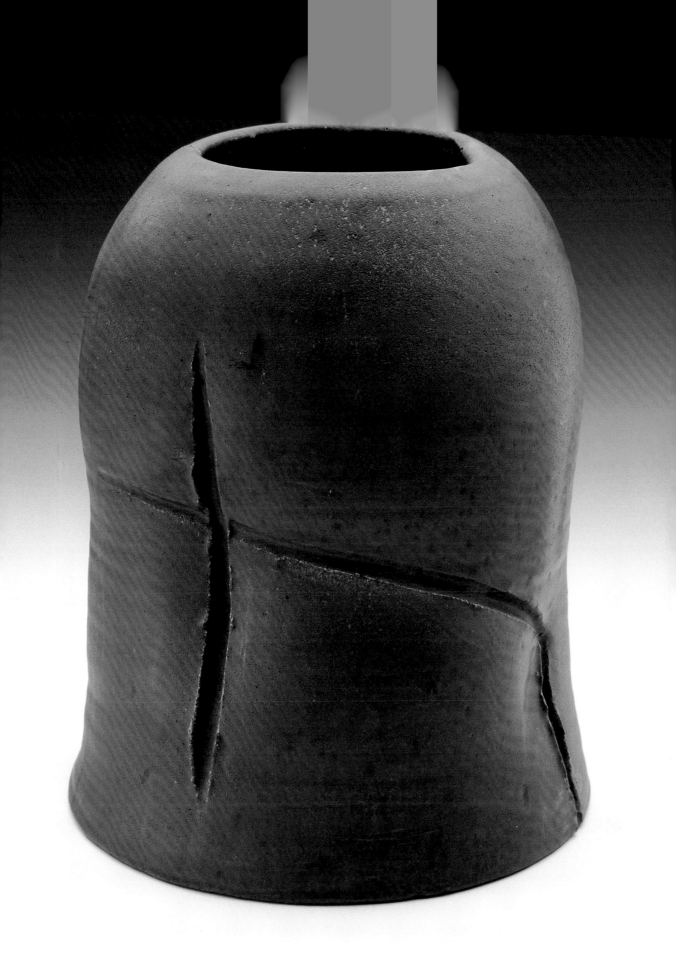

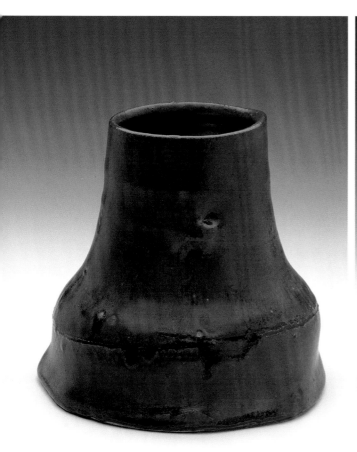 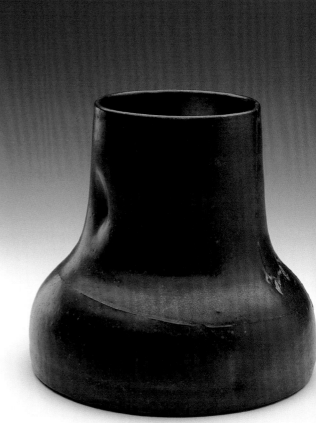

Penland Red

1972 approx. 8 x 8 ½ in. (20.5 x 21.5 cm.)

*An accident. The simple physical breakthrough of the clay wall at
the base during the throwing process transformed this geometric pot into a thing hinting
of the organic. A heightened feeling—the start of new possibilities at that time
of openness and searching.*

Black Form

1971 7 ½ x 8 ⅟₁₆ in. (19 x 20.5 cm.)

*This small piece—a circle of geometry—is moved to the organic
by the touch of a hand. So simple, so accepting.*

Prisco

1973 12 ½ x 10 ½ in. (32 x 26.5 cm.)

*The metal armor of a medieval knight has appealed to me ever since childhood visits
to the Metropolitan and Brooklyn museums, where I first saw the taut, shiny beauty
of its volume. The helmet seemed a mask. The shaped opening for the eye
and the slit into darkness were scary and mysterious. A slight disjuncture formed
the beak of an aggressive accipiter, a hawk.*

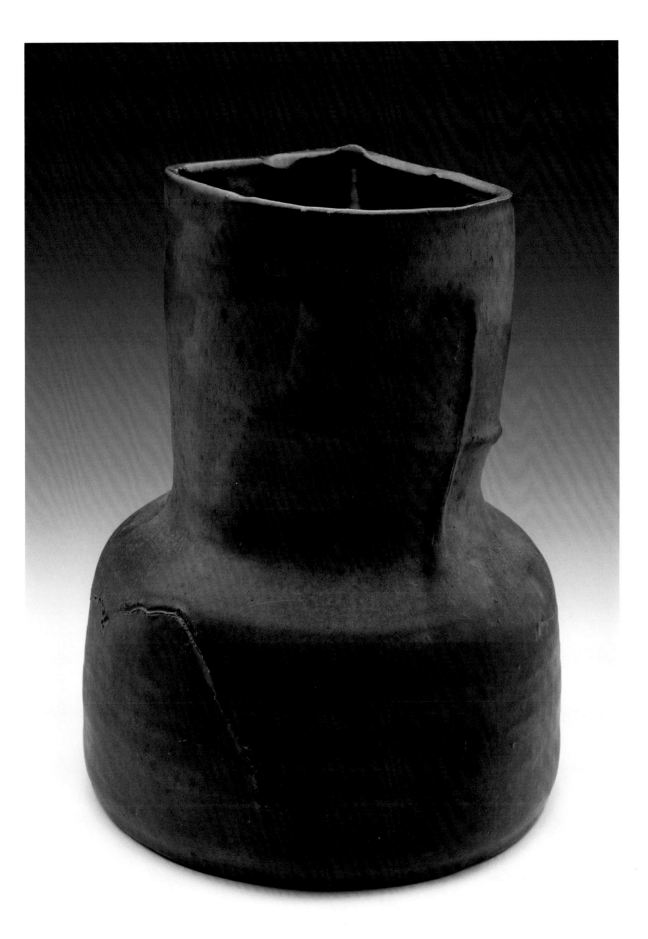

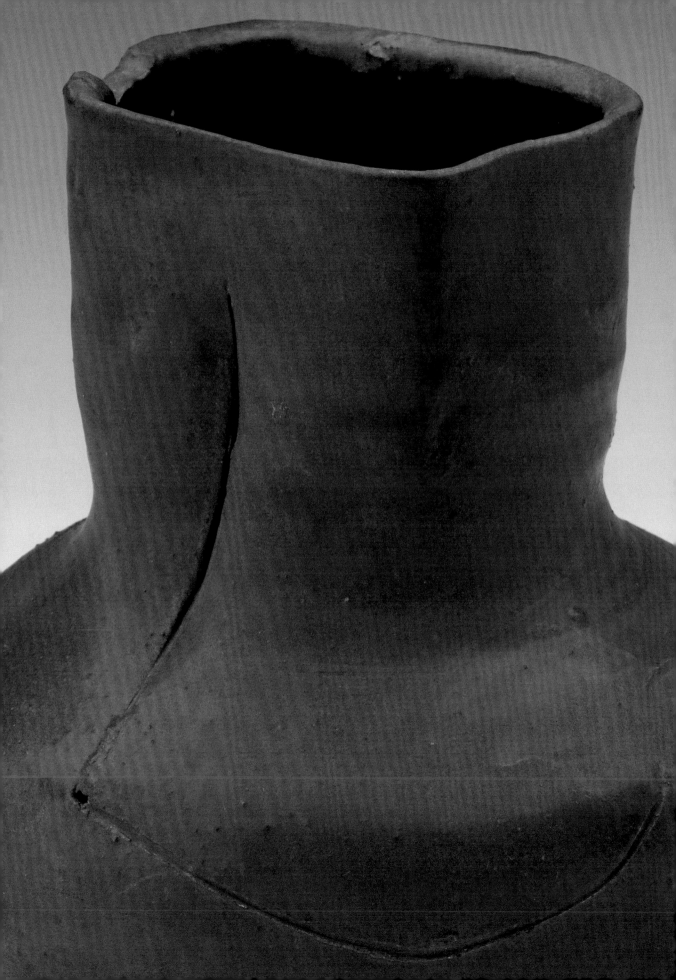

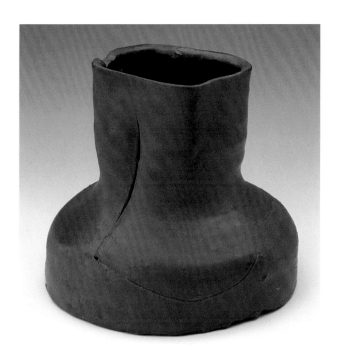

Circle-Square
1974 8¼ x 9¼ in. (21 x 23.5 cm.)

This reexamination of two well-known forms, which I throw one above the other, has an ambiguous nature. How the cylinder and the cube join in that process remains an uncertainty, a surprise. Does the cube spring from the circular dome below or does it rest upon it? How they nest always captures that wonderfully unclear nature inherent in the stability of the form. Perhaps this ambiguity is also inherent in the life I look for when I am throwing-rejecting-throwing this shape. ■ Its life plays on the edge of collapse.

Bowl Squared
1977 8 x 10 in. (20.5 x 25.5 cm.)

Obviously, the circle-square relationship has continued to intrigue me. Here, the marks of events have altered the abstract form that had started the piece.

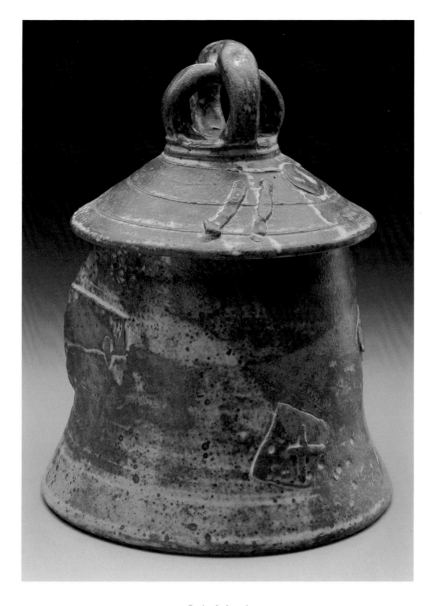

Early Ashanti

1973 8¾ x 7¼ in. (22 x 18.5 cm.)

In one part of Nigeria there is a type of circular dwelling, the roof of which is a cone made
of grass matting. The structure ends in a hole on the top where the smoke goes out.
An old, broken pot sits on top of that hole—black and charred.
(From "Born Remembering")

White Pre-Ashanti

1973–74 12⅛ x 9½ in. (31 x 24 cm.)

South of Owerri in Nigeria, the chief's son took us into the woods to the Mbari shrine.
The tin roof of the square enclosure extended on all sides over spirit figures.
It was late afternoon, just before light faded. The juju *(priest) of the shrine shared with me a*
cola nut brought on a white enamel platter by his son. Upon seeing this pot again long
after I first made it, I suddenly saw in it the white Goddess Ala of the Mbari shrine, with her
extraordinary, extended neck. The posture of the pot carried that image, although in forming
the pot some years ago, I had no conscious thought of its human aspect. The intensity
of the Mbari image remains—the goddess in the shrine, her maidens, an imagined elephant,
and the geometric patterns visible on the posts and on the wall behind the figures.
Street humor, myth, and sophistication mix.

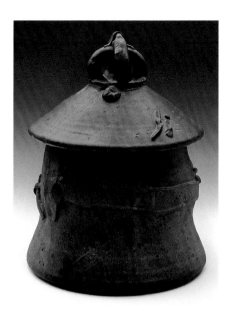

Ashanti

c. 1974 12¾ x 9¼ in. (32.5 x 23.5 cm.)

*Solid, earthbound, and nonelegant—the scars, the mending, the stability. The events
(a brush fire, a pair of climbing figures, a ladder perhaps) confirm physicality and
create scale. The conical cover recalls the thatched roofs in the village of Ushafa, Nigeria.*

Ashanti

1974 12½ x 9½ in. (31.5 x 24 cm.)

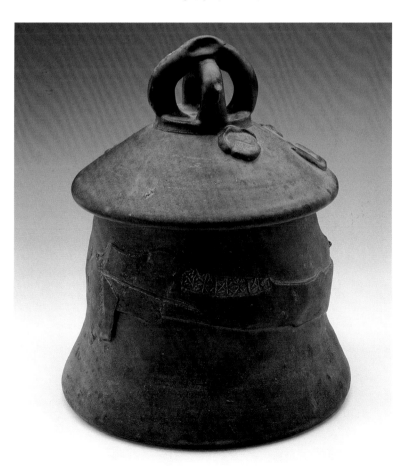

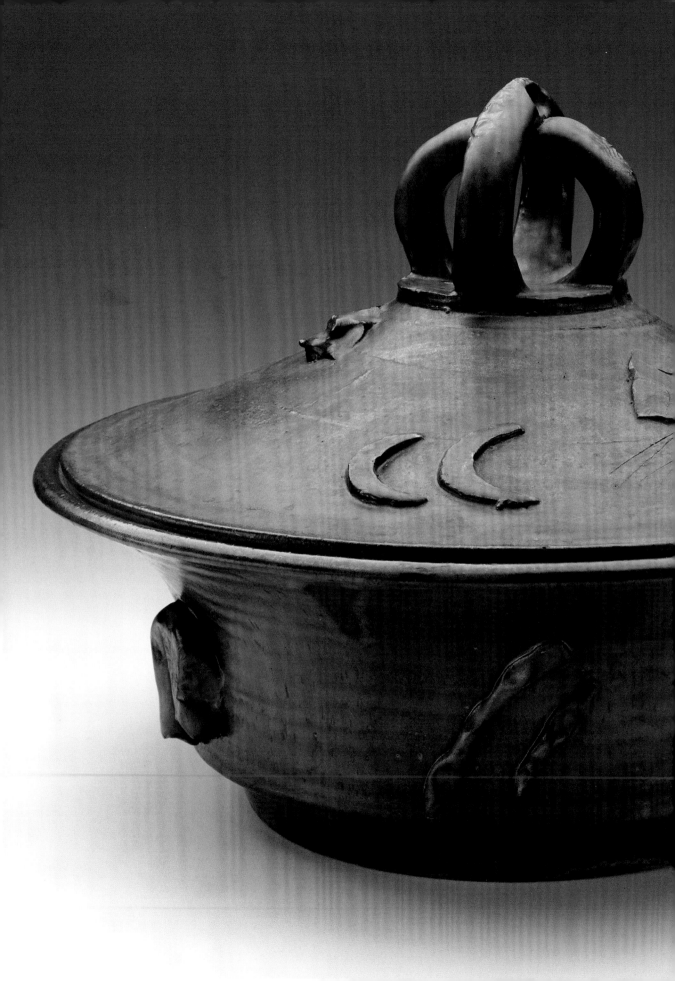

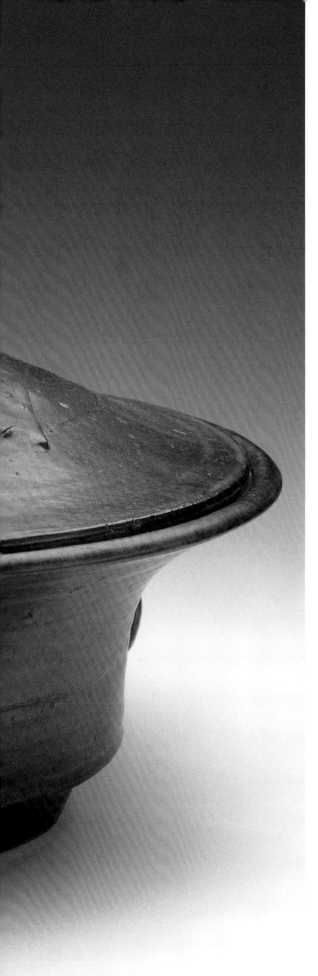

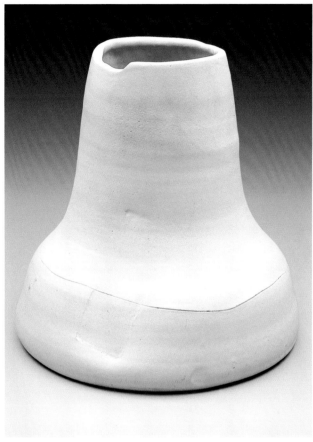

Beach
1976 8 ½ x 9 in. (21.5 x 23 cm.)
*Membrane and weathered-white shell: where water and sand mingle,
the waves hit the rocks, the sun bleaches all things, and the marks
of time are everywhere.*

Ceremonial Tureen
1974 11½ x 16¼ in. (29 x 41 cm.)
*Images and objects we know that focus "place" also rise up into
and expand the space that the cover occupies. The idea of creating
abstract "marks" grew in the following works.*

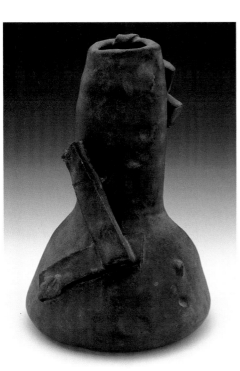

Akan NEW FORM
1980 9 ¼ x 6 ½ in. (23.5 x 16.5 cm.)

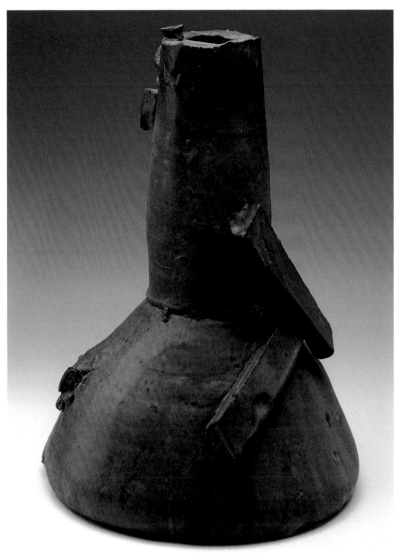

Akan
1982 14¼ x 11 in. (36 x 28 cm.)

*I laid rectangular units of clay on the thrown shape to find a way of moving
around and upward, as though in space. The units begin to move as
a structure, as in a dance, spanning space like a bridge—almost as
if I could take the pot away and they could exist by themselves.
They define the pot they are on while, at the same time, they begin
to have an independent life. Now, however, I have reached the point where
I'm not so sure they can do that; they depend too much on the pot.
(From "Born Remembering")*

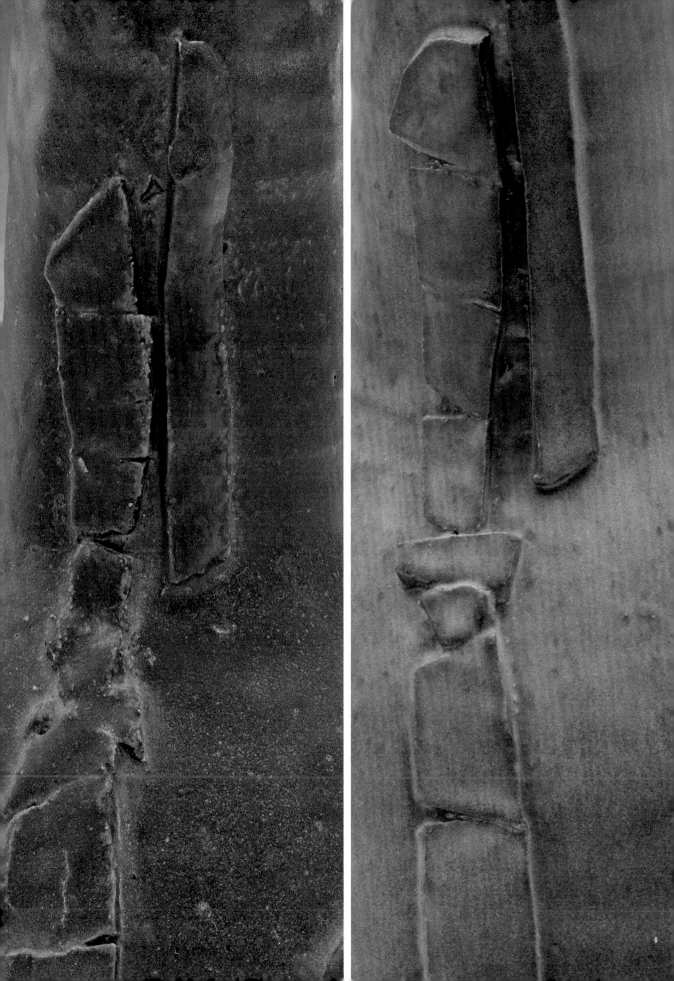

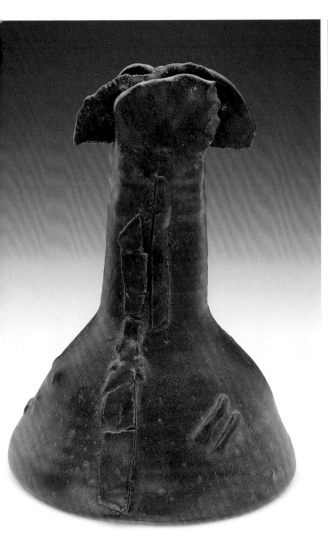
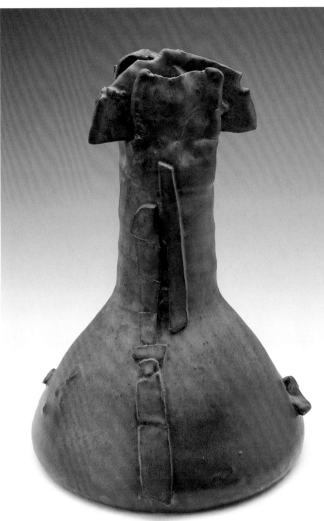

Black Ife NEW FORM

1980 8¾ x 6½ in. (22 x 16.5 cm.)

The Ashanti and Ife pot series are about time, place, and resolution.
They share internal movement, scars, accumulations, chance, and improbable,
or awkward, but inevitable possibilities. Together, they confirm a presence
and a physical reality.

Ife

1982 16¼ x 7½ in. (41 x 19 cm.)

Ife is a marker pot. This is a simple, universal kind of inverted cone supporting a cylinder.
The cylinder moves up and into the shape of two facing planes of clay. The space within
the pot rises in transition from circular to square. Two clay rectangles extend beyond the rim
of the squared cylinder and are attached to it, on the two opposite sides, facing each other. These two
enigmatic shapes speak across the chasm they form. They have something to do with
that deep, deep, dark space inside because they are dark, almost black—a bronze black. The color
and texture are important. They have a worn and particularly meant-to-be unity about
them and their purpose. ■ Resting on and between the opposing rectangles, a "key" stretches
down to explore the interior. It has the look of a stone hammer, which adds to the sense
of its double function of ritual and tool.

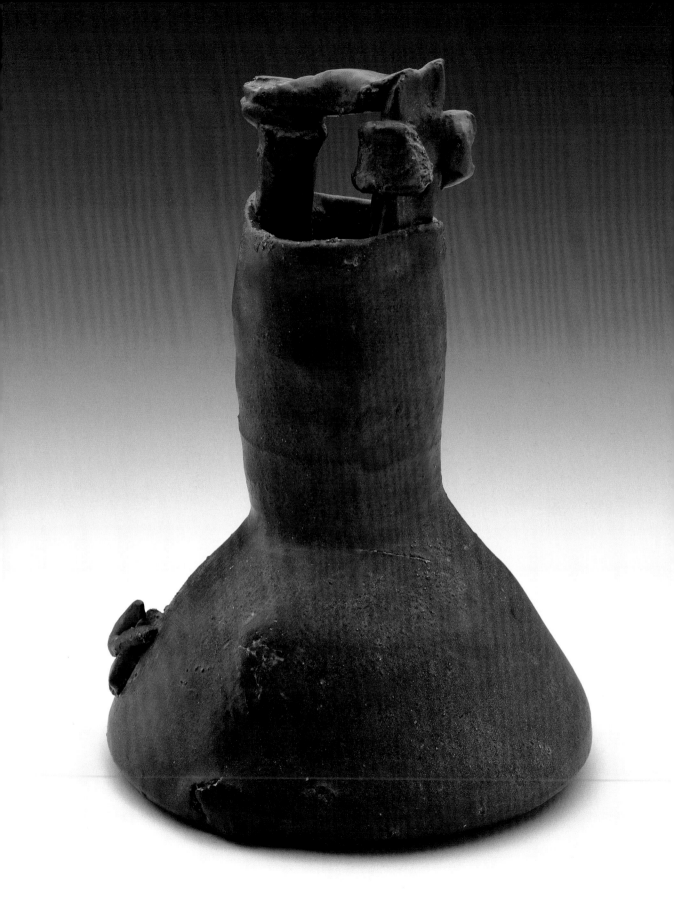

Oshogbo
1979 9¼ x 7 in. (23.5 x 18 cm.)

Little Sioux
1980 6½ x 6¾ in. (16.5 x 17 cm.)

I feel that Little Sioux *was seventy years in forming. It took time.* ■ *There is a mix of the inevitable and yet of not knowing that the relationships I saw here would happen.* ■ *A Han figure that I saw somewhere, the year before* Little Sioux, *was striking: its limbs as weighty blocks, ponderous yet free in dance movement.* Little Sioux *recalls that texture, age, and vitality.*

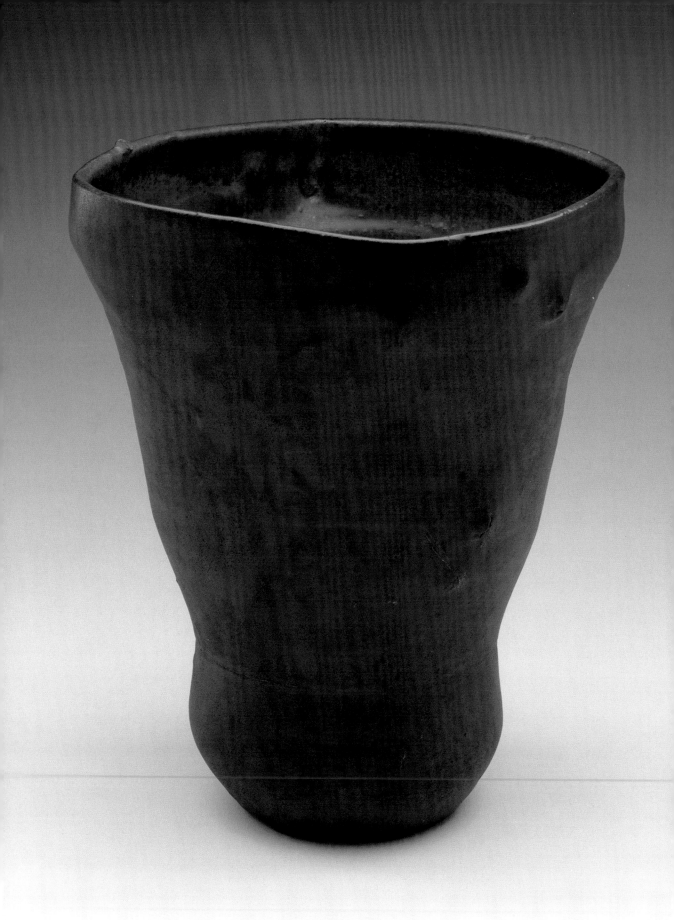

High Square I
1980 11⅜ x 10 in. (29 x 25.5 cm.)

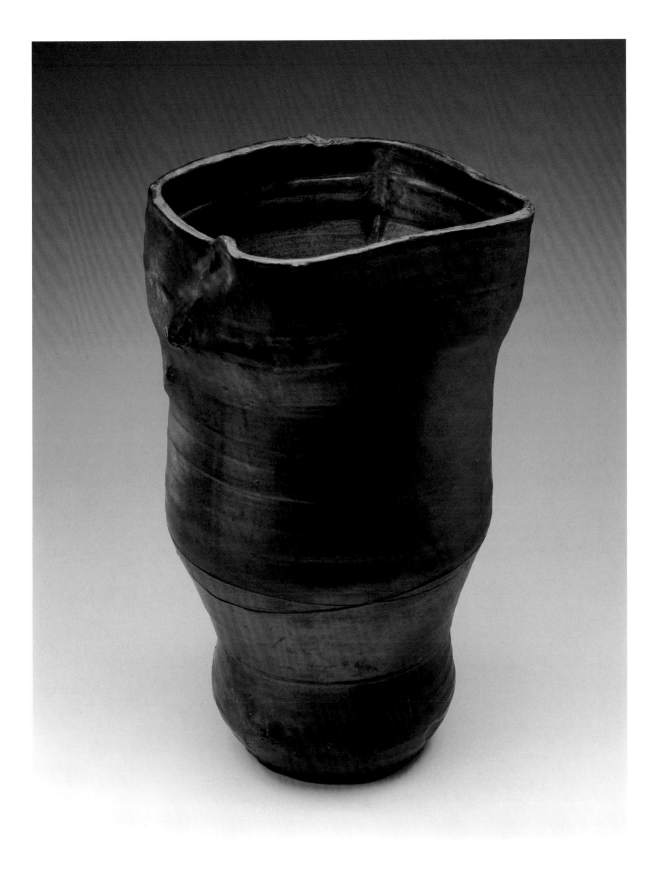

High Square II
1994 20 x 12 in. (51 x 30.5 cm.)

*Canyon walls pull in and down. Energy seems to be held
back, pushing within the volume. Quiet events in an intimate
place. The piece was made slowly.*

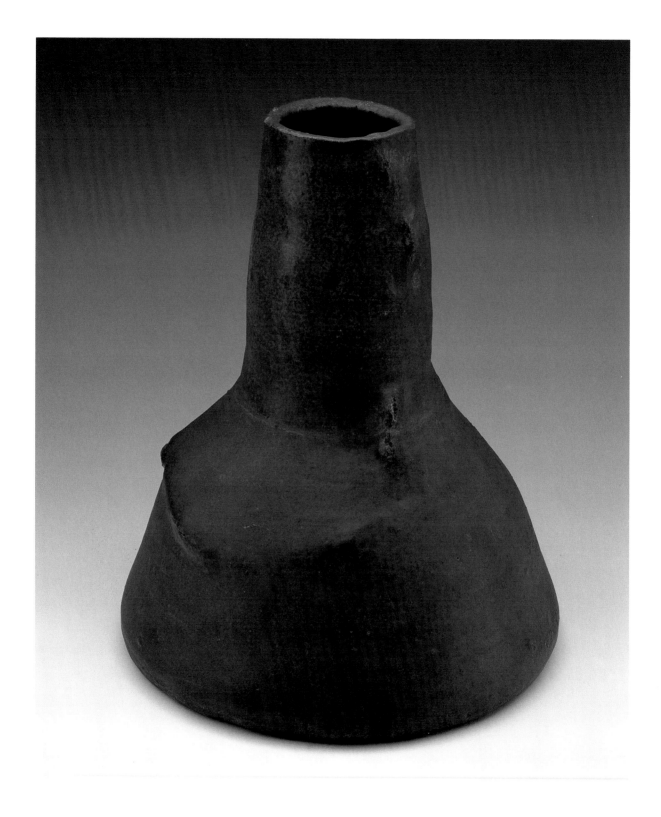

Canyon de Chelly
1984 13 x 10½ in. (33 x 26.5 cm.)
Canyon de Chelly *is about gravity, natural events*
(perhaps violent intrusions, or extrusions, which leave the canyon
marked but intact), and the quiet flow and weathering of such
a time-marked place.

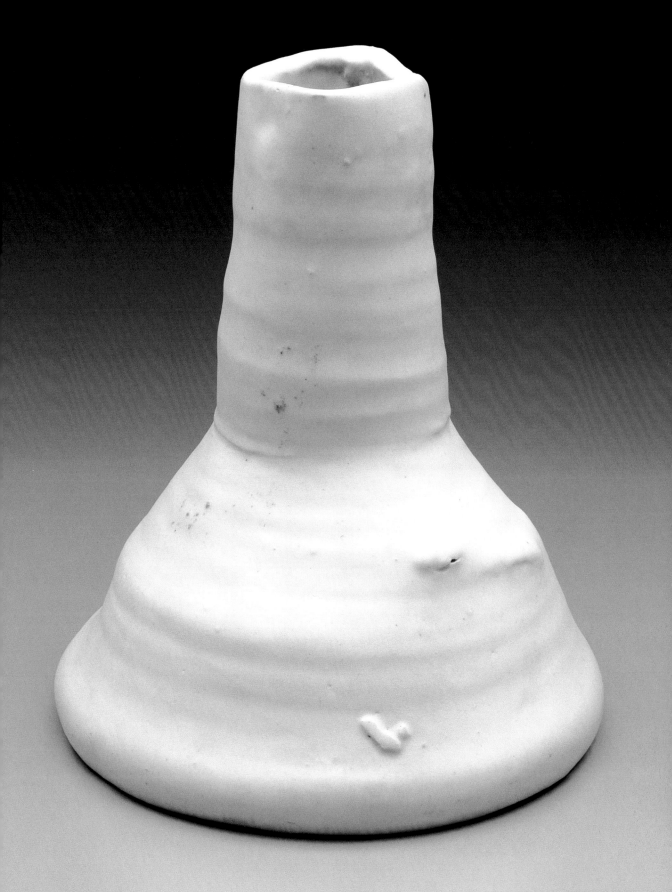

Shore I

1989 10 x 9 in. (25.5 x 23 cm.)

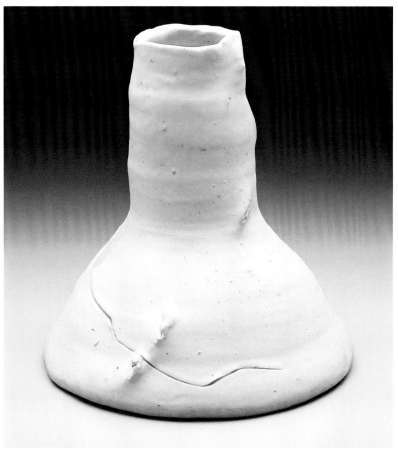

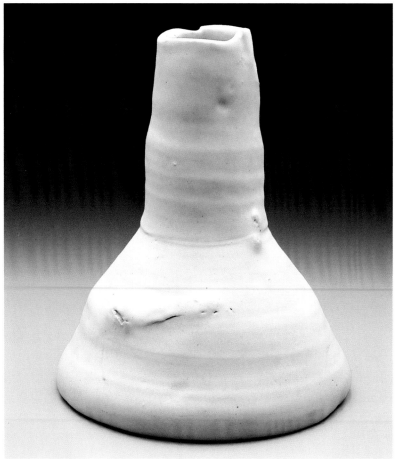

Shore II
1989 8¾ x 8½ in. (22 x 21.5 cm.)

Shore III
1989 10 x 9 in. (25.5 x 23 cm.)

I try things and wait for "it" to ring true—true to accumulated experience, to an intuition of how things react and reveal themselves. ■ The piece is working if it takes me to an organism or form that either moves or is quiet in space.

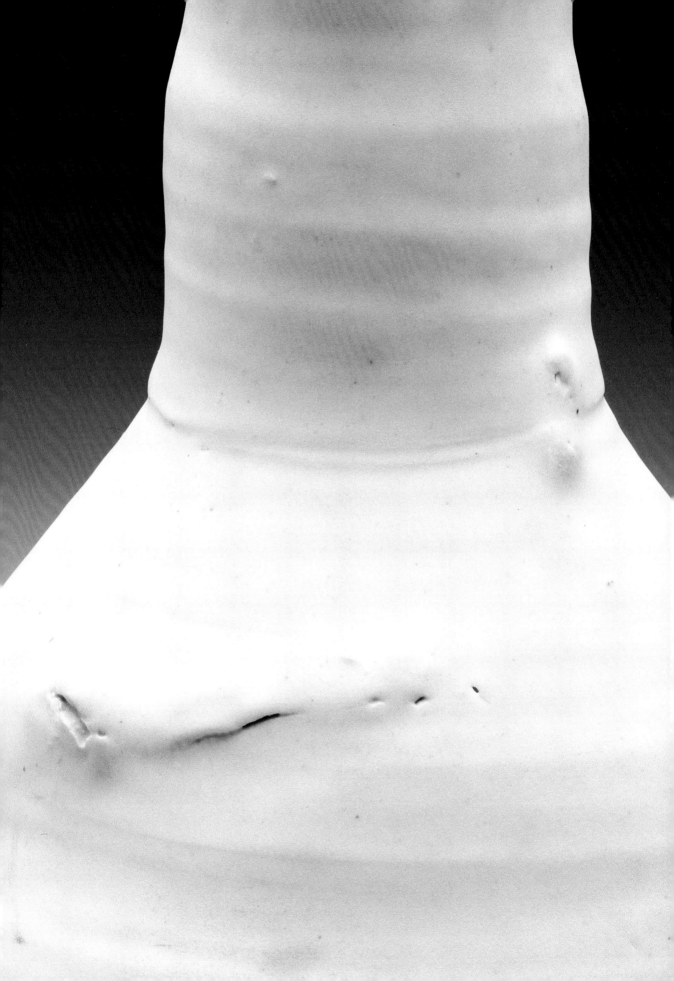

Jar WITH LID
1994 16 x 13 in. (40.5 x 33 cm.)

Owerri I
1994 16½ x 15¼ in. (42 x 39 cm.)

Owerri *is the meeting of two different
forces, of different energies in a kind
of balance: the stable, stoic cone and
the embracing arm frozen in
movement. Each makes the other
necessary.* ▪ *Physicality seems
dominant. The achieved presence went
beyond my expectation
of the idea. It looks larger than it is.*

Akan V
1994 21 x 15 in. (53.5 x 39 cm.)

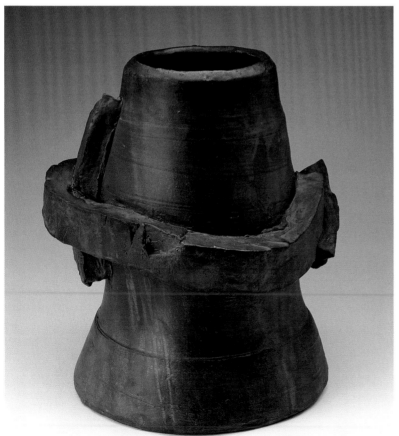

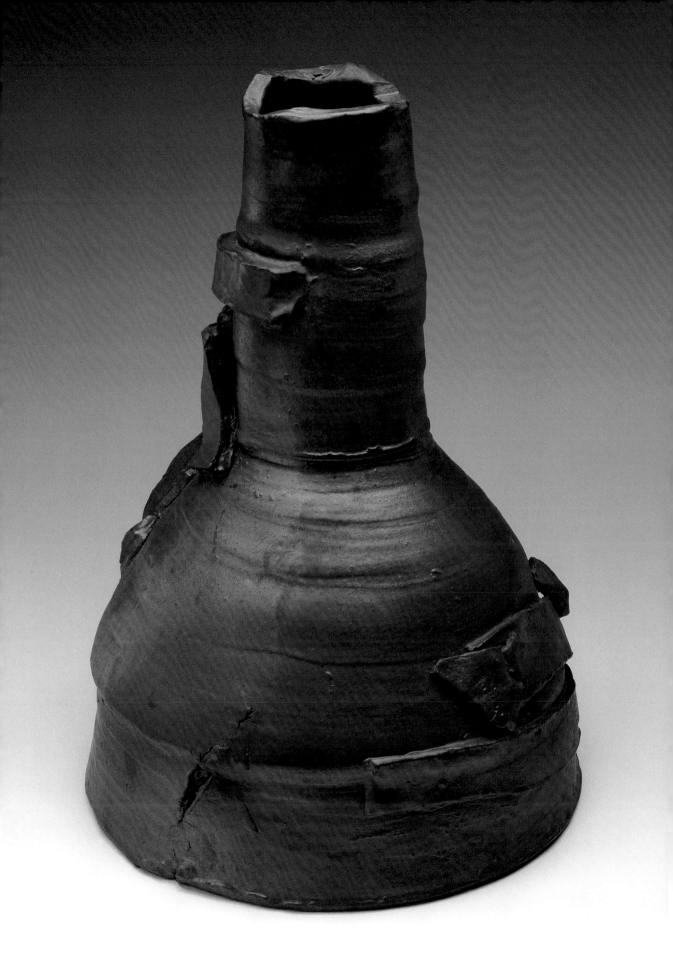

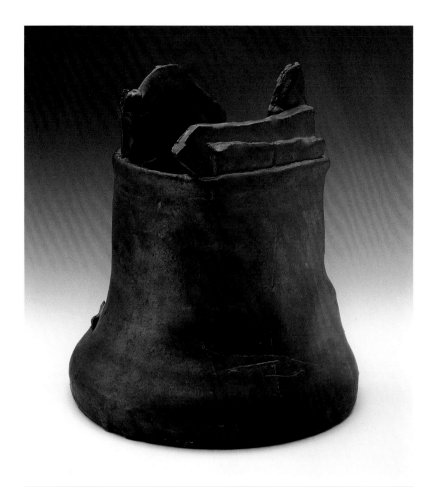

Form II
1989 13⅝ x 11 in. (35 x 28 cm.)

The ambiguity of the things we see—causality, time, whether accidental or inherent—is a boon. That either or both possibilities, as well as others, may be so encourages curiosity and an openness to greater truths. In my photos of 1972, and the way I still see it, the old church in Taos Pueblo is a structure of both geometric order and organic nature. Weathered and worn, spires of vastly differing heights reach upward from the still, square tower. As sculpture, there is a melted geometry to the entire simple building. It is monumental in its immeasurable scale. The geometric and organic coexist in visual unity. ■ That version of the church now no longer exists. As rebuilt, it is small and commonplace; its dual reality is gone.

Basket
1989 10¾ x 9¼ in. (27.5 x 23.5 cm.)

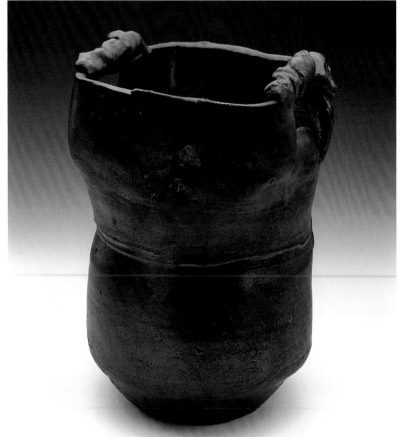

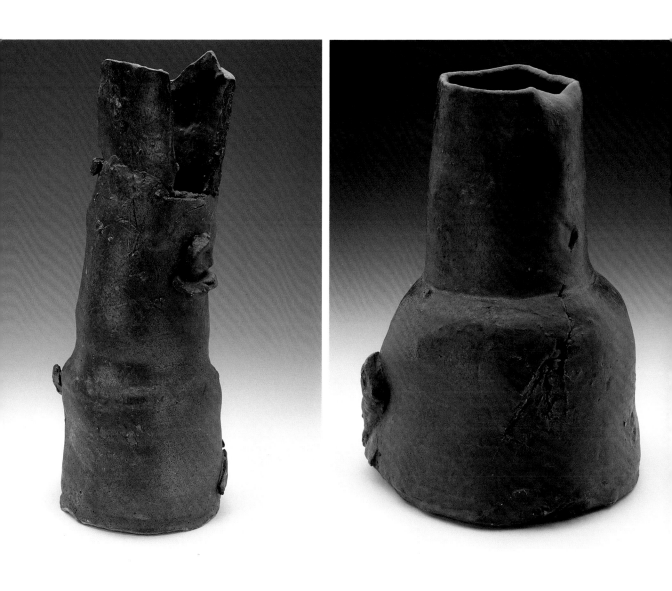

Onitsha
1993 19¾ x 7¼ in. (40 x 18.5 cm.)

Form I
1989 13 x 8¾ in. (33 x 22 cm.)

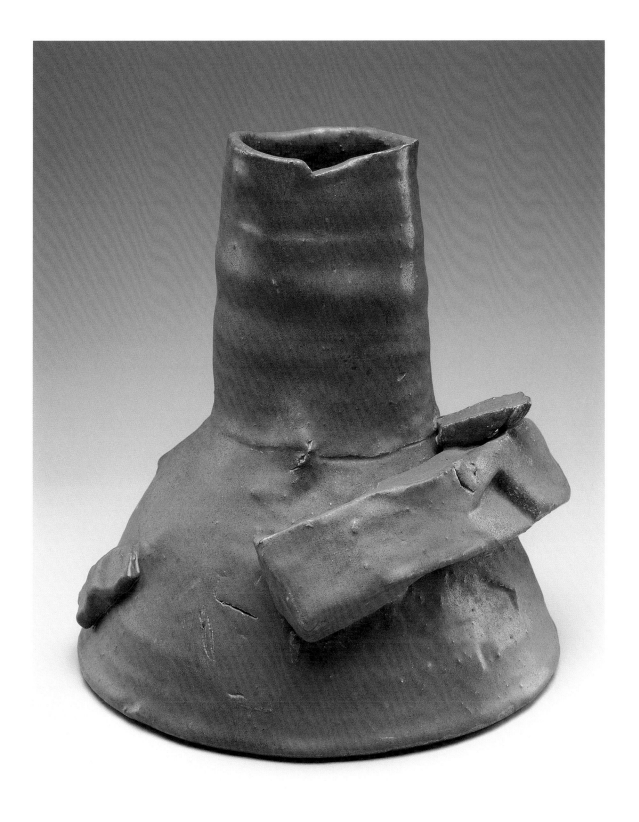

Canyon III
1997 10 x 16 in. (25.5 x 40 cm.)

Energy gathers in fortuitous contests. Thus in the brook
a stray log imposes itself.

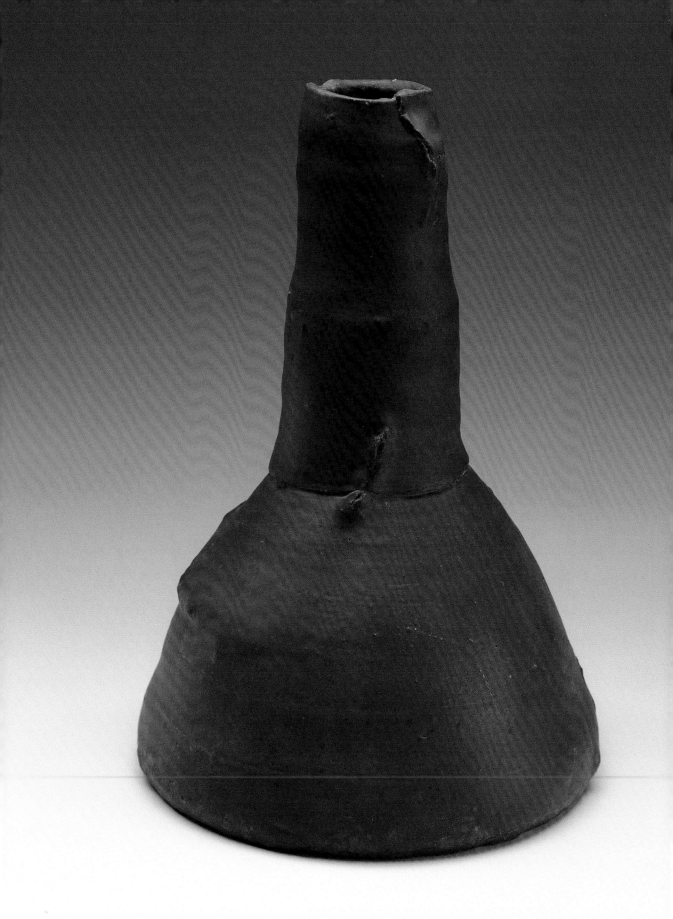

Canyon de Chelly

1988 17½ x 12½ in. (44.5 x 32 cm.)

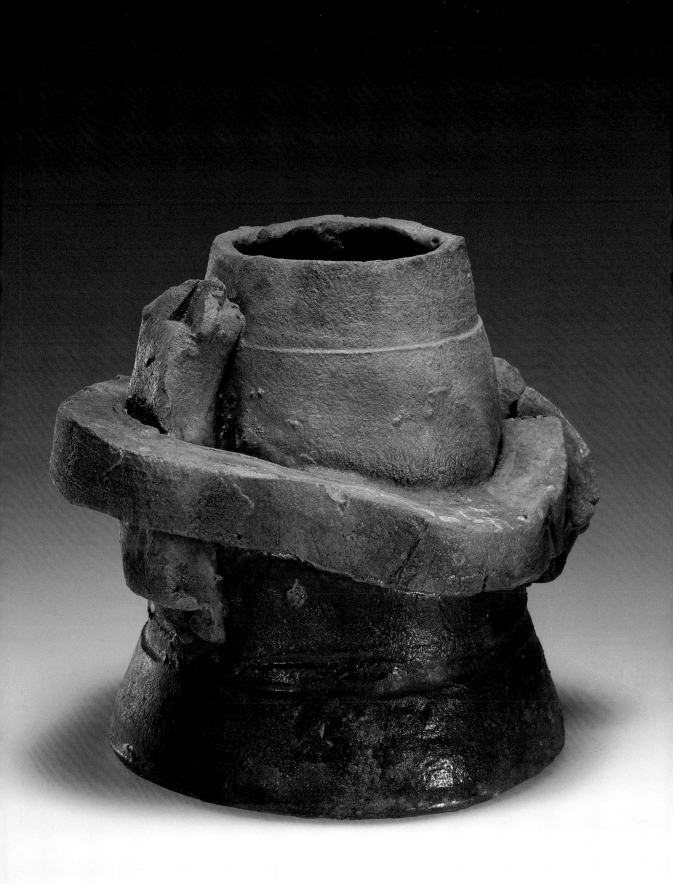

Owerri III

1998 9¾ x 9 in. (25 x 23 cm.)

A smaller, more recent Owerri, the result of
a firing by wood.

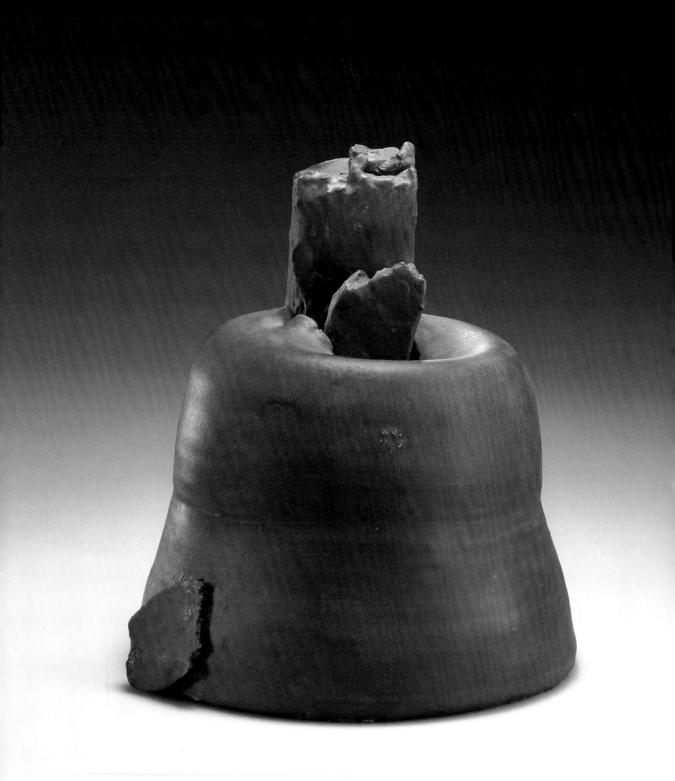

Tsiping

1999 12 ½ x 11 ½ in. (32 x 29 cm.)

In northern New Mexico, a low mountain chain ends in a rather narrow mesa, or plateau,
facing north. Up on the plateau is a hollow within a ring of fallen stones. This sacred
place, which remains from its thirteenth- to fourteenth-century inhabitants, forms a small
kiva. We sat and faced east as the full moon rose. The whir of wings, a flight
of ravens just above the sleeping bag, briefly interrupted the night. A black ridge
of flint dominates the west.

ROBERT TURNER: A CONSIDERED ART

Marsha Miro

As a ceramist whose artistic identity is rooted in the idealism of America in the 1950s and the moral strictures of his Quaker beliefs, Robert Turner is committed to the universalism of art. Many cultures and forces, chosen because they convey essential experiences, resonate in a Turner vessel. He creates pots, not twenty-foot-high metal abstractions, because the vessel is for him an expressive object with a long history of wide-ranging significance. His work has included that past within the interdisciplinary concerns of contemporary art.

With deliberate purpose, he uses the common threads of instinct, chance, and necessity to uncover the truths that link us. His vessels relate varied conceptions, unexpected confluences, disparate psyches, and juggled contexts. The pots are abstract yet specific, based in the scientific and experiential. Sensual and hard, multiscaled, stable yet precarious, they balance his life experiences with his ideals, physically and conceptually. A Turner vessel is an affirmation of the ecumenical spirit that links us all.

"In developing his vocabulary and vision through [his] forms, Robert Turner is creating pots that convey the vital core of our contemporary culture in the same manner that historic pots convey the nature of the cultures in which they were made," wrote Alice Westphal, Turner's Chicago dealer, in 1987. "Historic works were and remain coherent communal expressions. Turner's pots are communal expressions in the largest possible contemporary sense. The power that you feel in these works is due to the vast scope of our experience, which Turner has perceived and synthesized and transmitted in these abstract expressions."[1]

Bob Turner is both a remarkable artist and a wise man. While he may speak a bit abstrusely, that vision and wisdom are evident in the vast ideas and simple truths that animate the concrete bounds of his work and words. A contextualist by instinct, he says:

Our perception of the nature of the universe is dependent upon the act of observation. The nature of the universe we perceive can be constantly changing. And that's why it's so interesting to see how another culture perceives our universe and how important this is because their observation is different than ours and just as legitimate in terms of what they were given. They're different and they're equally true. It suggests a way of opening yourself to possibilities.[2]

The origins of Turner's beliefs can be found in the way he was reared. Born in 1913 to a well-to-do Quaker family living in Brooklyn, he was the fourth of five children. His father, Henry, was an

057

engineer and president of Turner Construction, a successful commercial building company. His mother, Charlotte (nee Chapman), loved the arts and involved her family in them.

His father, in a brief history of the family's Pennsylvania retreat, Skyland Farm, written in 1944, described the future artist as "a handsome little boy—none too strong . . . did not become a vigorous worker at the farm. He was not so active in harvesting oats or hay, or in the garden, but he [was] always active in keeping the tennis courts in order and in cutting the lawn, and he was dependable. He was keen for tennis and for art work—for drawing and modeling."[3]

From the first Robert Turner was called the informal "Bob." His family showed an understanding and an offhand respect for his identity as a child and for whom he promised to be as an adult. Such security allowed him to develop his natural gifts and move through the difficulties of growing up with his eccentricities accepted. But before he could veer off, he had to take the old-line educational path to adulthood. It took him more time to get where he had to go, but for Turner, the odyssey is always critical.

Father Turner revealed his final acceptance of his son's identity in inscribing the family history: "To Bob, the artist, a very lovable and tolerant character."[4] Perhaps being the fourth of five children also made a difference. The oldest brother, Chandlee, went into the family business, followed eventually by the youngest, James, who was called Jim. Bob Turner says that when he chose to play tennis, instead of golf, his father knew he would go his own way. You can't settle any business deals on the tennis court.

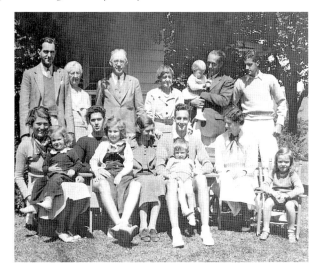

The children were separated by a considerable period of time, fifteen years from oldest to youngest, which seemed to have provided individual growing space. "We were a peculiar family," recalled Jim Turner in 1997. "My oldest brother was a person who was a conformist. The next child, Katherine, was a loving person who opened her home to the surviving 'Hiroshima Maidens,' for treatment in the U.S. Next was a person who was his own man, Haines. He was early on a socialist. He voted for Norman Thomas. We used to get into good arguments at the dining-room table. Bob Turner was not interested in those areas at that time. He was more reflective, with a good sense of humor."[5]

When Bob Turner speaks of his siblings, he, too, singles out Haines.

My oldest brother didn't influence me much, although we were very close. My next brother Haines influenced me a lot. He was a debater at school. He was very purposeful. He was always a rebel. Haines wore a blue shirt, a workingman's shirt. It doesn't sound like much to me now, wearing a blue shirt without a tie. It was.

He worked in the apple orchards. He wanted to find out what a workingman felt when he did that job. He organized trips for people in the union to go abroad and meet with other people of similar professional interests.

Listening to Bob Turner remember his growing-up, one hears details in brilliant snatches. It is as though he recalls an incident by seeing it replay in his mind's eye so he can sort through and find meaning. Conclusions come out slowly. Expansive syntheses conclude mundane sentences in what can only be called a "Turneresque" manner.

His earliest memory is of rolling down a hill at Westover, his maternal grandparents' Long Island estate, where he was born July 22, 1913, and spent his first three summers. The house was one of those big gray shingle-style "cottages" that sprawled across the horizon.

While considering, at age eighty-three, the paucity of his recall of his first years, Turner commented: *I don't know what you think you remember, rather than the actuality.* Whether he did roll down that hill would be a matter he might contemplate for quite a long time. The distinction between what one thinks happened and what occurred is an important question for Turner. Many of the earlier cultures he references in his work based their collective knowledge on memories that were passed on through rituals and ritual art. The actuality is less important in these pre-Cartesian societies than an object's sacred mission. Turner has been preoccupied with including both the factual and the implied memory, congruent or incongruent, of significant experience. He also focused on collective and individual, cultural and nature-based memory.

From among his ancestors, he singles out the activists and artists, anchoring his adult passions in this heritage:

My (maternal) grandmother, Marianna Wright Chapman, was a social activist, important in the suffragette movement. Governor Theodore Roosevelt asked her to speak many times to the state legislature on women's right to vote. In her own quiet way, she was critical. Men or women have the same responsibility. That's part of the Quaker tradition.

Father's family came from Maryland. They were active in ways I respect. Grandfather was in the lumber business. They were Quakers. Grandfather's father was part of the Underground Railroad. That was important for me to find out. And it was grandfather's sister Rachel who used to paint. She wanted to go to art school, but they wouldn't let her.

My father's great-uncle was a painter, a founder of the Art Students League and head of the American Academy in New York—Charles Yardley Turner. He was very accomplished. [His art] had all that bastard Greek influence, like Puvis de Chavannes, idealized.

Turner's parents were well established by the time he was born. His father built a hugely successful business from a rather revolutionary idea, reinforcing concrete with steel rods. The increased strength enabled concrete to be used for the construction of larger and taller structures. One of his first jobs was building steps to subway stops in Brooklyn. From there Turner Construction went on to national, then international, prominence.

We didn't realize how important Father's idea was until later. "Turner for Concrete World Wide. Turner for Integrity." I remember he went to the office in Manhattan, 420 Lexington Ave., the Graybar Building, every morning. . . . Father would jot down things for the day we had to do. Father was very organized. He was the supervisor of things. He wasn't someone who went out and fished with me, because I wouldn't fish. We led parallel lives on many levels, going our own way.

Mother mothered you up. I was very secure and protected.

The family lived in Brooklyn, on Monroe Place, in a six-story brownstone. It looked like many others on the street and was simply decorated, with very little art. Because they were Quakers, they were suspicious of pomp or displays of wealth. Instead, a sparseness was considered proper. The house did have a side yard where the boys played ball and swung from the clothesline. While Turner loved athletics, his allergies and frailness kept him from most organized sports, except tennis.

Mother ran the house. It was a beautiful house.

The Turner family at Skyland Farm, Buck Hill Falls, Pennsylvania, 1930–31. **FROM TOP LEFT, STANDING:** Chandlee Turner; Mary Chapman (aunt); Henry C. Turner (father); Charlotte Chapman Turner (mother); brother-in-law Herschel Parsons, holding daughter Martha Parsons; Robert Turner. **SEATED, LEFT TO RIGHT:** Virginia Turner, wife of Chandlee, holding their daughter Marlee Turner; Jim Turner, holding daughter Ann Turner; Cay Turner, Haines's wife; Haines Turner, holding son Clark Turner; Katherine Parsons with daughter Ramsay Parsons.

We did have servants . . . cook, maids, and a chauffeur who took my father to work and knew all the cops and knew how to swear at taxicabs. It was a privileged life without me realizing it, because it was the only thing I knew. One thing that was really wonderful was, it was a ten-minute walk to school. Four minutes away was the firehouse with those great big fire engines and horses. . . . I remember going up there and seeing the beds and boots lined up.

My mother loved to go to the opera. She loved Caruso and played the piano. She never attempted to have the children do one thing or another. Chandlee and Katherine studied piano though. The rest of us did not study music. I always wondered why, because mother loved opera and I love rhythm and music. So does Jim.

Instead his mother recognized and nurtured Bob Turner's artistic nature. She took him to special art classes, had him tutored by various professional artists, and acknowledged his creative efforts as significant.

We didn't go to museums until I would have been eight or nine, and I was modeling things in plasticine. I made a figure and mother took us to a place in Brooklyn where they made it into bronze. I remember having to fix an arm on it.

He went to the Brooklyn Friends School through high school, as was the family routine. His mother was on the school's board. He remembers being only an ordinary student, with a "C" average. But he was particularly excited by two things: reading about Lincoln Steffens, whom he admired for his social activism, and working as art editor of the school publication, which gained him awards.

"I remember entering a contest in art when I was nine or ten. I got an honorable mention the first year, and I won the second year. I received a prize, a tennis racket. I loved that I won. It was for a drawing of something, a football player or a dog, not a scene. I did a lot of sketching; the normal things people did when they moved out from being really young to copying. I did art for the school magazine. I did illustrations. I just thought it was something to do. I didn't think it was special. I think I was a pretty lazy kid, not highly motivated. I didn't enter fully into the games of living. I did things on my own a good deal. . . .[6] But when I liked doing things, I just kept doing them intensely. I liked to play tennis. I liked to draw."[7]

Mother arranged for me to work with a teacher at Pratt. I had drawing lessons. He'd show me how to shadow and draw a line and do pencil work to make images look real. I could work with clay. I made objects. I remember more of the studio, looking around at all these amazing figures and trying to copy them. If you're affected by physicality, it's a presence you respond to. It all probably had some lasting effect, making me want to do more clay. There wasn't any major immediate effect.

One of my last years at home, it was again my mother who, on Sunday, took me on the subway to New York, across from the Metropolitan Opera to a sculpture studio. No one was in it, and I could sit there and see models in plaster. I don't know how much I got out of it, but I remember putting my hands around a massive figure. I don't know who the sculptor was.

Turner graduated from Brooklyn Friends in 1931, but it was decided that he needed some tutoring before he went on to university, because he had done poorly in French on his college boards. He went to the George School, a Quaker preparatory school in Bucks County, Pennsylvania, where he made a conscious decision to study and improve his marks in order to get into college. He worked hard, began loving learning, and his grades rose.

He also took a drawing class with a woman who awakened his fascination with other cultures.

We were mostly looking at things and drawing them, lots of Egyptian things, those idols and figures. It didn't sink in. I didn't tie it into things I got excited about, until much later: the ritual things of Africa and North America.

Recognition of the power of seasonal change in nature began for Turner at this young age. He remarked on the tree buds enlarging in February, long before one thought spring would have an effect. The continual shifting was important to him, a sign of elapsing time and varying sensual states, which he would later incorporate in the marks and forms of his pots.

It was inevitable that he end up at Swarthmore, the Quaker college his father and older brothers had attended. They majored in engineering or economics. So Bob Turner majored in economics, an indication, he says, that he wasn't really sure what he wanted to do yet and was, perhaps, still trying to fit into the traditional mold.

Sue Turner remembers the man she would marry at Swarthmore, where they met. "Bob was a member of Phi Kappa Psi in college. He wasn't the fraternity type. He joined because there hasn't been a Turner at Swarthmore who hasn't been in PKP. They were the smoothest. He was president of the Friends school class from first grade on. One thing about Bob is he was always the head of whatever he did."

I enjoyed athletics. I went out for football, but the doctor stopped me from playing. I enjoyed tennis and played in college and I was in the intercollegiates. But I wasn't competitive. I loved the form. I loved the movement, the pairing. It is almost like a dance, the movement of the ball coming and how you meet it and where you meet it. Whether I won wasn't all-important, though I didn't want to lose. I was more interested in the strokes and enjoyment of them.

Art history and literature provided him intellectual inspiration, though he failed his first art history class because he was so interested in the slides the professor was showing that he didn't take notes. In literature, he was taken with the course in authors' letters. He studied Dostoyevski and Chekhov—their short stories and *The Brothers Karamazov*, as well as their correspondence. *Chekhov was very symbolic to me and very important. I think it was his personal observations of things and the way he talked about them. It might be dust on a lilac flower, [or] the hidden meaning about this young man who drank milk. Milk meant physicality, health, stability, rather than dreams and going out in the moonlight.*

In his mature work, Turner has no compunctions about using abstract forms as signs, making a multitude of connections by the presentation of an intrinsic element, rather than a pictorial representation. He often points to Chekhov as one of the reasons he thought to do this.

In college he wrote very slowly, as he still does today, following all his thoughts through to some extreme mental point. Conclusions arrive after what seems to be endless internal discussion. Writing remains painful for Turner, a problem that plagued him in some of his English classes. But he did arrive at understandings through his writings that he feels are closest to what he later did in painting and clay. While he didn't write poetry, the idea that he could reveal both internal feelings and external experiences with the same words, that phrases can *contain a thought and be contained by it,* he relates to his ceramics.

Much later, Turner recognized that developing his perceptual skills during his last two years in college was more important to him than acquiring information. By his junior year he knew he would finish his general education and go on to art school. After graduating with a B.A. from Swarthmore

Robert Turner after working on the tennis court at Skyland Farm, 1928.

in 1936, Turner spent the summer bicycling around Europe with a close college friend, Frank Gutchess. This was Turner's first trip abroad, his first exposure to the Renaissance in Italy and the cathedrals of England. His amazement at the depth of the cultural experiences in societies that continued to add to their heritage provided an introduction to the fluidity and accessibility of history.

He also began a serious relationship with Sue Leggett Thomas. The couple were just friends when both attended Swarthmore, dating others among a shared circle of acquaintances. They became serious about each other after graduation. Sue Thomas also traveled in Europe in 1936 and had similar experiences to those of Bob Turner. "That set us apart from the rest of the group," she recalls. "We just started to see more and more of each other. We were both Quakers. We had an implicit understanding. . . . The thing that attracted me to Bob . . . was that he was so oblique. It was the way he wrote letters. He labored over his letters. He labors over everything, never taking things head on. I loved getting his letters. They were so different, so much better, than other letters. . . ."

While Bob Turner went off to study in Philadelphia that fall, Sue Turner remained at Swarthmore as assistant to the Dean of Women. They got engaged the winter of 1938 and married on June 24, 1938. "Mother is his other holding vessel," explained their son Rob Turner, of the equal significance in Robert Turner's life of his wife and his art. "She is his other great strength." [8]

A FORMAL ART EDUCATION

Turner began a program in painting at the Pennsylvania Academy of Fine Arts in Philadelphia in September 1936. He was admitted based on some drawings he had done during the summers, because he hadn't had any art courses at Swarthmore. The drawings were about seeing something, seeing a picture and just copying it. He was recording details.

The academy was renowned for its realist-based art education, an orientation that is often tied to the teachings of one its greatest practitioners, the nineteenth-century American painter Thomas Eakins. The painting and illustration students took many classes together, allowing them to make a decision on which professional course they might pursue as their education progressed. Training emphasized life drawing, portraiture, and the landscape, traditional subjects for artists intent on working from observations of the external world. Copying from the masters and drawing from casts of their works, typical aspects of a studio education, were also part of the curriculum. A course in color given by Henry McCarter was one of the few that Turner felt pushed his understanding. Critiques occurred every Friday morning, but Turner remembers that the comments on his work were rather perfunctory, just a statement that he should keep going the way he was.

"I was being moved by whatever I was copying, I suppose, much more than [by] the image-making capacity. The pure imagination did not occur, I think." [9] Turner became a fairly accurate realist painter working in a 1930s American style. Using outline and loosely painted color, he did memorable portraits that have survived of his father and younger brother.

Astonishing to Turner when he looked back was the fact that the academy did not acknowledge the existence of modern art, nor was any mention made of the famous Armory show of 1913 in New York, where great Picasso cubist paintings were exhibited alongside Marcel Duchamp's famous ready-made "urinal," sculpture. The academy provided a conservative education, designed to develop skilled practitioners, not avant-garde seers.

By his third year Turner's craving for something new led him to cut classes and spend Wednesdays outside Philadelphia at the Barnes Foundation in suburban Merion, which had been established and owned by Dr. Albert Barnes, an eccentric physician who made a fortune selling Argyrol, a silver compound used to prevent infant blindness. Barnes spent time before World War I in Europe collecting masterworks of impressionist and post-impressionist art. He knew other great collectors of the period, including Gertrude and Leo Stein, and art experts like Bernard Berenson, and he is credited with helping to discover Chaim Soutine and Amedeo Modigliani. Barnes commissioned Henri Matisse to do a huge mural, *The Dance*, for his museum, a neoclassical mansion, where great paintings hung from floor to ceiling, interspersed with odd examples of metalworking. Underneath the Renoirs, Cézannes, and Derains were wooden chests, chairs, and functional objects on tables. That installation, which Turner found strange and exciting—*Something like that makes you more open*—still exists, as required by Barnes's bequest.

Turner attended lectures by Barnes as well as by his disciple, modern art scholar Violette de Mazia, and peace activist Bertrand Russell, who taught a course in Western culture. Turner remembers watching Barnes himself sitting in a chair under the Matisse mural smoking a cigar with a little dog in his lap, pretending the dog could talk. *Barnes was a huffy man. He would do aesthetic analyses of paintings to show the good, better, and best, and would always say that he could prove what was the best. I remember he and Russell arguing because Russell would say the best was only from Barnes's point of view. Barnes got furious.*

Turner immersed himself in the great painting collection. Hour after hour he stood in front of works by Soutine, Matisse, Modigliani, Cézanne, Renoir, and Courbet, observing, absorbing the lessons of space and movement of color in Renoir, the physicality of forms in Courbet, and the importance of an underlying abstract structure in Cézanne. Soutine's inventive expressionism and Modigliani's amazing figures of drawn line provided new ideas for Turner. And it was the first time he saw works by the African-Americans Jacob Lawrence and Horace Pippen.

I was essentially studying the late nineteenth century. It was good training. I loved that quality of painting in Courbet. Cézanne was the geometry. Cézanne was the giant. My work didn't reflect it, though. At that time I wasn't thinking geometry, though the early casseroles done fifteen years later were circular spaces. But I don't think of painting with space. I learned to draw off Greek plaster casts of the figure. Only later on, in the late sixties and seventies, did that space of the figure become important.

The impact of the exposure provided by the Barnes collection could be seen at this time in Turner's Renoir phase, when he painted voluptuous women in patchy and brushy color. Successful as rather earnest reproductions, they reveal his ability to learn from the past. *I seemed to be in love with Renoir, his ability to use color so increasingly [that] the forms became sculptural. I was learning a skill. I did feel attached that way.*

In 1939 Turner received a prestigious Cresson Traveling Scholarship in painting from the Pennsylvania Academy, which gave him eight months of free tuition at the school and four months of support for travel. He and Sue Turner chose to roam around Europe that summer, spending an idyllic month bicycling in Ireland. Random notes, jotted down during the trip, reveal the strong impressions each place made on him: *Ireland is fashioned like a bowl and has most interest for the traveler in those coastal regions that form its edge: Ireland for a land of fairy tales, for natural beauty and color, for a friendly, free-spoken people. . . .* [10]

The remainder of his written memories just tumble out, observations mixed erratically without any attempt to order them. Here Turner reveals the fluidity of his thought process as he touches on mythical, cultural, and natural inspirations. *Managing to live on a little—bread, eggs, and tea—in the often wild scenery of the mountains and among evidence of the past civilization in the crumbling monuments and their symbolic boulders . . . a hard climb far back in the hills overlooking the water . . . the seven sisters, huge boulders arranged in a circle for worship by the Druids . . . the tropical growth along the southwestern peninsulas . . . the field after field of peat and simple whitewashed thatched-roof houses. . . .*[11]

Afterward they traversed Italy, where Turner looked at Renaissance art, particularly the work of Giotto. *Why do I respond to Giotto? It may be an emotional feeling about the way he dealt with paint and his subjects. He seemed so in touch with what he was doing in an intimate way. His things have enormous power and simplicity and they are very symbolic, which triggers the imagination. He had his own ways of inventing things to fit what he wanted.*

This was Turner's memory of what Giotto meant to him then. Looking back to that moment, Turner realized this idea of being able to invent things to fit, not having to take what is known, provided another legitimization of creativity even within a religious iconography.

Soon after they saw the works by Giotto, the couple was caught up in the war. They left Italy for France, which was still safe but subject to blackouts. They knew what was happening behind them, in Germany and Eastern Europe. Bob Turner had seen Nazi soldiers when he was there in 1936 and sensed the underlying threat. He had been in the stadium during the Olympic games when Hitler entered. The couple contemplated the implications of such conflict for unrelenting pacifists. It took another frustrating and fearful month to get home.

That next year, 1940, Turner won his second Cresson scholarship, a rare occurrence that suggests his work was more highly respected by his professors than Turner reveals. This time the couple went to the Southwest and Mexico. They drove in a used car, often camping at night. He was deeply affected by the geology.

We saw things going [back] through the eons like a group of stone structures in the Grand Canyon that expressed a sense of time and age. . . . The results of weathering on the internal materials left some hard, some soft, as well as resulting in unpredictable mesas in the desert. I had some recognition of the effect it had on Native Americans and how they incorporated it in their myths. They were part of the landscape that affected them.

In Santa Fe the Turners met Native American traders in their wagons. Contact with an authentic non-European culture was exciting and different. This place was to draw Turner back for years. Keeping track of the location of gas stations and stocking their car with extra provisions, they drove all the way to Mexico City, where they visited a museum full of pre-Colombian sculpture.

We went on a bus and I looked at the people and they were the same people as in the sculptures. I had a sense of different cultures. Their great triangular monuments [the pyramids] were amazing to see up close, with the detailed images. The power of these images I carried away was very important for me.

The Mexican muralists, particularly Diego Rivera and David Siqueiros with their social messages, were also significant for Turner. The immediacy of Siqueiros' images with their deep emotive portrayal of the poverty and suffering of the people was unforgettable.

The raw power and movement was so much stronger than what one then saw in painting

in this hemisphere, the power of their belief and their faith in what ought to be established. Implicit was the belief that art could make a difference in moving people to some sort of present or future action. It was painting to express a message, and that was so different from Renoir.

A PERSONAL QUEST IN A WORLD AT WAR

On returning to the Pennsylvania Academy that fall, Turner began contemplating the importance of painting to the rest of his life. *I had challenges I liked. But I never really felt accomplished as a painter. I became aware of looking and interpreting what I saw and what I would do with a brush. But the learning was limited—one window, and a narrow one.*

His art education had certain legacies, though not enough. By 1941, his fifth year at the school, he wasn't there much. World War II was closing in. The couple applied for and was accepted at a Quaker work camp in Indianapolis. The fact that he had to put his career in painting on hold didn't bother him. It was the right action at that time, because he didn't feel accomplished enough to be able to affect political events with his art.

"We worked in a Black district. It was to rebuild a settlement house. Sue was the dietician and cook on thirteen cents per person, per meal. We met and enjoyed the people who were there, not a large group. And the sense of having worship before going to work, that kind of a routine [was important]." [12] *We were there several weeks, before I was called to report. Before leaving, we were in a hotel room looking out at a man in a soldier's suit and I thought, 'Gee, that would be so much easier, just to put on the uniform.' That didn't last very long.*

Turner's commitment to Quakerism wasn't imposed by his parents, rather it grew from attending meetings as a child until, as an adult, his convictions were unwavering and naturally based in Quaker strictures, which held nonviolence as a critical commitment. For Turner, being a Quaker goes beyond a religious affiliation; it is the moral code by which he lives and acts.

To the Religious Society of Friends the concept of continuing revelation is basic. Thus, new perceptions and an openness to change are intrinsic. Quakerism is based on the belief that there is a God or something spiritual that becomes internally evident, that you can speak to, refer to, and that people have the special capacity in their humanness to respond to in other people, giving a sense of unity between beings.

This notion, that there is something precious within each person, is three hundred years old [in Quakerism]. I never use these words, but it is a deep feeling that is a reality when the words begin to be resonant with how you think and feel. It's only true when it's experiential, it fits experiences—that's true.

Becoming a soldier would have violated Turner's beliefs. Even if the people he fought were the enemy, that wasn't enough reason to destroy the spirit in them. Quakers don't believe in original sin. But they do believe in evil, which is the lack of awareness and perception. The remedy for such evil is understanding, teaching your enemy to understand himself and to find his own spiritual center. Though an individual like Hitler was considered irredeemable, he was not cause enough to take the lives of others. Having decided he would not participate in battle, Turner applied for conscientious objector status, which was granted, then taken away, and finally reinstated because of lobbying by the American Friends Service Committee representative.

The war years must have been difficult for the couple, who were isolated from the world they

had been part of, often separated from each other, and living on very little. But that is not how they recall it. Assigned to Civilian Public Service, Turner worked in forestry conservation at a camp in Big Flats, between Elmira and Corning in New York State. He was confined to the camp, which was supported by all the peace churches, the Quakers, Mennonites, and Brethren. Pay was minimal, just $35 a month, supplied by the churches at first. Sue Turner worked in the Elmira library system.

The camps were set up like a base camp. There were long dorms remaining from the Civilian Conservation Corps days. We creosoted them. We painted posts and planted seedbeds. We were supposed to do work of national importance. [But] they took you where they needed labor. I was mostly out in the woods. We went in trucks to work. I was the crew leader.

I met a man called Clayton James who was a painter. He was in the kitchen crew, so he never had to go out in the woods. 'Turner,' he'd say, 'are you ever going to be a painter?' He did paintings I liked. I remember painting alongside of him and feeling really good about it. It was no longer Renoir; that's for sure. It was reds, and blacks, and blues. But for the most part, painting was for another time.

There was nothing physically keeping us in there. If there was any fence that was the fence you felt. You always felt you were separate and were a minority. It was a very important experience to know you were being looked down on because you were not meeting people's measures. It was a potentiality that was there all the time, the sense of ostracism. . . . If you believe a certain way, you have to take the consequences.

The physicality of his work at the camp was important, offering him a contact with nature that provided a release from his situation and a religious bond with the earth. *In that I was much closer to the woods, feeling the wood, felling trees with my ax, and the physical activity, and in winter being in the woods with snow. It was so quiet. Something is precious in all of nature, trees and rocks too, so the environment becomes a natural extension. It's a very important part of Quaker concerns.*

Turner concluded that the experience helped him understand the communal and shared, recognizing the unity of people and nature because we are alike in needs, and that we are of one universe. *This is important because it builds openness to sensing things. You try to sense the nature of things, the way things work over time, the way they grow, the way they fall apart, trying to uncover what may be there and what seems to be there. You are expectant and confident in your ability to see within and underneath and find some values in life.*

By 1943 Turner, other religious internees, and the churches were questioning the significance of their work, as well as the fact that the churches were paying for projects dictated by the government. The original goal was to use their contributions to demonstrate a constructive alternative to armed service and war, but what they were doing hardly made that point. Hence the couple volunteered to serve abroad doing relief work. But when that program was cancelled by Congress, the Turners went to Maine, where he worked at the Training School for the Mentally Deficient at Pownal, and she cooked in a boarding house ten miles away for men of his unit who were off duty. Turner worked a twenty-eight-day schedule and then had four days off. For him, this physical work of changing bedpans and wiping brows led to an emotional closeness, a connection between hand and heart, touch and feelings that he would reach back for later.

In the midst of this turmoil, the Turner family was changing. Charlotte Turner died of cancer in

1942. Bob and Sue Turner had their first child, John, in 1944 while they were living in Maine. It was a bittersweet time.

Yet ironically, the war years were seminal to the development of Turner's aesthetic, providing negative experiences that were the counter to what he had known in childhood. This sense of opposition, which he also found in nature and religion, had a center, a point where the balance of the two sides created an order. This would be the center in his pots. *We experience stability and precariousness, trust and risk; and encounter improbability in some kind of balance. I think these conditions and phenomena seem fundamental to what I make.*

FINDING CERAMICS

As the war drew to a close, Turner sought a way to integrate his moral strictures into his artistic passions. Though being a painter was the career for which he had been trained, the following dialogue between the couple reveals why ultimately he chose not to pursue it.

I knew my painting would never support us. I didn't want to make portraits [which would support them]. It was retreating from painting to do portraits.

"You didn't want to paint mother's friends," said Sue Turner, implying that a life spent pleasing others' vanity would never have satisfied a man with such a progressive social agenda and artistic ambitions.

Although Turner didn't feel at ease painting, he wasn't sure he could give up all that a career in the fine arts meant to him. He looked for close alternatives, like pursuing an advanced degree in art history in preparation for teaching or working in a museum.

While I was still in service we took a trip one spring day when the water was rushing down the hills to Harvard. Turner met with the great art historian Paul Sachs and listened to a lecture by George Edgell on the Renaissance, both of which impressed him. But he had nagging doubts, which he articulated in a letter to Winslow Ames, a friend who had also worked at the Quaker camp in Indianapolis.

I like the art field but do not feel that I have enough on the ball to be especially useful or socially valuable as a painter. The factors of social conscience and Quaker background seem pertinent, for the world today is not healthy; and [as] the State is gaining more control over man as a mere unit of a mass, there is strife and frustration in the individual. His soul is being smothered, it seems, lacking the power of expression that is creativity. Escapism follows the monotony of a routine job for untold numbers. How relevant is art as a contribution to living fully? Certainly we can say that men who find constructive use for their creative abilities live more fully and are likely to be more alive as citizens. Certainly there is a crying need for more creativity today and the fine and applied arts offer one major form of creativity and for expression of what one might call the soul. Furthermore, that which opposes the growing hold on people currently exercised by the new gods of Power, Mass, and Quantity, is vital today and such opposition is, of course, inherent in art.

Finally, however indirectly, what part, if any, can and should the art world play in revitalizing people of a perhaps degenerating culture, a culture in which people seem to be morally soft, often, and unaware of the result of their actions, insensitive to the moral religious values in situations? Have not art and those people who know its values more to say than they have

said, not only to make art a more vital and integral part of community life, but to minister to the spiritual needs in the broadest sense of the term? Or can art say anything to this need, even though sensitivity to the aesthetic often has not meant sensitivity to and moral obligation concerning the results of actions in human relationships?

In writing this letter on December 29, 1945, Turner had for the first time gathered together his thoughts and feelings about his future on paper. It was a coda to his underlying beliefs.

Ames advised him not to pursue art history, but a field involved in the creation of art, which was a decision Turner had reached on his own, as he always did once he had gotten to the point where he knew what was right. Whatever he chose to do, he believed it had to satisfy both his moral and aesthetic obligations. As he backed away from a career in painting or art history something else grew increasingly more compelling: *I realized I wanted to use my hands as tools and make things. I went back to the camps when I knew I was going to be discharged. There were men who had been making things, firing them in a kiln.*

Making pottery became a focus, but he wasn't sure whether it was right for him and investigated three different programs to find out. *One option I pursued was to visit the School for the American Craftsman when it was at Dartmouth College [in Hanover, New Hampshire]. I went up for a weekend, stopping in Elmira where I knew someone making wood stuff. I spent the night. I woke up fresh, ate at the stream. We had oranges. [Then] I went to Dartmouth to see the pottery up there. . . . I remember visiting Aileen Webb of the American Craft Council about this time in New York City.*

Webb was the founder of the American Craft Council, which sponsored the School for the American Craftsman. Originally at Dartmouth, the school moved in 1946 to downtown Alfred, New York, becoming part of the Arts Division of the College of Liberal Arts at Alfred University. The curriculum emphasized the integration of hand forming with production pottery techniques. But almost from the start there were problems of competition and control with Alfred's own College of Ceramics.[13] Eventually the school moved, ending up in 1950 as part of the Rochester Institute of Technology at the University of Rochester, in New York State. In 1940, under Webb's leadership, the Craft Council also opened America House in New York City, a shop that provided a marketing outlet for the handcrafts. Webb's goal, when she began, was to provide sources of income for the rural poor of the state, by making craft items. After the war, the council saw returning veterans as possible students for a more modern craft program at the School for the American Craftsman.[14]

Turner was a perfect candidate. He found the program interesting, feeling it would provide him the skills he needed if he decided to make pottery for a living. But it was a nondegree course of study and the school was too unsettled for him at that point. He also needed more experience with clay.

His next stop was Penland School of Crafts near Ashland, North Carolina. Founded in 1923 as a rural handicrafts school, Penland originally offered local people a place to make and sell weavings, so they wouldn't have to rely solely on agriculture for their livelihood. By 1946 the program had expanded, offering three-week classes in separate buildings for each of the crafts.

"I went down to Penland, North Carolina, and was there for three weeks trying to find out if this was really it. I thought, "What is clay like? I've never even touched it [before this]. It was a romantic thing, feeling clay and the sun came in and the sense of people working with the material and it felt right. . . . A little old lady taught ceramics. . . . I hand built a little cup. I knew enough from it that this was what I wanted to do. Its possibilities, its potential seemed right."[15]

Henry Turner holding his grandson John, age two, on the porch of the Turner house in Almond, 1946.

Finally, after so long away from a medium, here was a plastic material I could do something with. I never had a concept that I was going into sculpture, but into the making of pottery.

Penland was not important as a place that would train me to be a potter. [Rather], it showed me that making pottery was a means of reviving a way of making a living. It was definitely a social movement. The thought came from the Scandinavian crafts movement, because that's where Haines went for his studies of the consumer cooperative movement.

"I was entering an area that would permit me to make work that would be something I liked to make. If I liked it, I felt other people would like to get it. I could make things that I liked that other people would buy at a reasonable price." [16]

Pottery was for the people. Integration was a big word then, integration of social life with something useful you could make money in—that carried on the sense of what I wanted to do.

Once he had settled on his medium, this same kind of ambling intuitive action led Turner finally to the place that would become his home for the next half a century. In the spring of 1946,

he visited the College of Ceramics at Alfred University, a campus of the State Universities of New York, located about one hundred miles south of Rochester. The ceramics program, which had begun in 1901 as the New York State School of Clayworking at Alfred, produced many important teachers and practitioners over the decades. Ceramics was connected to the Liberal Arts course, which to Turner meant that he wouldn't be studying pottery in isolation.

The curriculum was skill-based and would give him an advanced degree. Turner had done quite well at the Pennsylvania Academy, according to Roy Nuse, head of the Coordinated Course, who sent his recommendation to Alfred, on April 18, 1946: "I have given you, herewith, a transcript which covers your highly honorable period of study in the Schools of the Academy, together with a personal endorsement." [17]

Alfred accepted Turner as a special student in the industrial design section, even though the program was full. Turner made his choice quickly. The day he was admitted to Alfred by Charles Harder, head of the department, the Turners bought one of the two houses in the area that were available, and rented out half. Located in the little village of Almond, just north of Alfred, it was a nice house with a long porch on the front and narrow clapboard siding. It would become a generous home.

Bob Turner, like so many men who had postponed their careers because of the war, began as a graduate student. When he registered in the fall of 1946, he was thirty-three years old, intent on learning how to become a potter, not just the occupation, but the day-to-day, the rigor of living that life. *I felt I was embarking on an adventure. Many people were making a living from pottery. I hoped to become one of them. Use and function, that was the reason I went to Alfred, to make something useful with my hands that had a social function.*

Turner benefited from the earlier work done at Alfred by T. Sam Haile and Alexander Giampietro, among others. Their knowledge of different stoneware bodies, glazes, and the subtleties of reduction firing were all absorbed by Turner. But more importantly Haile, who had graduated from the Royal College of Art in London, brought a critical philosophical viewpoint to the Alfred program, that under Charles Harder's direction led to an addition to the curriculum. While students could still choose preparation for careers in design, factory, and large pottery production, they could also follow a path that emphasized the making of functional ceramics by the individual artist in his own studio.

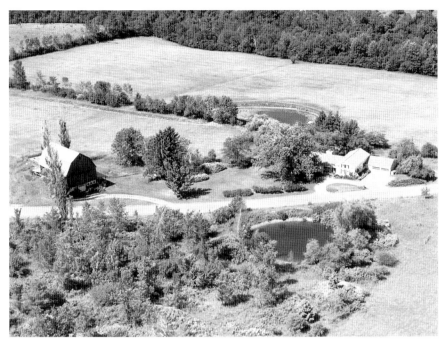

A 1996 aerial view of the Turner house and studio/barn in Alfred Station, purchased in1951.

According to Melvin Bernstein, a historian of the ceramics school, Haile believed that there should be a balance between "the applied-art–happy manufacturers and the artist (after Ruskin, Morris, and the dogmatic handicrafters) who wished a plague on all industrializations of art. . . . There were experts in art as there were in chemistry and physics, but [either] could be wrong. If the very humanist tradition of Anglo-French art was in question, Gropius and the Bauhaus put the problem in focus: rethink the aesthetic standards congruent with the new vision, new perceptions, new processes, new materials, new uses, and supply the new societies with contemporary expectations. Ceramic design was not applied ornament; nor was 'art' applied 'principles of design.' Behind art skill was the intuitive artist. . . . What is immanent in a Sèvres group, a building by Gropius, a poem by John Betjeman, or a porcelain insulator is a 'culture-feeling' of agreement of function with appearance, of material with the making, of non-antagonistic collaboration of men and machines."[18]

Harder, who was trained at the Chicago Bauhaus, heeded Haile, as well as other prevailing changes, to institute a new program. It prepared the functional potter with courses in how to set up your own studio as well as how to make beautiful ceramics, looking to develop the artist/potters and teachers of the future. Many of his students would go on to develop and teach in ceramic programs around the country, establish their own studios, and show in galleries and craft exhibitions. Harder wrote of his ideal graduate: "He will surround himself with efficient modern tools and equipment, which he will arrange logically and know how to use to best advantage in expressing his ideas. If, in doing these things, he should discover that historic styles and treatments become a bit rebellious in such an environment—then we may be sure he will find out a more natural answer."[19]

It is the combination of these two approaches, Haile's and Harder's, that became the philosophical bedrock of Bob Turner's professional practice, ideas he would come back to over and over again in his work. In the meantime, the specific course work in the department helped him develop his

The barn that holds Robert Turner's pot shop in Alfred Station, 1996.

skills. Turner studied ceramics with Harder and pottery and sculpture with Marion Fosdick, an instructor who had interviewed him for the program. Harder taught the technology as well as the philosophy, introducing Turner to the history of ceramics and transmitting an excitement about the importance of infusing ideas into one's work.

I learned about a whole new world, where clay comes from, technical stuff. There were three things I was doing: throwing, sculpture, and plaster molds as part of the forming. I thought, if one of those three things goes [well], I'd be satisfied.

From Harder I got his enthusiasm for the way things work together, the physics of how temperature affected things. . . . I thought things he got excited about were worth getting excited about. Not so much what glaze he used to get this color. He was very excited about social theory. We had talks on sociological phenomena. That was important.

From Marion Fosdick, Turner saw how making art could be a life-style. She encouraged a very quiet, sensual dealing with things. She helped students develop confidence that they could work problems out. She had a light hand, shaping functional vessels with bands of carved ornament that had a timeless beauty.

Turner began by making simple bowls and vases on the wheel, but gradually he became intrigued with organic forms, "free forms," as they were called in Scandinavian design, which was an influential style at that time.

I made a pitcher for my exam that came from the sense of an English lute, that beautiful, deep volume. I designed it in one day, making the shape and figuring how to carry it through the glaze. I sat by myself in a dark room and wrote it down.

It was a terrible pitcher. I got a C. It led to the ashtray, a sculptural form, a free form that had a foot. That was part of the experience of the first year. The ashtray was accepted in the Ceramic National Exhibition.

Figuring out what he meant by the word "natural" was important to Turner at this moment. Over a period of time he developed an understanding that would be critical to his mature work. The knowledge entailed questioning what he was doing to objects of nature. He explored what their tactileness could mean, realizing that he could convey the physicality of nature by presenting the actual feel of these natural objects on one level. Clay, the material, is not made to be a metaphor for anything else in his work: it is of the earth, as is stone, and remains that way.

But the object/vessel does have metaphorical connections in Turner's work. He used the formal qualities to carry meaning. Turner relished seasonal changes, which he felt must be understood in clay. Abstracting forms from nature, a way of seeing that was used at this time by Japanese-American sculptor Isamu Noguchi, Finnish designer Tapio Wirkkala, as well as American designer and architect Eero Saarinen, made sense for Turner. He expressed his own values and his spiritual and physical closeness to the earth through shaping a piece. The clay body of his vessels would grow from his hands and the wheel, with a lack of self-consciousness, like a natural thing. His conscious assessments and alterations came later, after a basic shape had been thrown. By allowing clay's nature to assert itself in the making, he brought his Quaker beliefs into the process and product of his art. There was an honesty in the materials and the forming process. Whether his pots were functional and contained food or purely sculptural and contained only an inner space, he invested the pieces with this sense that they were of nature, both human nature and Mother Nature.

At this early date, Turner was already—though probably unconsciously—developing this approach

to linking nature and art. For instance, the ashtray he mentions has the clean elegance of geometric form, which is basic Turner. It is remarkably well crafted (given his lack of experience at this time), recalling Scandinavian modern forms. But the foot on which the asymmetrical bowl rests is odd, like the foot on which a hermit crab drags its shell in the sand. A marriage of organic and geometric handmade forms, the ashtray is a graceful intimation of the relationship Turner would establish, another nascent strand that would surface more clearly years later.

He wasn't aware then of the significance abstracting natural forms would carry in his work. He was just focused on learning Alfred's way with clay. *"After that, I used the wheel and the press mold. I was very intrigued by the idea of being able to make things which were imaginative, which were not controlled by the wheel, in which one could invest one's interest. I think of two things: a sense of growth that one sees in nature—growth, and materials such as rock. And to make things which carry that interest, in a long tray, which you could use also to float or put flowers in, and that kind of thing. I could see that they would sell, and they did sell."* [20]

In his third year he cast a bowl in a plaster mold that was a much larger version of his footed ashtray. Remarkable for its ambitious size, the bowl is evidence of Turner's brilliant sense of scale. He embraces a pot with his own physicality, making it fit within the span of his arms, in human scale. Meant for use in the garden, the bowl received an honorable mention in the Ceramic National Exhibition. The Cincinnati Museum bought one cast; another won a purchase award at the Los Angeles Fair Association and is now in the collection of the L. A. County Museum of Art. Alfred has the original.

During Turner's last year at Alfred, Daniel Rhodes, the figurative ceramic sculptor, began teaching at the college. Turner was doing his thesis on setting up a one-person pottery and the procedures that would permit it. Rhodes became something of a mentor. Turner worked with low-fire clay and glazes every morning in Rhodes's studio.

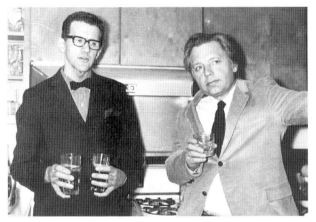

Robert Turner and Daniel Rhodes (**RIGHT**) at the Rhodes's house for an informal supper party, Alfred, New York, 1968.

I respected Rhodes and liked his work. He was knowledgeable and able to translate that knowledge into work and words. He was very giving. I liked the way he could use clay for drawing in and on, and his ability to make claylike work but get close to the East in feelings. I was moving in that direction in my last years. He pointed out what could happen and how one could move ahead with what one wanted to do and find expression.

While Turner spent most of his free time at home with his family, he did become friendly with a few other students, peers like sculptor David Weinrib and potters Ken'ichiro Uyemara and Ted Randall. Randall was a close friend whose work would parallel Turner's in its development, though each had their own styles. By the spring of 1949, Randall and Turner talked about going into partnership in a pottery after graduation. Charles Harder tried to discourage them, noting that they would have to share equipment, limited space, and the job of selling. Only saints could succeed given the circumstances, he maintained, and his view prevailed. The immediate future held something different for Turner, but Randall actually built a working studio in Wellsville, New York. Their lives would reconnect in 1951 when Randall began to teach at Alfred, where he worked part time from 1951 to 1953, then full time from 1953 to 1973. Randall was department chairman from 1958 to 1973, by which time Turner was also a professor there.

While he was writing his master's thesis and contemplating his future prospects, Turner was offered a teaching job at the highly regarded, avant-garde Black Mountain College in Ashville, North Carolina, where many of the greatest artists in this country came to work together across disciplines on experimental projects. Though Turner hadn't applied for the position and didn't really understand Black Mountain's innovative approach to art making, he considered the appointment. As is the Quaker practice, he discussed it within the relevant group, in this instance, his family, now expanded to four with the birth of a second son, Robert (called Rob) in September 1947.

"When Bob got the offer, he had measles," recalled Sue Turner. "There, in bed, we all considered it. He got the letter inviting him from a man who coincidentally was a Quaker too. That's how it happened. We thought it was a terrific idea. And it was."

After Bob Turner graduated with a master's degree in Industrial Ceramic Design from Alfred, the Turners left for Black Mountain. Their stay turned out to be more of an adventure than they had anticipated. According to Sue Turner: "We ate yogurt and homemade brown bread. It was a lifestyle that was prevalent in the sixties, but not much known in the forties. The school was a communal place. Everybody had to work and pull his weight. When there was a strike in the coal fields, Black Mountain decided not to buy any more coal. The wives, even the pregnant ones, had to drag logs to burn for heat. You were a cog in a wheel. Interesting people and exasperating people. It was a hard place to bring up children."

The pot shop at Black Mountain College, designed by Paul Williams in collaboration with Robert Turner, 1949–50.

While Sue Turner was readying things for the birth of their last child, Rosalind, in 1950, Bob Turner was busy starting up Black Mountain's pottery program. Josef Albers, the great color theorist and Bauhaus painter who had been important in shaping Black Mountain's adventurous interdisciplinary approach to art education, had just left for Yale. Though ceramics had been considered an acceptable trade, practiced at the Bauhaus in Germany, Albers, according to Turner, did not seem to believe it was worthwhile, taking issue with its handicraft heritage and the unstructured nature of the material. Under his stewardship the pottery program was given low priority and little funding, but Turner didn't feel intimidated by the residue of Albers' attitudes. "*I did not feel myself the artist at that time. I was a potter. I wasn't someone who'd [been] into the new wave of painting, what was going to be in the fifties. The Motherwells had gone through that and those working with Albers. I was separate from them.*"[21]

Following Albers' departure control in the faculty shifted: *When Albers was there he was autocratic and ran the show well enough so people accepted it. When that ended, it changed.* Left mostly on his own, Turner taught and made some pottery. *I was too involved with what I was making and the mechanics of getting a shop built and a kiln. It was not a time of discovery so much as consolidation of what I had learned.*

He also immersed himself in the rich dialogue that went on among those at the college. Art critic Clement Greenberg, who was known for his commentary on abstract expressionism, the abstract color field painter Theodore Stamos, and architect/philosopher Buckminister Fuller were there early on. Later, contemporary dancer/choreographer Merce Cunningham and his regular collaborator, composer John Cage, spent time working on new dance performances.

[John] Cage came down with Merce [Cunningham]. It was new for me. He did his music. It was startling. It was something I saw and recognized in my head, but didn't use. Black Mountain was never a part of me at that time. I didn't understand the experimentation, that it was so important as something growing and new, rather than as something referring to the past. . . . I thought this place was going back to the twenties with experiment for its own sake. It was only later that I realized something new was occurring in a social sense and in an art sense. I understood the challenge of no commitments. It increasingly became central to my perceptions in the years to follow.

Another aspect of the program would also affect him later. *"The core of the Black Mountain avant-garde 'revolutionary' influence [on me] was intellectual, not nonintellectual. I think by the seventies trained thought had reasserted itself in the ideas moving the craft or clay world."* [22]

While the experimentation and idea-based approach to art making were important to Turner, it would be wrong to surmise that Black Mountain alone informed certain critical Turner concerns. He was there for only two years and already had a philosophical base of his own. For example, the incorporation of chance, a fundamental in John Cage's music, probably did enter Turner's subconscious at this point. But his use of chance also evolved from other sources: Oriental ceramics and abstract expressionism provided an aesthetic context, but his Quaker faith was also crucial. The way Turner merged these inputs in the late sixties, which distinguished his use of chance from that of Cage, the abstract painters, and other ceramic artists, evolved from the premise of control. For Turner, allowing a chance occurrence into a work entails letting go of control in order to invite other forces to emerge. It suggests that through these uncontrolled happenings the common spirit in all of us can be discerned.

By the spring of 1951, Robert Turner and his family were ready for a more predictable existence. Sue Turner remembers that Bob wanted to leave Black Mountain to get back to his pottery. As a faculty member he was always in meetings. His work there was more like being on fellowship than an artist-in-residence. He had found something that was a compelling preoccupation for him. He needed to do it.

John and Rob Turner supervising their sister Rosalind's first steps at one-year; Skyland Farm, 1951.

A STUDIO POTTER

Marion Fosdick had issued Turner an open invitation to teach at Alfred, but he decided to teach only occasionally so it wouldn't interfere with his making pottery. The family returned to New York in June 1951 and Turner taught ceramics that year in the summer program at Alfred, then at the University of Wisconsin the summer of 1957, and he did a couple workshops in between. But mainly he worked. Finally, Robert Turner was a full-time potter, an accomplished functional potter turning out wares of elegant form.

The Turners lived on a 100-acre former dairy farm just outside Alfred, in Alfred Station, which remained their main residence for forty-eight years. Built of fieldstone and wood, the house is situated on the ridge of a high hill overlooking fields where herds of deer feed. The structure has been added to a number of times, yet retains modest proportions and a snug feel. The landscape is austere in winter and rather lush in summer.

Sue Turner researched the property in 1952: "Our farm is known as a 'Hill Farm.' A neighbor commented that we have a lot of level land for a hill farm. But the topography is typical of the

edges of the glacial formations of this part of western New York. We have fossils in most of our rocks, and our fireplace in the remodeled farmhouse, being built of stone, which farmers in bygone times have stacked along the fencerows, is largely made of this fossil rock. We drove our secondhand four-wheel-drive Jeep across the fields, often snowy, to search out weathered rocks and haul them in to thaw out before the mason should be ready for them."[23]

Turner studied nature over long periods of time here.

We have such variety because of the changeable weather on the hill by our house. It goes from a white to deep blue sky, from mauve to blue to deep gray above a white plane. And then there is a tangle of trees and brush with dogs and deer. It's a Bruegel scene.

There are major valleys cut by the ice that came down from the North and retreated and both gouged and left material. That's true of even our tiny little valley. Winters are traumatic and beautiful because of the great fields of snow and the intersection of [field] lines going east and west always broken by the trees. And the trees are dark green and dark red. It's not stark because there is a lot of straggly brush growing up into the trees. It's quite beautiful. [The soil is] quite black, and it's amazing what will grow.

Turner made the dairy barn up the hill into his studio. (In Alfred, probably more barns are used by artists than cows.) The middle section was for storing clay and packing pottery. The rest was divided into areas for potting, drying, glazing, and firing. Finally Bob Turner had his pottery, which his wife described in 1958: "The shop is set up as a one-man studio, thus making it possible to preserve the personal and individual element in each piece of pottery and insuring freedom in execution and design. This is an expression of [Turner's] concern to keep the human touch on the things with which we live."[24] She also recalled the rhythm of the work: "He did paper work in the fallow periods. He needed a cycle and did packing, shipping, billing, then would go back to the clay."[25]

Turner's basic tools and materials have not changed much over the years. Early on, he prepared his own clay body, getting the raw materials from the United Clay Mines in Trenton, New Jersey. He would blend the ingredients together himself with an old commercial dough mixer. He still uses the same clay, but the clay department at Alfred began making it up for him in the late 1980s, when he was in his seventies.

The clay I use is put together with five or six materials, to make the stoneware the way I like to work and get that hard, dense product. What I do is very dense and the surface is part of it because of the way it's fired and then sandblasted. It's not better. It's got disadvantages because I don't get high color variations. Mine is much more like the landscape.

Turner also made his glazes from formulas he worked out. He still uses many of them, especially his favorite matte blue.

I kind of worked out my own glazes at school. I used simple ones, not anything extraordinary or beautiful. They give a stony look to the pieces, somewhere between stone and marble. I had Mediterranean blue and green and a couple blacks. It was always for certain pieces that I'd have a particular glaze. I would have a relationship.

I started using a dark iron slip under the matte blue, so color would come up into it, with the dark warming up the blue. There were different possibilities: the glaze pooled blue at the edges; otherwise it would be a warm charcoal. If either the glaze or slip was a different thickness you would have more differences from real black to real gray to tawny bronze copper-green. I got a lot of different effects within that range.

Once Turner fired and glazed his pots he sandblasted them using air mixed with sand, streaming from a hose. It is laborious and unpleasant process. Breathing the air with the sand can be toxic. But the results were just what he was after. He could vary the shine and finish on a piece from one side, or one small area, to another. He preferred removing all the shine on the edges. Color changed in tone from the blasting, becoming more intrinsic, seeming to be part of the skin of the clay, rather than a layer sitting on top. This made a piece more natural looking. *The glitter of [the glaze] kind of kept you away, rather than making the pots something you could feel close to and want to touch, like the way you like to touch rocks.*

Ted Randall designed Turner's wheel, on which he continues to throw. It has a tractor seat that is orange-red with circular holes in it, and isn't motorized, requiring a kick start. About 1980, Turner added an electric wheel, designed by Paul Soldner, a ceramist who curated the annual ceramic exhibition at Scripps College during more than three decades when he taught there. *I like the Soldner wheel because I can make larger things on it than the Randall wheel. The Soldner is lower to the ground, so you can work above it. I've used it more and more. The slower [Randall] wheel is intriguing, but to make what I have in mind I like the power and continuousness the motor provides, rather than waiting for the wheel to speed up.*

He used his original, gas-fired kiln until they moved out of the house in 2000. Turner explained in 1996: *The old kiln stays together and works well. I thought about tearing it down, but it does what I'm used to. I can oxidize back in the corner, which gives me that redder look. I have twenty kiln shelves, but I only use twelve. When I made small works I'd stack them.*

He fires his pots at the same temperature as many porcelains to make them nonporous and durable, so hard in fact they have been mistaken for stone. When he was making functional work he would fire a kiln every three weeks, producing a few hundred pieces each year.

Earning an income from his work was Turner's next goal. "*Bonnier's [department store] accepted what I was doing and it was good for their place. I realized I was getting about a tenth of the price on my floor, the first floor, as compared to what somebody from Japan was getting up on the second floor.*" [26]

This wasn't a problem for Turner. He considered himself a neophyte compared to these potters from Japan, who were tremendously accomplished and perceptive and worked in ancient styles. Turner's pots were reasonably priced to sell and be used. That was important to him—getting the handmade object to as many people as possible.

Bonnier's and America House were the main outlets for functional potters in the 1950s and sixties. Turner's work sold well at such stores in Philadelphia, Washington, D.C., and New York. In fact, he remembers visiting his brother Chandlee, who was then head of Turner Construction, and noticing a familiar ashtray on his brother's desk. It was a simple flat form with a heavy horizontal rim, white and kind of moon faced, made of a toasty textured clay. Bob Turner knew it to be his; turning it over, he saw that it was. But Chandlee Turner hadn't known that when he bought it.

During those years, life at the Turner house in Alfred Station was interwoven with art as fellow

artists and students were always visiting. Val Cushing, a colleague at Alfred and a friend, remembers meeting Turner in 1951 during Cushing's senior year at Alfred. They were introduced at a square dance and Turner let Cushing see his studio. "Bob's work environment was totally a work space with nothing ostentatious, nothing pretentious. It was a realization for me that you could start your professional life in a very simple way, and you didn't need to have everything. It was a big, romantic thing to see a life-style intimately connected to art. His house was filled with pots. His studio was filled with pots. I saw a potter and a studio artist as not separate, where life and work can be intimately connected.

"Occasionally we'd go to Turner's house with Marguerite Wildenhain, 'we' meaning the senior class and everyone majoring in ceramics, fifteen of us. We were a very close group. One night Marguerite was sitting there in her jeans talking in her idealistic, visionary way of what crafts meant. She said that, like Frank Lloyd Wright and Paolo Soleri, we should have a community of artists working together who have studios. Black Mountain was another paradise environment of these high-powered artists in an informal environment and studios." [27]

During the 1950s, Turner's sources for functional pottery derived from the past: *The references I [had] imposed were Minoan and early Greek. I was trying to be in control, using what I already knew. It was a tightness then, what I now call the Greek influence of ideal perfection and timelessness.* Wildenhain represented a later tradition: trained at the Dessau Bauhaus, she made simple, functional forms of classical proportion that relied on the modernist elimination of decoration. Turner attended her lectures when she taught at Alfred between 1951 and 1953 and they became friends. *I realized her way was so wonderful from Europe and the Bauhaus . . . My reaction was more and more to the Bauhaus, stronger, simpler, letting form and glaze speak simply.*

These varied influences complemented Turner's education to date. The curriculum that Charles Harder had developed at Alfred reinforced the importance of integrating form and function, as well as the significance of individual artistic experimentation. Turner combined all these sources in his own unique way, which differentiated his pottery from that of others from Alfred. His interest in early Greek architecture reveals the appeal of classical harmony. He added the idea of reductive, geometric order as structure, as understood from the Bauhaus. *"For a period in the early fifties I made things that were very elegant. Even there, I think the play on the surface was something that was independent, but merely permitted by the piece, not required by the piece. Certainly not required by use. . . . I loved to make the bowl, [a particularly] exquisite shape."* [28]

Turner also made quite a few trips to the Royal Ontario Museum in Toronto because he was captivated by its fine collection of Chinese ceramics, especially those from *the Han period. The Han [appealed] in more of a sculptural way, their sense of shape and form. The appeal of the Song Dynasty was the actual bowls, which just blew my mind—the colors and all of that. That was a tremendous influence in the sense of the thrown work and the material and high temperature.* Turner's particular refinement of the geometric Bauhaus order led to forms that were leaner and lighter and more perfectly abstracted from nature, more like Song ceramics. Ken Ferguson, the functional potter who studied at Alfred from 1956 to 1958, defined this style as Song Bauhaus, which described the undecorated, high fire, reduction glazes used by a few Alfred potters from this era.

Many who knew Turner's functional bowls, casseroles, and mugs praised them for their distilled and honed geometric forms, simplicity, and slight ambiguity of shape, all Turner hallmarks. The pieces had a sense of inevitability, as though they were meant to begin and end where he left them.

Form did evolve from function, but with slight natural eccentricities. He made asymmetrical platters with thick rims that curved like the lips of a mouth. His covered jars were often slightly taller than most, with spool-handled lids that were as inescapable a conclusion as the cap on a toadstool. Whether small, medium, or large, his vertical vessels had a classical tripartite proportion, of balanced bottom section, middle, and top. He was already adroit at keeping a harmony of scale, volume, and proportion.

His tea cups, for instance, were a bit taller than usual, perhaps because Turner is tall and has long hands. But the increased height didn't result in bowls that were awkwardly wider or contained too much space; rather they just seemed bigger than the norm, as the result of his body context. The cups had thin walls and smooth surfaces of just the right weight and tactility for pleasurable handling. The surface fit the body as the peel does a banana.

The casseroles were generous forms, usually rising in two sections. The walls moved from the bottom outward. The bowl had an embraceable profile, as though you were to hold it in the middle where it swelled so your hands could grasp the body firmly. The wheel rings were more defined at particular junctures, often midway like a marker of change, a way for the eye to measure the proportions.

All these functional works began with bases that flowed up, conveying the liquid quality of soft clay spun into its hardened state. Where they appear, the surface rings, formed by the fingers and knuckles in pulling up the clay on the wheel, rise clearly on forms, carrying the sense of growth from the earth upward in their motion, freezing the moments of their making in abstract perfection. The Greek idea of creating harmony by balancing parts within the confines of a piece was strong. This internal order, of clear and controlling geometry, made external decoration extraneous.

Cushing describes Turner's work of this era: "A Turner casserole, with its white satiny glaze on such a strong form with no decoration, was the most refreshing breath of air in the world. It made all the connections from the forties. MoMA was fostering good design. Bob Turner casseroles were role models. . . . [While others did variations] it was Bob Turner's pieces that were honest in the sense of Danish modern furniture. The joints were not concealed. Bob's work was the epitome of that." [29]

Wayne Higby, who joined the Alfred faculty in 1973, remembers Turner's functional work of the 1950s. "Bob's casseroles turn out to be one of the great classical statements in ceramics, such a strong concentration on form. He knows it's going to function, but art is not in function. Art is in the way a pot is. Lots of potters succumb to the dogma of function." [30]

AN EXPANDING AESTHETIC FRAMEWORK

As good as Turner's classical pottery was, it wasn't enough for him. He kept pushing. From 1954 through the 1960s he slowly accumulated the information that he would need to make his mature vessels, shifting from an emphasis on function to ceramic art. Early on he became more cognizant of Japanese pottery, which would have a powerful effect on him.

I became aware of Japan, which was utterly different from old China, and I began comparing: in the sense of time, in the sense of place, in the evolution of accident as a way nature works, as opposed to the way man wants to control it.

The Japanese master Kitaoji Rosanjin, who believed the greatest pottery was made in much earlier times and set about to revive it, visited Alfred in 1954, sparking Turner's interest in both Zen

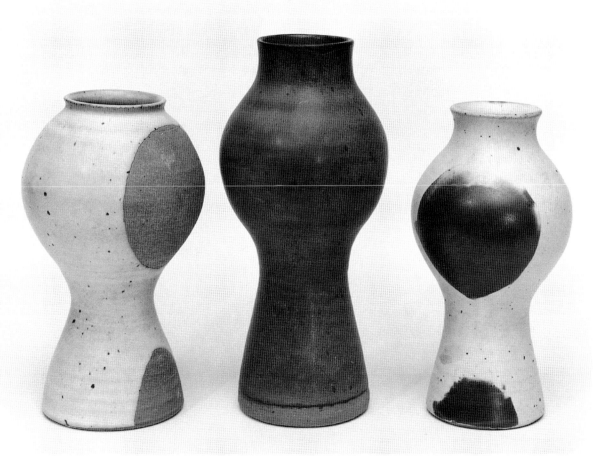

Nonfunctional, trial pots, where Turner was experimenting with shapes and glazes. 1954.

philosophy and the traditional pottery of Japan. Combining elements from various historical Japanese styles, particularly thirteenth-century Bizen pottery, Rosanjin's vessels were essentially simple forms put together, like a cylinder on a globe or square. Some pieces were unglazed, others minimally painted. Although Rosanjin owned a restaurant in Japan and made his pottery to be used and displayed there, he believed that ceramics exemplified the presence of ideas as well as evidence of technical expertise. They were "an art of the mind," a concept Turner stored in his subconscious for future use.

Turner described a Rosanjin bottle that was part of the Alfred Museum collection and important to him in 1954: *"I saw a cylinder simply plunked down more or less symmetrically on a hollow base which had sunken a bit unevenly, yet which in its own internal space-pressure established a kind of balance in the tensions. I visited the piece frequently at that time as a new relationship and felt a distinct power in the raw fired surface and the abrupt meeting of the upper and lower shapes. It was expressive of geometry, of weight and of gravity, of forces of nature as a significant determinant of form."* [31]

Rosanjin's views on change made Turner realize the importance of *"a sense of time and events. That events meant change and those changes could be reflected in pots. Pots could be the visual evidence of events that had taken place. And this . . . suddenly fit what I was seeing, what I wanted to see. It fit the work of Rosanjin, for example, the acceptance of what the kiln*

did, and the way it gained certain effects from the kiln, those broken lips, or broken something, that was either deliberately done or not, but it was accepted as part of the piece; became part of the story of our lives in a sense, as we see it out there and we start to realize, why, that's us. These things are also our human history. And the history of lives.

"But this is later. I think this sense of its meaning as symbolic of our lives isn't so important. I was accepting change and the evidence of change as being reality." [32]

Turner began questioning his reliance on Greek classicism and timelessness, thinking instead about the significance of change for his pottery. *I recognized that some things happened unexpectedly that led you to the truth; that was the way things happened. All of it was part of chance. The essential contest I saw to be Plato vs. Asia and Zen: the ideal, perfect, symmetrical, the timeless, absolute, and eternal, holding mankind over nature. . . . As against a reality of change and time altering events of unpredictability, of the internal, the intuitive, oneness with nature.* In the mid-1950s, he took modest steps toward incorporating such unrestrained ideas into his work, but they really didn't effect his pottery profoundly until later.

Changes Turner began incorporating in his work in 1955 related to the ceramist's interpretation of Zen. He made rough, tactile objects that conveyed a sense of the earth, carrying with them the possibilities for reflection that such physicality brought. In both this work and the mature vessels, the Zen idea of inside and outside being of a single piece, of everything being done all the way through so there is a concentration from the inner self to the outer, is present and important.

Turner was still involved with Scandinavian design, admiring both its simplicity and that these well-designed objects were mass-produced. But his reliance on Bauhaus ideals gradually waned throughout the early 1960s. Though Turner had originally admired Wildenhain's approach, he gradually reassessed its relevance to him as an artist.

I remember watching Marguerite work and comparing what her work said to us, her experience, as opposed to what the Far East was telling. The Europeans, including Marguerite, made the uncomfortable assumption of man being top dog, which becomes more and more obvious as erroneous. Man must work in cooperation with the universe.

Certainly his Quaker faith would support such a conviction. As Turner rejected Bauhaus modernism as the single answer, belief in the importance of all cultures—not solely the Greek ideal of Western cultural dominance—gradually took hold. He never abandoned the Greek, which cropped up in sculptures when Turner needed what it signifies. But his sense of harmony was rarely based again on achieving stasis; rather he balanced at a center where opposites meet. The human and natural rhythms with their nonperfect, spontaneous moments countered those that were controlled. These realizations would have substantial ramifications for Turner in the 1960s.

Abstract painting was another important element in Turner's education in the 1950s. Though he had left painting for ceramics, he would shift to a painter's two-dimensional perspective when he needed it. He went to New York City and the Museum of Modern Art regularly in the 1940s and fifties, looking particularly at the work of the principal cubist artists, Picasso and Braque, as well as Stuart Davis's vernacular interpretation of the style. Turner sought to understand the way painters created abstract forms that related real world experiences. He also studied very contemporary work.

That whole period I was going to shows in New York by people like Robert Motherwell, Stuart Davis, [Franz] Kline and [Mark] Rothko. I'd stare at those things, wonderful big, simple shapes . . . dramatic shapes and contrasts, shapes coming from shadow forms and the interplay

The Bizen vase by Kitaoji Rosanjin in the Alfred Museum collection that inspired Turner. Unglazed stoneware, 9 1/4 x 6 in. (23.5 x 15 cm.)

A great piece and a gorgeous relationship between the cylinder form and base, between what is sinking and what is rising.

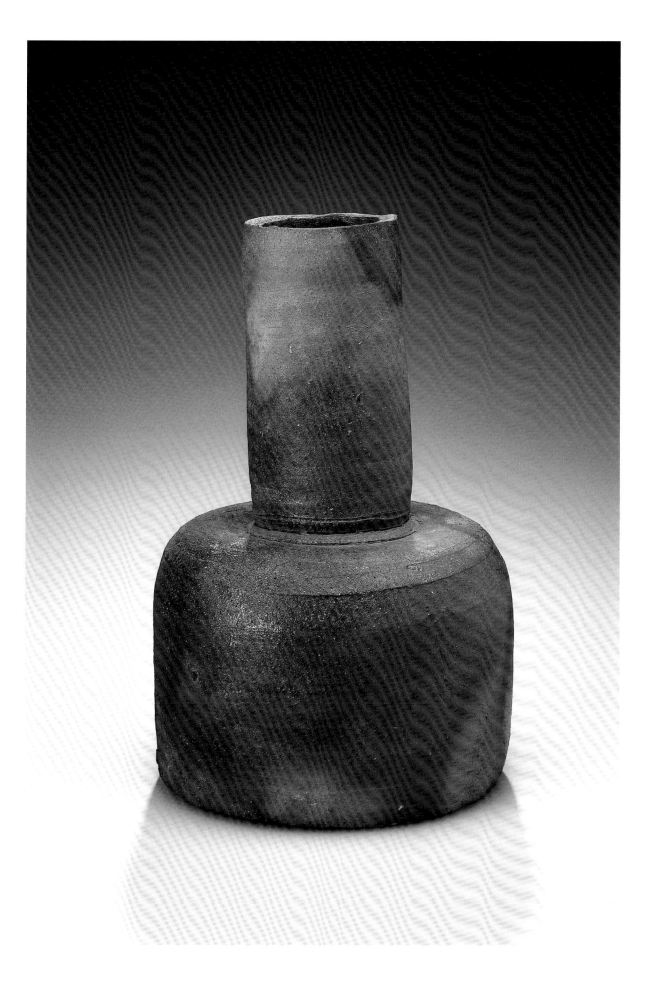

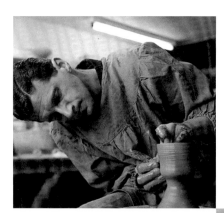

Turner throwing tea cups in his
Alfred Station studio, 1957.

*of dark and light, of the foreground and
background. And how a new sense of space
and movement along the edge happens so
[a shape is] not contained, so what you're
looking at goes beyond the canvas. Mother-
well and Kline, that drama of the city clash,
the contrast and interpretation . . . it was
like seeing nature anew. I don't know their
language. I just like going to the mountain
or stream and being amazed.*

Turner saw the creation of large abstract
shapes in two-dimensional space by these
painters as similar to the three-dimensional
vessel forms of English ceramic sculptor Hans
Coper, whose formal sculptures are toned either light or dark. In the painters' forms, he perceived a
three-dimensionality and a sense of weight akin to that in Coper's pieces. During the 1950s and for
most of the 1960s Turner's work evidenced little relationship to abstract expressionism. By the end
of the sixties, he too began using abstract forms to express feelings and experiences. There are both
similarities and some differences between what Turner did in his mature work and what these
painters were after. Both Motherwell and Kline, among the abstract expressionists, painted large
natural shapes, dark forms that moved across the canvas with weight, energy, and a sense of the
moment, of imminent change. As Turner intimates, he invests his vessels with these same qualities.
But his three-dimensional forms not only convey idea and feeling, they are physical manifestations
that can be touched and held, hence also experienced haptically.

The painted shapes grew out of the artists' brushstrokes as Turner's do out of clay. The painter's
touch is revealed in that signature brushstroke, as Turner's is every time he touches the clay. Like
the abstract expressionists who poured their feelings and experiences of nature and life into the
paint, Turner put his into the clay itself, into the body, the vessel. This is important to him—that
nothing is superficial, but his gestures have the directness and reality of a deeply felt mark.

A chance drip of paint might be left in the masses or ground of these abstract paintings; simi-
larly a drip of glaze appears on a Turner pot. With Turner, it is as much proof that liquid has been
used on his surfaces as it is an indication of a chance occurrence. This evidence is important in
revealing the truth about the materials. Such trustfulness is a fundamental tenet of modernism, but

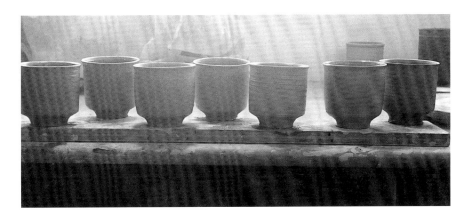

even more, for Turner it is called for by his Quaker beliefs, so it is an essential expression of him as both a person and an artist.

The clarity of the mark making is also relevant to Turner's later work. As with the expressionist painters and the Japanese potters, any surface mark on a Turner pot is essential, not decorative. His marks are part of formal solutions and express meaning. The early pictographs of Adolph Gottlieb and the calligraphic paintings of Mark Tobey bear marks inspired by similar sources. These artists were seeking a universal in the Jungian well of the collective unconscious, whereas Turner was gathering together his own universals, from all the specific signs he identified in nature and different cultures. All three sought archetypes, perhaps settling on some similar marks. Turner, like some of these painters, also believed in the importance of the unfathomable.

Like the abstract expressionists, and the cubists before them, Turner treated figure and ground as an integrated solid, not as one thing seen against another through the Renaissance "window." The physical vessel is Turner's arena, inside, outside, in the clay, of the clay; not the ceramic vessel as support for a picture. Turner isn't picturing the way natural forms appear but rather how forces feel and affect, how they create form. Turner's marks are abstract signs that transfer to his pots nature's way of marking the landscape. Marks on his pots also reflect human interpretation of nature from pre-industrial cultures such as the Native American.

Turner's early belief in multiculturalism drove him to look beyond the Western hegemony, beyond the abstract expressionist bravado of one man's mark made on a canvas or dug into the surface of clay. In Turner's work from the late sixties on, a gesture, whether a slit line or a finger trough, is formal, geographical, and cultural. It can be a way to counter horizontal with vertical and to convey the manner in which, over eons, a river carves a channel in the side of a canyon, or, in a few moments, the ocean makes ridges in the sand. It could also be a sign of human presence, a direction, or a link to the way marks are made in other cultures.

Exposure to abstract painting and Japanese ceramics reinforced Turner's growing dissatisfaction with his functional pottery in the early 1960s. He was on the threshold of shifting to making metaphorical vessels that would be informed by abstract expressionism. As his uncertainty in his pottery was growing, he moved through some especially low points and moments of self-doubt, questioning his ability to achieve what he was after. Over and over in his reminiscences and writings, Turner sees 1960–65 as a time when he was painfully lost, trapped in work that wasn't essential.

I was [mistakenly] interested in the external elegance . . . rather than anything that had real meaning and was [not] reaching where I wanted to go.[33] *I knew I had lost my own way in my work. A confusion as to what I was doing with clay had taken over. Probably that*

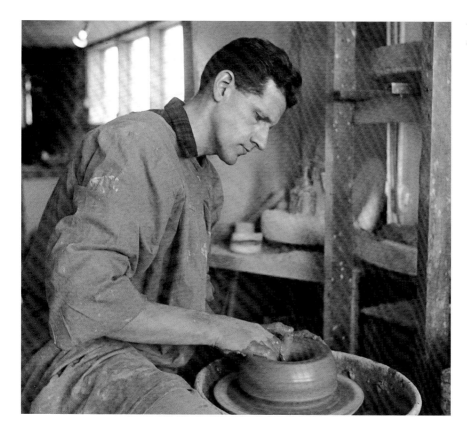

concentration on the utilitarian had begun to lose its importance to me [as had] using past forms and altering them. I seemed [to be] floundering.

It was just searching. . . . What I had been doing before no longer seemed to make much sense. I had been making things that reflected all this history, and I loved it. But now I'm thinking, 'Yes that's great. Now what are you going to do?' And I was going nowhere. In my mind I have what is known as my 'Dead-End Pot' (of 1962), which symbolizes external perfection, something that was both Chinese and Greek, maybe in some ideal sense. There were little odd chips here and there, but basically this was an external perfection, something to be photographed as a profile.

That he speaks and writes so much about his lack of direction reflects the depth of his quandary, as well as the intensity of his passion for finding a way out. Yet these years were critical, because he was generating ideas, images, and beliefs, gathering up the raw materials that he would eventually concretize in his mature work. This was a formative period, the time when he developed the basis for his vessel sculptures.

During Turner's tenure at Alfred, teaching would help him find his way out. The college had been considered important from its beginnings in the late nineteenth century, known as a technical school for ceramic instruction. The program when Turner attended was oriented to industrial ceramic design and the studio production of functional pottery, for which it was equally respected. In 1958, when Turner officially became a part-time instructor in pottery and sculpture at Alfred, it was still operating that way. But Turner and his colleagues gradually began to shift the emphasis to art and ideas.

Bill Parry was here teaching in the undergraduate program in design when I began full-time [in 1966]. Parry arrived here in 1963. He had graduated from Alfred, worked in indus-

trial design, and taught at the Philadelphia School of Art. We loved to talk over ideas, some-thing we've read. It is the way we grew up together in the department. It started with five or six people, one sculptor, one painter, and two or three ceramics people. Then Ted [Randall] developed the educational aspects, turning it into a real art program where eighteen or twenty people were teaching; painters, sculptors, photographers, and graphic artists. That's where the change was. Each person was teaching in his own area before. [Now,] in terms of technique, we learned from each other.

Sue Turner recalls the faculty working together, the very early group creating the program as they went along. Val Cushing remembers how he and Turner discussed curriculum continually. "We talked all the time about what we were teaching. Everyone teaches different levels of glazes and chemicals. Bob taught kiln construction on a structural level. I taught throwing on the wheel. We both understood the risk of skill overwhelming idea. But we felt the idea part of the curriculum should be in better balance."[34]

Randall, chairman of their division, kept raising the commitment. *Ted had gone through Yale and had a classical education and found none of it was valuable to him. His mind worked like an architect's, putting things together. He would look for the beautiful: See this. See this. See how it works. He was always making a still better program.*

Dead-End Pot
1962 16 x 9 in. (40 x 23 cm.)

Melvin Bernstein, in his book *Art and Design at Alfred*, explained the underlying philosophy of the program once it was organized as an art-based, not craft-based curriculum. "Randall insisted that, whether done by a craftsman or a potter, the work of his hands had a common creativity, and that while the craft of pottery was changing visibly to the art of pottery, what was changing was our perceptions about the potter and his work in our times. Along with other modern artists, the potter had moved from his restricted act as expressive maker of his own vessels especially for use, to become the maker of objects with the recessive accent on function and domi-nant accent on speaking to the public in constructions that were less mimetic and more symbolic. Pottery was in transit to a newer state of freedom. No longer need the potter restrict himself to delivering a representational world. . . . Function had semantically broadened. Clay work could function as symbol, revealing the myth-making, the intuitive, the night side of man's need to act, form, know, express, and communicate."[35]

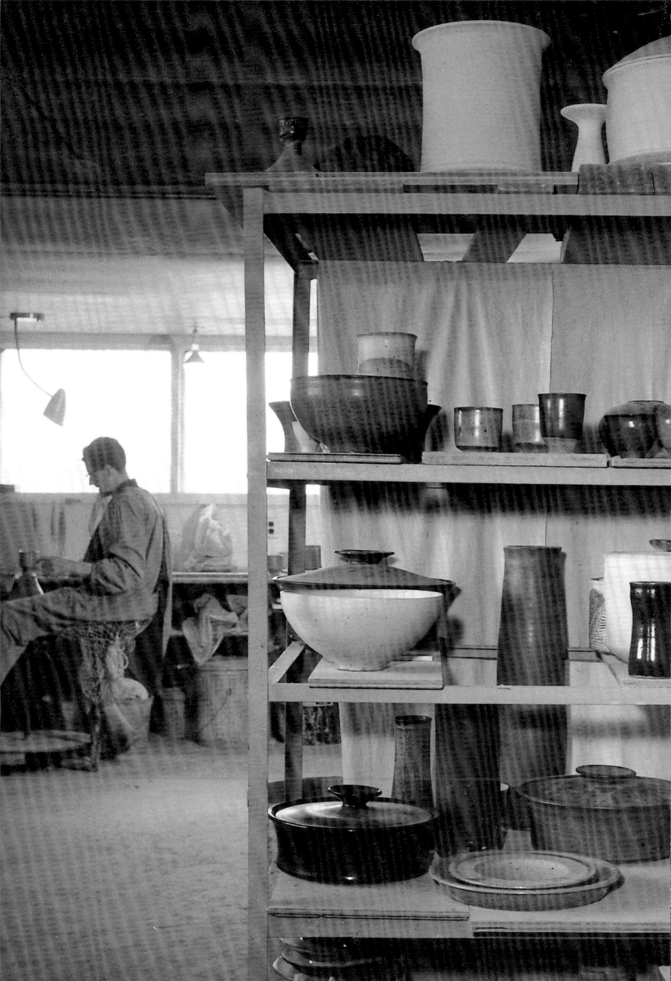

As a result, while clay would remain the center of the program, the other arts, besides design, became intrinsic to study and practice.

As the teaching program became broadened in the early 1960s, we got into separation of foundation year, and held clay off until the third year, so the first two years were mixed media. In the later part of the sixties we had a team that taught the program. Lots of ideas began to flow and be exchanged. It was a time of experimenting with various media. We delayed clay so people would not be focused so narrowly that they missed the ideas and experiment.

Through teaching, Turner came to realize how significant experimentation was for him. *Exercises with students were important because I could be involved. They could do things. My mind is much more limited. A group would turn out things that were unexpected.* The students' free explorations led him to experiment more. This was the 1960s, when spontaneity, change, and openness were elements of the contemporary mantra.

Turner made vertical pieces consisting of one cylinder on top of another, each verging slightly on a cone shape, which formed covered jars. He did a cup with three feet that was appealing. He tried using uncharacteristic colors, such as red glaze on a bulbous jar. He began working more as a sculptor than a potter, examining clay in different forms, manipulating positive and negative shapes, thinking about how forms came together, fit together, and extended, studying virtual or implied movement and relative contexts. He thought about Chinese bronzes, mulling over whether to explore their strong geometry. He studied issues of time elapsing and context, doing a series of photographs, twelve every hour, of a street corner when it was snowing. Causes that were unforeseen, results that could not be predicted, became intriguing to him. He was trying everything.

A BREAK FROM SCHOOL AND STUDIO

Finally Turner decided to get away from Alfred for a while, taking a sabbatical from teaching during 1965–66. One source of renewal for Turner was, and would continue to be throughout his life, participation in acts of social protest to effect change. That year he and his sons John and Rob made a few trips to Washington, D.C., carrying on a family tradition begun during World War II.

We went to protest. There was no question the Vietnam War was wrong before it started. We were protesting in '65 and '66, that was exactly 300 years after a pivotal event—the beginning of Quakerism. The Quakers said there is power in truth that prevents the use of the sword. Internally it is impossible to deny the power of the spirit and unity, the sword being useless to change people.

At last Turner's type of activism was in sync with the times. "People were talking pacifism and alternative thinking," recalls Rob Turner. "These were things that were inherent to us." [36]

In the late sixties social change was filling my head. I very deliberately was trying to act out things, to figure out how the process and forming affect result. The forming invited something beyond what I already had known. In 1969–70 it was a faith in something beyond one's prior experiences, which was consistent with the Quaker experience. Things became evident by trying things out. The Quaker thing is experiential. It is not one-two-three. It's kind of a growth and knowing something is true by experiences, by a feeling in the lower gut.

Turner was stretching himself, seeking new thoughts from new experiences. Travel brought him a different awareness. During that sabbatical year Bob and Sue Turner went back to Santa Fe.

Turner at the wheel in his Alfred Station studio. Functional ware—bowls, cups, and casseroles—line the shelves. 1957.

We came on the train in 1966 and began staying each summer after that. I made some pots. I was in the geometry period. We [saw] Sam Maloof and his wife Freda. They were here every year from the 1940s. We spent a lot of time with them.

The Turners and Maloofs had met in 1963 in El Salvador when both couples were part of an Agency for International Development program helping native craftspeople improve the marketability of their work. Turner was the ceramist in residence. Sam Maloof, a renowned furniture maker, was the wood master. Since Freda had worked on the reservations before she married Sam, the young couple had access to many of the Native American pueblos. They introduced the Turners to that culture, taking them to places most outsiders would not have known. *Almost every year we would go back to see the same people and we would visit many of the sites together, like Canyon de Chelly. It was the culture that was important and I love the sky and land, the air. The ground is red, mixed with sand. Indians dig clay. It is a whole religious process.*

During this first visit, Turner discovered the church at Taos Pueblo, an iconic example of southwestern architecture that has influenced many artists over the years. It provided a clue for Turner that would help him move on from the organizing geometry of his functional work, to geometry changed by nature. *The Taos church has this soft geometry, geometry that is a basic structure used to build, but a material that has been altered in a way that makes it soft relative to people and use.*

From Santa Fe the Turners went on to California. Bob Turner wanted to see West Coast ceramics for himself. *I saw [Jim] Melchert, Ken Price, [Peter] Voulkos, and [John] Mason. I saw Voulkos and [Jerry] Rothman sculpture and the Price 'Egg' Series. It was Southern California. I visited people I'd heard of. I was aware of their work and wanted to see them. I think it opened my eyes to what was going on out there. It was very important to meet these people. Once you meet, you remain in the same world.*

Turner and Sam Maloof (**RIGHT**)
in El Salvador, 1963.

Their work provided him with a model for his evolution from potter to artist. He was interested in the immediacy of their sculptures; that these artists weren't thinking about what happened before, but what was happening now. The work of Ken Price, Jim Melchert, and Peter Voulkos was particularly important to Turner.

Ken Price, who had studied with Voulkos, became known in the mid-1960s for his transformation of containers, particularly cups, into conceptual sculpture. The Alfred Museum owns a 1959–60 Price jar shaped like a rock, with the lid being a slice of the top. A track of incised lines circles the exterior, bridged by a watery shape of dark, dripped abstract forms. It is a remarkable container. Turner sees it this way: *The emphasis for me was a pot charged with idea, carried by surface, edge, color, and volume. It was intensely personal and intimate in scale and character. . . . Here was fundamental form, a wholeness which permitted expressive use, containing signs of events.*[57] *It was abstract and yet almost a piece of biology. Things would erupt almost like little animals.*

Price had taken (and so offered to others) the license to shape a pot like a rock but not have it depict any specific rock nor even actual rock. It was a pot about the idea of rock, about the possibilities of things that might occur on or around that rock, a rock as a container of layers of history. It

was also an abstraction, a jar with a surface that looked like a rock, a surface that referred to things including painting, which had little to do with rock. The disassociation allowed Price to include even more content.

In 1963 Turner was on a jury that had awarded Jim Melchert a Tiffany fellowship for his entry, *Leg Pot*, which pushed the definition of pot as container into conceptual as well as sculptural realms. The pop culture associations of the plumbing-pipe–like leg made this one of the seminal pieces in the development of contemporary ceramics and an important landmark in the developing California funk style.

Leg Pot *was sculpture, yet it carried the hollow geometry of pottery away from symmetry, a compelling aberration for me. It was a fresh look at circle and square combinations, a new perception of connections.*

Although Turner first met Melchert during his sabbatical trip to the West Coast in 1966, the connection between Alfred and conceptual ceramic artists in California would become regularized with artist residencies, conferences, and shared jurying of exhibitions throughout the rest of the decade. Melchert's visit to Alfred in October 1968 was extremely important to Turner.

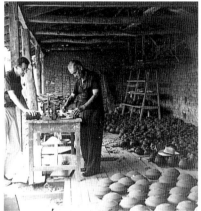
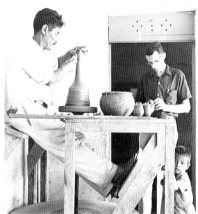

Turner working with the craftspeople in San Salvador. **ABOVE**: A kiln rebuilt with Turner's guidance. 1963.

Melchert obviously enjoyed investigation, uncovering connections, the challenge of assumptions and of apparent incongruities and evidence of chance. When he was a visiting artist at Alfred . . . years after Leg Pot, *in demonstrating, he lifted his clay slab sculpture and let it go. As the slab fell to the floor [he said] 'There, that's better'—incorporating the elements of unpredictability and physics.*

I know I have been alerted in my own work by Melchert's approach. However subtly it may reveal itself . . . I think the effect is carried within much of it—the kind of balance of certainty-uncertainty and the terms of geometric and organic, the play of the force of gravity in the circle-square relationship.

The Supermud Conference of 1966 at Pennsylvania State University was another significant experience for Turner during this period. Turner was invited to demonstrate with Peter Voulkos, already considered the sculptor who liberated the vessel from pottery; Don Reitz, known for his salt glaze pots; and Rudy Autio, who did large figurative pots. For two days, Turner was on stage with Voulkos and the others. Because it was the first time he had found himself in this professional context, he felt it was important that his work hold up to theirs. But he was still stuck in that quagmire between functional and vessel work, and was unsure of himself. The results were disastrous: *I was making a casserole form, and I was picking it up and it got deformed . . . I felt stupid.*

The church at Taos Pueblo, 1972.

Turner's relationship with Peter Voulkos was close. Turner enjoyed participating with Voulkos in occasional workshops and discussing the evolution of ceramic art as they juried exhibitions together. Turner felt that Voulkos was leading ceramics in an important direction, transforming its base with the tenets of abstract expressionism. *What Pete Voulkos had done ten years before [in the late 1950s] was something I admired. His geometry became a clue and a guide. What clay could do naturally had a basis, if I only recognized its ways of connecting, taking two objects, joining them and you have a third.*

Yet they are very different artists, as Garth Clark writes in *American Ceramics*: "The influence from Voulkos can be plainly seen in Turner's most distinctive form, a circle cut in half and surmounted by a square tower. Voulkos developed this form in the early sixties but did not play with contradictory geometry, leaving his tower circular. Turner was inspired by Voulkos and drew his new vocabulary from Voulkos's innovations, but what Turner produced with his vocabulary was not imitative." [38]

The issue of what Turner owes Voulkos is complicated, but Turner is happy to acknowledge that he learned from Voulkos. Voulkos was one of the first potters to move clay concerns beyond those of craft and, from that point on, was considered a sculptor as well as a ceramist. Turner clearly involved concerns from painting and sculpture in his ceramics, a legacy of Voulkos and others, but whereas Voulkos worked in metal as well as clay, Turner wasn't interested in working with other materials. Turner did not forsake aspects of craft, including the belief in finely making something. He continued to consider himself a craftsman and a ceramic sculptor, though such definitions didn't really motivate him to work one way or another.

Voulkos's use of geometry and the various painterly and sculptural ways he joins or stacks forms specifically influenced Turner. But Turner's vocabulary is a product of his heritage, environment, intelligence, and hand, as well as the influence of other contemporaries. Both artists use the pot as sculptural metaphor, but for completely different purposes. A Turner pot is an accumulation of elements from a vast range of cultures that carries pivotal bits of those cultures within. A Voulkos pot is much more about personal expression, a physical manifestation of American individualism.

"I think Pete had a tremendous intensity, an internal intensity, and it demands to get out.

It's an intensity that isn't dependent upon other objects or histories or anything for inspiration or guidance. And I think that sense of spontaneity, that sense of vigor, has always attracted me. He's an original." [39]

Turner's mature work is continuously dependent on sources, histories, and events outside himself. He uses the spontaneous gesture not as an indication of free personal expression, but as a manifestation of his willingness not to control everything. While Voulkos speaks of clay as allowing him "to be quiet, to be loud, or to scream," [40] these are personal emotional responses that wouldn't enter Turner's vocabulary. Turner's mark making, sculptural gestures, and forms include metaphorical references that are abstract and yet specific, relating to forces of nature, cultural practices, appearances of land formations, and much more. Turner includes meaning as a neo-expressionist artist would, with signs and images, rather than with the instinctive gestures of the abstract expressionist.

While chance and gesture are critical to Voulkos and Turner, both came to abstract expressionism as well as Oriental philosophies on their own and left with some of the same and some different elements. The biggest difference is Turner's Quaker beliefs. This philosophical foundation, which binds organic geometry to the relationship of man and nature, is founded on the Quaker universal and is a distinctive element of his work. The sense of inner focus leading to external order is critical. That is why harmonic resolution is essential to Turner, who seeks a balance of opposites in each pot, conjoining flux and control, chance and order, geometry and nature, passion and logic. By embracing differences, Turner shows the way to make things whole.

"If something looks inevitable, it has a sense of completion. Not in the sense of shape or form so much, but the completion of that experience. It seems to be convincing and compelling because we know it. We see it. We feel it. We've been there, but never quite that way before." [41]

Turner says Voulkos showed him that taking the risk of cutting up a form to marry it with another is *very exciting, when you cut down through something. You only come to an opening when you are willing to risk the whole thing and let it present itself to you, and by being willing to slice it.* Turner had learned the importance of experimentation from his experiences at Black Mountain and his teaching at Penland and Alfred, but he points to Voulkos, for whom imperiling a piece has always been a central action, as a mentor for incorporating risk-taking in his process. But Voulkos takes risks differently. He stacks and balances discrete elements whose roughness and inherent instability are defining traits, whereas Turner smooths his parts together, with transitions that make the pot seamless and unified. Turner's vessels are essentially and always pots; that's all he makes. He's taken the chance, but balanced it with some action that is controlled.

Turner always considers the interior volume of a pot, which defines the bowl, as a container of space. He will demonstrate the topological formation of a piece by pushing from the inside to make a change on the exterior and vice versa, and so openings on his pots vary greatly. Often the interiors are as visible and carefully considered as the exterior. In Voulkos's work from these years, whether a single pot or the stacked pot sculpture, the exterior is the focus; the sense of mass, of weight being moved around, is a significant characteristic. Voulkos worked at the destruction of the vessel form, while Turner was always interested in making it inclusive and whole.

With all these inputs, from Voulkos to Rosanjin, embedded in his thoughts, it was time for Turner to return to work. He went into his Alfred studio and began searching for ways to release the ideas, feelings, and knowledge he had been accumulating. Eventually, from 1966 to 1969, he developed a process that helped him pull things out.

"I deliberately sat down with the [idea] of combining geometric shapes and trying to avoid extravagant differences in dimensions. I wanted to see and depend on what the very limited permitted. So it became a trial and error, an examination in which I was dependent upon my own perceptions of what was happening." [42] *I wanted to make the shapes relate.*

Somehow I'd determined what I'd make was "tight geometry," that had a sense of what I was about. The conclusion came to me both consciously and unconsciously. I'd already questioned the thrown functional pot. I was questioning why you call it a foot, belly, shoulder, as those were related to old pots and people. What I realized was: These were cylinders and cones. I was trying to get back to what was there before pots for use were there.

1966 was an attempt to move from history. I wanted to be involved with forming in a deeper sense. Geometry [was an] idea separate from making pottery, so geometry would be the birth of the forms that express, say, round, square, and cone forms that will be universal. [I wanted] to see what clay does with abstract geometry.

So [my purpose] was not to make another pot, but to investigate the geometry of the universe, our pushes and pulls and tugs on clay, in what way the physical element of the material was altering the pure geometry.

Turner began his new work using two shapes, the circle and square, or in three-dimensional form, the dome and the cube. *These became the basis for combining one, two, or three shapes in one piece—two shapes and how they affect each other, one larger than the other. If they were going to be combined vertically, how would they join? That was the excitement and curiosity. One cylinder only slightly larger, usually below. Thrown on a wheel and finding that I was intrigued by the way two shapes would meet, and how they met was a critical factor. Does this support that or is this suspended? What is this? And I realized I was into ambiguity. Later on I realized that this ambiguity was so important.*

At first he used different colors, then found that a single color—white or red or black or off-black—allowed him to emphasize the form in its three-dimensional aspects as opposed to the surface planes. Size was another important variable. While he had been making shapes that were easy to throw and then put together, he deliberately combined some larger pieces to make a pot that was a third bigger, a couple of feet tall, so he could allow the chance occurrences of handling and the settling of clay itself as it dried to affect a form. The pieces began to shift, to move and give a bit, as a result of natural forces.

"[I] was deliberately setting up a process which was in keeping with what I thought for so long about change and about acceptance, and letting the visual result tell you about the event that took place. The shape and form are a result, reflecting a process, not a concept of design, and what it should look like. It would look like the process had made it. I wanted it to make its own form. I would be the trigger. Obviously this is within limits, because I was using shapes that had been formed on the wheel, which had the geometry. When I got to geometry it was really a decisive determination to follow the idea of that universal geometry, which I realized was at the base of all these forms, anywhere, and was at the base of painting and sculpture of the abstract expressionist period. There's a lot of heritage and history in this stuff. For me, it was a revolution in how I could look at what I could do." [43]

Turner didn't immediately abandon his functional pottery, but slowly weaned the work from function, as he explored his "tight geometry." The first pieces from the mid-sixties were cookie jars,

particularly ones with a concave band creating a space like a bowling alley in the joint between the two cylinders that formed the jar. The double loop handles, of a thrown slice of clay twisted by hand, are beautiful and direct realizations of the gesture of their making.

I made cookie jars that were thrown circular forms. A cylinder formed the upper edge with a larger cylinder on the bottom [that had] a little more diameter. I was slightly changing diameters. Rising between and connecting the cylinders, a concave band of clay held the upper cylinder apart from the lower. Sweeping around and between, as a culvert, a half circle, it became for me an intrinsic part of the geometric surprise.

The jars used the vertical and circle. The lid was two circles. The handles on the top were like horses' necks. [As with] the casseroles, I was moving away from pure circles, pushing out so there could be a horizontal line, where top and bottom meet in a circular plane, the top expanding to that meeting place and the bottom producing another kind of circle. It was fun cutting lines into it, in a diagonal sense connecting circles. The volumes were circular, too. All the variations were very simple things.

Landscape, a vessel of 1967, is an embryonic piece. An odd combination of two cylinders, it consists of a tall, narrow cylinder that is cut in half, with a wider cylinder joining the halves in the middle. A band of imagery through the center of the wide cylinder abstractly depicts (in the splash of glaze meeting clay body) the mountains of New Mexico seen in the distance across the desert. Its awkward form reveals Turner's struggle, but he manages to resolve the piece as a whole, by manipulating the scale and proportion to achieve a balance.

The first pieces of 1969–70 eloquently foreshadow future approaches, but also reveal how Turner finds inspiration in life experiences. Traveling in Yosemite in 1967, he marveled at the sheer cliffs of Half Dome: *magnificent in scale, its shape both a surprise and striking as an inevitable possibility of natural forces.*[44] *Early Dome*, of 1970, a cylinder that rises into a dome, is proportionately symmetrical, harmonizing the cylinder and dome shapes from top to bottom and side to side, except for a few incidents. While Turner's ability to throw the geometric shape he wanted verged on mastery, when he lifted the piece from the wheel, the weight of the wall and the movement of his hand collided, causing a lower side to collapse. Turner left this as it was, looking almost like he had punched the clay. Then he drew a square in the clay, from the top opening to a bit below the top of the smashed wall, connecting the incised, linear, controlled geometric shape to the accidental physical disruption, the organic indentation, which is three dimensional. The two activate the surface and the interior volume, connecting figure and ground in a tension that energizes the serene form. This is the first time Turner sculpted and drew on such a vessel, also the first time he allowed such a disturbing chance occurrence to remain in a work.

I began making things larger than I could handle. It took arms, not hands. I couldn't dip and pour on them the same way. I was using my hands differently. I introduced a necessity that was unexpected, that demanded new responses from the hands. I took an external influence and found an internal response.

He didn't stop there, adding painting concerns. One section of the glazed surface is darkened with an iron oxide slip, but the majority is brown from salts in the kiln that have descended on the piece and formed a sodium silicate glaze. As dramatic as the caved-in side but carefully controlled, the glaze composition provided another layer of meaning, recalling the color and feeling of the earth. In using both drawing and glazing on the surface of a thrown, assembled, and sculpted

form, Turner worked the entire vessel. The results were of the clay and its forming process, taking it into the contemporary art mode.

It was an interaction where I'm not in control of everything. I'm responding to what's happening. . . . Surprise flows like a poem, comes to closure, opening something else up.

Turner did a few of these cylinder dome pieces from 1969 to 1971, the dome simply being a way to stretch the clay over the top to complicate and complete the geometry of the cylinder base. *The Domes were all very simple cylindrical shapes made by variation in the circle, combining the domed and covered jar. I was beginning to get into geometry, the circle and square. Then the interaction of the hand and clay, was an organic movement.*

Another experience that was critical to Turner at this point was teaching summer workshops at Penland School of Crafts in North Carolina from 1969 to 1974. He called it a "watershed." While there, he studied dance with Carolyn Bilderback. Wayne Higby expressed what it meant to Turner: "Bob likes to make abstract body movements to the music, because he was part of Black Mountain School. At Penland, a teacher said lie down and roll on the floor, and Bob would be the first. . . . He's always responding to moments; dancing is like that. He is always willing to take on something that pushes the sense of imagination without being self-conscious."[45]

Turner recalled how his involvement at Black Mountain watching Merce Cunningham brought up issues of movement in space and place. *That sense of movement and sense of space, and the effect of place and attitude you are facing, how does that relate to us, being faced obviously in dance. A person moves across the floor to a different place. Those are the signals or markers of a place.*

Dance was also important because it helped Turner know physically, within his body, when to hold on and when to let go, how occupying space felt, as well as moving in it and withdrawing from it, the push and pull of activities in space. This he would translate into the physicality of the pots.

Equally as significant as dance to Turner at this time was learning to embrace chance, as the result of certain actions he took at Penland. During the summer of 1969 he taught a class where they did exercises patterned on the surrealist game, *The Exquisite Corpse*.

People would do part of a piece and pass it on to the next person. So no one knew in advance what they'd have when finished. Process and material determined what the work would be if three different people put three different objects together. You are responding to what someone else has done. The immediacy of chance, accepting vulnerability, all that developed and came out of inviting the unexpected in. The sense of experiment was there. It was all critical because it helped me see what I was searching for—an interaction in art and life. I had introduced risk, change, and interaction.

At Penland, Turner also discovered that chance occurrences could convey ambiguity; this offered a way he could take pieces beyond the specific to the abstract.

I threw a cylinder and made a half dome of its top and cut underneath the whole to take it off the wheel. It needed my fingers on the sides so I could pick it up and put it down some-where else. I could provide the environment, shape what was there—the thinness and circular form—and I wouldn't determine what the piece was going to look like, only how I could pick it up. That would crush it inevitably and change the combined new form. So one knew that this happened, but not how it happened that way.

Turner's next move, also in 1969, was to cut the top of the dome off, making a square opening.

This first *Circle-Square* piece, a title given by his dealer, Alice Westphal, marked the beginning of an important series that continued to evolve through the 1990s. *How did I come to the idea of the Circle-Square? Geometry starts with those circles, squares, triangles, cones, and lines. A circle is a line. If it doesn't close all the way, suddenly it's an opening where the spirit moves in and out.*

Other *Circle-Square* pieces done a bit later combined two similar cylindrical volumes that finished in a wider square rim, shaped from the inside by the hands. Experimenting with proportions and scale suggested associations with natural formations. He developed a vessel that was higher than wide, with a lower cylindrical volume that moved into a second steep-cylinder form with clifflike sides and ended in a square opening.

The circle and squares were a strict geometry. The large circle shape at bottom came right off the plane of the ground and went up and would change. By 1970 I had been cutting squares into the circle, which became more and more obvious. [Then I found] by putting your hands in the [top circle] in two places and stretching, it becomes square. How you do that is critical. You don't want to destroy two shapes. The relationship and the transition are always curious and undetermined. And partly that is what happens with the clay itself. There may be uncertainty in how the pot is doing this, where the transition started, where does it end? Is the square springing [from] or resting on the object below? It is the third element, that transition. It is there and it's certain, but it's ambiguous.

The uncertainty is one of the important things about making. It [points to] something beyond your knowledge. It suggests possibilities. It has an air of expectancy and vitality. It's becoming, rather than [being] a monument to that which is there.

With these pots Turner took a conceptual leap, no longer seeing size as solely a physical dimension, but also as a mental dimension he could manipulate. In doing so he pushed the domed bowl beyond a representation. Rather, Turner was taking a feeling, a sense, an image of mosque, cellar, globe, and so on and abstractly presenting the idea of it, as the abstract expressionists and then neo-expressionists did.

The Circle-Square's *origin was in the abstract idea of dome and globe; and making that and realizing that was a kind of a world, a mosque. I could [imagine being] inside looking up, which related to exploring or relating to one's environment.*

No longer limited by the physical, but working in conceptual dimensions, Turner started bringing in meanings from disparate sources. He imparted an organic nature to a pot by altering geometric shape in ways done by time, water, and wind, or the relation of the sun to a sheltering tree. Clay, because it is of the earth, responded naturally. By subjecting the clay to this organic alteration he gave it the vitality of something that had lived.

Because this was clay and it was plastic, it moved with you, moved so it began to combine the geometric and organic. How did that happen? That tie [was] between two parts of the universe—geometry and idea—and how things happen in the growth of things.

Physically these pots were composed of two or three different geometric volumes. Gravity, weight, and tension, inherent properties in the assembled forms, became palpable and were allowed to affect appearance. They were powerfully felt through seeing. What Turner had arrived at was the pot as sculpture, the pot as metaphor, as abstraction, as landscape, womb and mindscape; the pot's history as structure, built on, taken forward into the realm of contemporary art. By fusing discoveries of earlier art periods—like the cubist notion of space based on something other than a rectilinear

grid and the modern idea of abstract signs, with bits of other cultures, with ideas of geology, geography of place, and movement over time—Turner began building dense content into his vessels. This was critical to what he was seeking. A Turner sculpture was now a geometric and organic form, a cumulative one, carrying the history of its making in its material and a range of ideas in its form. The pot was unifying.

I had started at Alfred when the big word was integration, making something other people would like and buy, something I could make with my hands that implied function and utility. It was years later when I realized function could mean a lot of things as well as utility. Things work because they are needed. It was very important, that opening.

My pottery had begun as [a] comment on what I saw in the history of ceramics, and it became [a] comment on what I see through experience, an internal response.[46]

Not everyone was as excited about Turner's shift to sculpture. Some of his colleagues at Alfred were almost nostalgic. "When Bob stopped making functional pottery, I felt sad about that," said Val Cushing. "Bob Turner found a new direction for himself, but I loved Bob's approach to function. I felt everyone was losing this connection between sitting here and drinking out of a Turner mug, which is different than looking at a Turner pot in a gallery."[47]

A JOURNEY TO THE OLD WORLD AND A RETURN WITH NEW EYES

Travel experiences have been important to the development of Turner's vessels. They have been a way of connecting to other cultures, opening himself to new contexts and restocking his imagination. *I'm just observing and mixing observations. One time we were going along a road and I realized, just by looking, that what appeared to be a house was only the front. Things aren't what they appear to be. And how you are fooled by it, making assumptions about things and they are wrong, being surprised by things that are unexpected because they are beyond what your mind has already taken in, recognizing this has an effect on how you make things and your interest. . . . Pottery is an opportunity rather than a definition.*

Of all his traveling during these years, the trip that pointed Turner toward his future was the couple's travels in Nigeria, Ghana, and South Africa during his 1971–72 sabbatical from Alfred. He knew European and Asian ceramics; now he wanted to go beyond these usual historical sources.

I went to Africa to see the power of the sculpture that so influenced Picasso. What was it? What was behind it? I wanted to find things out. I had seen the magazine Horizons, *with a story about a painted village in Africa. I wanted to see that too. The village was in South Africa, of the Ndebeli people, living north of Pretoria. The buildings were within a square wall of earth, of clay, one foot or so thick, laid out as a long fence. As you went toward the entrance there were triangles of black [going up the fence]. They used color and geometric designs, some very abstract so they were insignias or emblems in black, white, blue, green, and reddish to cover the walls. The fence was all white on top. The colors were below.*

The houses I saw didn't have colors on the walls. Within the house the wife used her broom and made shapes and forms in the sand where you walked.

It was an astounding visual sight, right in the middle of the desert, to see this feat of color and organization. Obviously it is something that comes from their tradition and is authentic in that sense. . . . This was decoration in a place of living.

From Pretoria, the Turners traveled to the First All-Nigerian Art Conference at the University of Zaria, an urban center in Nigeria. It was here that they learned about the sacred shrines of the Owerri people in the northwest, in Mbari. Turner asked to see them. It was a difficult journey necessitating stops at Abuja and an Onitsha village, both in the savannah, before they could reach the forested area of their destination. After transportation and bureaucratic hurdles were overcome, they were finally allowed to journey into the country.

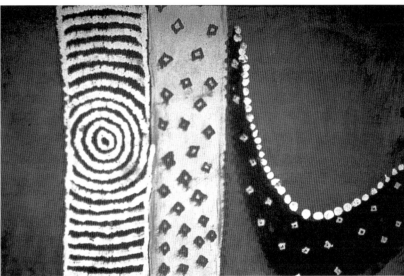

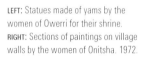
LEFT: Statues made of yams by the women of Owerri for their shrine.
RIGHT: Sections of paintings on village walls by the women of Onitsha. 1972.

The first day we arrived at an outpost in Abuja. People lived in round buildings composed of earth, with the roof being straw. The houses were scattered around in a group that created an open area outside where they made pottery. The women brought the clay in on their shoulders to keep their heads clear for the sacred. The women made the pots for different foods and liquids, different sizes for different purposes and different closings of the mouths.

Then I heard about ritual pottery and realized there was a distinction between something [the women] made for use in the kitchen and stuff made to help them survive spiritually. I understood that the men made these, the religious objects for the time of birth and death. I didn't see them being made but saw them in an almost museum. One I picked out was a gorgeous enclosed pot, like a casserole set on a huge mound of earth like a grave. The pot perhaps contained blood, and whatever would be important for the person. The cover had a likeness of the dead person's head or face. [Men] made pots that had to do with celebrating sacredness . . . responsible for the sacred world. Women were supportive of life.

At the Onitsha village there were paintings on the walls of snakes, fishes, lions, and figures. There was a high level of energy in the village. Masks were used for survival, making contact with the grandfather and gods and woods, similar to Native Americans' approach.

South of the Owerri village, the chief's son took us out into the woods to the Mbari shrine. It was in a clearing. The shrine was under a tin roof and was square, with an inner square chamber behind its massive façade of clay figures. The queen and her helpers [were made-up with] white faces that had to do with myth and images important in [this] religious ceremony. This was as a prayer to the goddess Ala to make things right in the village after unexplained tragedies. They were imploring the gods to come to their aid, which was the central meaning of the shrines.

The shrines were built not for a monument, but for worship, to get close to god and bring happiness to the village. The internal was important, not the external stuff. The shrine was a visualization of spiritual meaning.

What Turner found here was a pottery tradition that was both useful and meaningful. Particularly important was the realization that as an integral part of their lives and culture, art was a necessity, not an expendable commodity.

Where life is difficult, as much effort is expended in worship as in work. The two are interwoven and each is absolutely necessary. Common belief is paired with common action. Something made by the head of the family carries meaning. How it acts is more important than what it looks like. What we call art is a street language. Art has a purpose. Sculpture has a purpose, the survival of the village. Sculpture and art are about survival, the continuity of the group. A child held by its mother while [she is] dancing in rituals learns his identity with her, with their universe, the village, with the dead, with loving, with the supernatural. He learns all this early.

I was finding that the power of sculpture comes from the belief of the people, that belief being animism. That they and all things are related as energy. That, in fact, it is energy that is the true nature of things, not matter. The possibility that people in this belief can, through magic, through ritual, act with some control over energy. They can bring energy through their own need, through what we call art. The act of making things is a verb here, not a monument. "Art is a verb." What it looks like is not as important as what it does. The thing can convey something that affects the spirit.

This was art with the power Turner had been searching for, from a place where religion is critical to survival. Art was motivation, not empty decoration. While utilitarian wares were important, the sculpture through its linking of important history over time carried its own power, embodying the collective memory of the people. Containing this energy offered control and value to the art. And this time Turner did not mull over meanings for months or years; the effects of the experience were immediate.

I was more influenced in a direct way by the Africans than by the Japanese or Chinese. On leaving Africa I began reading books and seeing that the ritual was critical to understanding what I was looking at. Why the masks were not heads hanging on the wall, but the energies behind them. . . . The trip was an experience that was both intimate and remembered.

Ulli Beier's book, *The Myths of Life and Death in Africa*, became a resource to which Turner continually referred. The text explains the creation myths from various areas of Africa, interpreting why things are the way they are. For instance, one African story explains why stones have no children. The book provided Turner insight into another belief system that contrasted with the Judeo-Christian one. The knowledge helped him understand what he saw in Africa. *African Art of the Dogon* by Jean Laude was also important for Turner. It included a story about two farmers who dug up a statuette that had been made by a people they didn't know. But the farmers recognized that the sculpture was sacred and so adopted it into their culture. From this Turner understood that an object imbued with a value can be recognized from people to people, or as Laude put it, "Each form has its own meaning. It doesn't take its meaning from exterior or prior sources."[48]

In between the Turners' several-month journey in Africa and a trip out West, Bob Turner joined Jeff Schlanger, a sculptor, and Peter Voulkos at the Everson Museum of Art in Syracuse, New York, to

jury the prestigious Ceramic National Exhibition. This significant show, which for several decades had brought together the best claywork in the country, had been suspended for a year. *When I heard it was starting again and I was asked to be a juror I thought it was going to be a new era for the exhibition. The country was being aroused and depressed by Vietnam. This show could be an important new energy to equalize the horrors of the war.*

The three jurors were separated, each looking at slides projected on a screen. They viewed some forty-five hundred slides but could find no underlying direction in the work. Turner remembers Schlanger walking closer to the screen to inspect a piece, thinking he might be missing something. *We were all, in a sense, shaking our heads. Right or wrong, we said try again, rejecting all the entries. I felt the absence of energy and conviction. Some people didn't send their best work. Things were not new or different. . . . It was sad.* The expectations of the jurors were disappointed: they did not see the aesthetic strength necessary to revitalize this forum. They rejected all of the entries, a decision that was broadly condemned at the time. Ironically this had been the first exhibition in which Turner's functional work had been recognized, when a piece was included in 1947, but the current entries had failed to set the pace for contemporary ceramics. The director of the Everson Museum put together an invitational exhibition to fill the time slot. Turner was asked to send work but refused, not wanting to take the place of other people who had submitted things.

A few weeks later the Turners took off for a summer in Santa Fe and the West Coast, continuing the cycle of travel they had begun in Africa. During this trip the mysteries of Native American pottery became clearer to Bob Turner.

The Mimbres use the open half-grapefruit shape, the inside of the bowl, as the world with a sky, creating a sense of space and movement and sense of the placement of things in it. It was kind of the universe we have when looking at the stars or looking up into that dimension.

Their use of the open geometric form . . . was enlightening. Shapes floated without axis or position, in that way related to the cave drawings. Mimbres probably had no sense of outer axis or dimension of space; therefore things could coexist; the horse drawn over the antelope. You don't need a vertical and horizontal axis because they [are] spirits.

Ideas of animism and energy, as he understood them during his African trip, were curiously echoed in the Mimbres pottery he saw in the Southwest. *I'd like to think that things take on and get their own energy, somehow in a physical way, that then is a metaphor for the things we get, in a poetic sense, from them.* He discerned a strong correlation between the core values of the two cultures: *They are all people for whom animism was the main kind of religion, utterly different from when man is top dog.*

Turner's artistic sympathy for African and Native American cultures was a keystone for his mature work. He had already accumulated the tools and techniques to express his evolving aesthetic. Changing scale and combining similar and divergent geometric forms were idioms he had explored in the *Circle-Square* pieces. Creating vitality in a piece through the dialogue that happens between pot and artist in the process of making is a phenomenon he relates to the animism he saw in these other worlds: *The pot begins to work when it's a dialogue. You make a move and it tells you what to do. The trigger that's critical is different than control [that is] based on design or form coming from something already known. Form is coming from a combination of these different forces, certainly your own experience of forming, of history before you. Nature is important. It is evidence of this connection between animals and place, why things happen*

here, not there. It has to do with how things work. It has to do with looking from something you know, to something you don't know. It's about perceptions.

Accepting chance, ambiguity, and inconsistency, employing gesture and metaphor, and taking a conceptual approach were legacies of art and Quakerism that Turner had made part of his work. Multiculturalism, natural history, animism, and science were sources found outside himself, that would be critical for his later work. Turner had identified most of what he would need.

The struggle to assimilate all that he had gathered, experienced, and understood in a bowl can be written as a logical process. And it was, in part. But much of what Turner would produce from now on erupted fully formed: pot types, metaphors, whatever. Ideas led him from one to another, but there were no progressions from simpler pots to more complicated ones. A more reduced piece could happen at any time. The mix of elements within a pot was varied and appropriate for that pot. Though he couldn't make the same pot in 1971 that he made in 1991, it would be difficult to discern which pot came first. Though one pot may lead him to explorations in the next, there was no hierarchy. The mature work is about multiplicity and fusion, not really progression with its inherent Western commitment to the next being better. Being on the "edge" of the new didn't mean the same thing to Turner as it did to other avant-garde artists of this period. He sought his edge alone, living in the moment, not judging one moment, one person, one event against another, but looking for connections. *By some kind of connection not made before one has experiences.*

Wayne Higby has observed: "When [Bob] is working he's there, in the moment with the work. You feel that even though he has a strong signature style, you always feel that he is working it out. It doesn't have a 'wow factor.' It's more on the road to a question. That's what keeps the work fresh." [49]

PAST THE LOGJAM INTO A TORRENT OF MATURE WORK

Between 1972 and 1980 it seemed as though all that had been building inside Bob Turner came pouring out. By using geometric forms, which are universal and hence stateless and acultural, but inflecting them with the sense and ideas of various places, races, and cultures, Turner moved between opposites, from the general to the particular. Something that is constant, the fired clay, foreshadows and implies change and variety. By unifying the general and the particular, he tells of something bigger than we are.

Most of the types of pots he explored during the rest of his career surfaced one after another, while the geometric bowls continued to evolve. He even made more casseroles. Beginning in the late sixties, and increasingly after the trip to Africa, the function of the covered jar changed, with new meanings arising. The container of rice or cookies became a container of events.

Turner made the first pots carrying the imprint of the African trip in 1973. *We talk about making pots or objects. It's how you bring your experience into your hands and find where it comes out, as part of a form that wouldn't have been that way if you hadn't done it.*

He called this type *Ashanti* after a people and area in Ghana. The name was symbolic, *recalling for me the power of traditional sculpture and paintings on shrine walls. . . . The piece itself so reflected my experience over there that I wanted to give that sense of identity of the place to the piece. The African experience brought a lot of meaning, particularly seeing the shrine of the Mbari. Walking around in Africa I had a sense that any object I made, I'd like to have sitting*

near a chicken coop on straw, not in a gallery, but be part of the event and environment that gives rise to such pieces, that gives it location which is just the opposite of universal geometry.

The *Ashanti* pots, like each of the types he would go on to create, have a specific, basic geometric form—the universal. Usually the pot is a squat or stocky cylinder flaring out at the base, and then gently tapering up. Some taper up higher than others. "Squat" here also relates to something close to the earth; the idea of putting down roots, settling in, and dwelling. With such connections the specifics are suggested. They are all lidded, with a thick, inverted conical bowl form that spreads out over the confines of the vessel like a Chinese hat or an African straw roof. Most lids have handles made of two crossing coils of clay, pinched or laced together at the peak.

The Ashanti *pot is a hut form with the grass roof, like the ones I saw in Nigeria. The wide base was a partial response to the way circular adobe buildings are built out of earth. That breadth and earthwardness was important to the width. Then it moves in and on up. The covered pots keep space inside like a cave. A cover is not just a lid, but suggests different ways to shut off openings.*

The form is also related to certain tribal ceremonial pots, some rather bell-shaped in bronze, others of clay. In fact, Turner says the *Ashanti* is a ritual-type pot, recalling those containers he saw in Ghana for dried blood, but his is a different shape. The handle is the only thing that is similar to what he actually saw. This specific ties the pot to the place just as the title does, providing a first and direct way to enter and begin understanding what is going on.

Because the shape refers to both house and vessel, it provides experiences of different scale. The piece alludes to the body as both a container of blood and, through surface markings, recalls scarified skin. Because the pot is something that can be held and lifted, it is also a reminder of use. To understand these pieces, layers of meaning must be unpeeled, by feeling, seeing, touching. This is how one gets to know a Turner vessel. It is equally important that there be much left unsaid and unknown, ambiguous, for this is the spiritual core.

The color of the *Ashanti* pots is usually the blue-black Turner prefers, a patina that recalls clay smoked naturally by fire. The antecedents are his covered casseroles from the 1950 and 1960s, which are a similar cylindrical shape.

The incised marks on the Ashanti pots and the pieces of clay applied to them add more particulars. Here, as on all his exterior surfaces, the marks are not replicas of what Turner had seen: rather, they carry the sense of what he was remembering. *They've come from something but once in or on the pot, they are on their own.* Raised lines evoke scarification patterns on the body. Incised ones summon memories of lines drawn in the earth with brooms, of petroglyphs etched in cave walls, the dots and dashes of rudimentary communication. Turner isn't referencing a specific African language, but basic gestures of writing. The physical difference between the two methods of lineation is strong, with the raised marks having the sense of swollen skin and the incised marks the dug-in feeling of lines made with a pointed tool.

The marks are emblems of handwriting and sign making; they are a personal act without a hint of the person behind the action. Not even Turner's hand is specific in these marks, in the way that a gesture might reveal the author in an abstract expressionist painting. Turner doesn't make the same lines on every pot; variations are based on many factors. They come from his having observed, intensely studied, and then inculcated basic marks used in different cultures. So the actual mark making is both specific to a pot and a generalized activity. Turner unites different perspectives so

one has the impression of looking down on an arm, or up at a canyon wall, or directly and closely at the mark. Conceptually they could be huge or tiny; one cannot tell. These are ways he shifts scale, direction, viewpoint, and internal context, so viewers decode the marks as they see them, making meaning open and accessible to people from various cultures.

Incising lines for formal reasons and to communicate meanings is a practice Turner continues throughout succeeding works. He may make a horizontal line that marks a joint between two different parts. Often the line is made on the wheel as the pot is formed, to emphasize both the motion of the forming and the horizontal nature of the way a pot grows. The line can also function as a horizon. But like the Mimbres potters, Turner inserts this horizon in an undefined space where applied clay shapes float above and below as though unaffected by the gravity of the pot or the earth.

Making a pot that is both grounded and free from gravity is one of those dissonances that are essential to Turner. For him, the illogic is part of the reason for doing it. It coincides with what he knew from his Quaker practices of the interface between the physical and spiritual. During meditation, the main act of prayer, one relinquishes mental control, letting what happens be. The goal is to release the spirit from the body, attaining a freedom of mind from body, this contradictory state of physical being and spiritual nonbeing.

The clay shapes applied to the pots are important developments that first appear consistently in the *Ashanti* pots. The idea of using shapes in relief grew in part from the way Africans fix a broken pot by applying strips of clay like a Band-Aid to the distressed area. Mended pots are considered better than unmended ones because of this evidence of use. They are richer for their connections to living. For Turner, there is an added link: use implies a history, a past. He continually conjoins past and present.

Often, on the *Ashanti* pots of the seventies, Turner applied a rectangular strap of clay that courses around the cylindrical lower volume, clinging to the bowl. The strap is made of ripped, not carefully cut, clay whose edges are raw and cannot be duplicated. It seems homemade, handmade. As it makes a path around the pot, the strap seems to gather energy, acting like a familiar signpost in a landscape for runners, points from which the viewers can measure duration and distance, how far they have gone and have yet to go. The straps create a continuing sense of location, between here and there, top and bottom.

I explore space by occupying space. The snakelike form of the strap captures space, touches space, and leaves free other space for something to happen. The strap encircles [the pot], holds it, and repairs a crack, so it is doing something that expresses a need.

Turner applies a variety of other shapes to the pots, such as a patch of clay with an X in it, or a fragment of a coil clinging to the top like a worm, or random coils that form an arch. The X is always crude, "like X marks the spot." It stops the eye and motion, pulling one in. It is both a precognitive mark and a formalized sign, collapsing the distance between early and later cultures.

Riffs of repeated tiny X or cross shapes are made in other areas by a rilette, a tool shaped like a corncob, that Turner brought back from Africa. *Though the cross shapes are African in origin, they could as easily have come from the Native American West. The Anasazi [ancient Native American people who symbolize prehistory in the Southwest] used geometric shapes, which you begin to see in rocks too. It's something we all pick up. It has to do with a common experience, seeing repetitive shapes. I use it to give location and detail and order.*

As one gets to know a Turner pot, one recognizes that a rhythm has been set up, so the eye may move from strap to edge of the top to an X, led by motion of gestures, shadows, and protruding

shapes, around, up, and back down. One is compelled to see and take in the whole pot, from two dimensions to three, as one would explore an abstract sculpture. This rhythm is always lyrical, a gentle climbing up with the pot that inculcates the physical sense of movement transferred from eye to body. The rhythm is also a source of the poetry of Turner's work, moving like a chant around and around and around and up.

Turner made a white *Ashanti* in 1974 that he realized later was inspired by the white goddess in the Mbari shrine. It seems bigger, fresher, and less squat than its ancestors, as though it were a pot that had a new skin. The white functions well as a signifier of something less earthy and more spiritual, by contrast.

I think of the Ashanti *as a pot or thing fulfilling its own need. It is a container of effective events. . . . With its encircling, there is also a sense of comfort, of gathering and saving, a very human sense of hugging and protecting something. One thing is different than two because two make a space in between and that space becomes active, and that is what is important to me in a deep way about life: the relation of two or more things making a community. . . . I don't think of them acting in the way the African ritual pieces or shrines do. They aren't a call for any particular kind of action.*

Instead, they are repositories of ideas. Mario Prisco, who was a painting professor at Alfred at this time and a close friend of Turner's, recalls seeing these first, Africa-inspired pots, and thinking: "What is this man doing, making pots of African heritage? They do come out of a deep concern for those months when he was there. He came back so excited about the deep validity of what he saw. He spoke about roadside things, like a dead chicken, or the different way this deity or power was evoked, oftentimes in public or in ways that were very ephemeral. After his African trip he changed deeply. He talked of being frustrated with his functional work. Bob's work has to do more with what he is, how he is, and what he feels. That's part of the thing that is both puzzling and fascinating and makes it important. Something that is all of a piece, altogether. The refinement of the piece."[50]

Working on the *Ashanti* pots led Turner, in 1974, to a related pot type, which he called *Niger*, a reference to the river that feeds this section of West Africa. The *Niger* pots are tureens that resemble the *Ashanti* series with the crisscross coil handle, but are lower in profile. The blue-black bottom moves out from a small circular base, into a slightly wider circle up to the top, finally flaring out quickly to form an edge that receives the cover. The cover sits inside a wide circular opening, which, with the bottom rim, forms a broad horizontal extension, like the horizon on the earth.

The swelling reflected an organic sense of what I was doing too, an arm circled around. Niger *came naturally from the casseroles of the fifties, which were simple and clear. I really liked the casseroles of late 1968–69.* Niger *came from there.*

The form gave Turner another arena. He rarely used incised lines on the *Niger* pieces because the pot was too shallow for the lines to be properly seen. Instead he relied more on applied clay shapes to carry his metaphors. In such a pot, two moonlike forms on the cover were persuasive symbols of the heavens, leading one to see the top as the great bowl of the sky. That there are two refers to the African idea of twinning, a way of pairing the heavens and earth.

While they are beautiful forms, they were limiting. Turner only made some six *Nigers* over two years. It was so laborious because they had to be just right. *One part demanded the same thing of the other where the two met, so I didn't have freedom of movement. If I wanted to see what the clay wanted to do, I needed more flexibility.*

TRAVEL TO CAPE COD AND NOVA SCOTIA FOR *BEACH* AND *SHORE*

Annual family excursions were also a fertile source for Turner's work. *Different environments affect the work, but always indirectly. I think somehow letting yourself be open, while you're doing things, like that poet Peter Viereck who talked about the side glance, the thing that leads you to a different place in yourself. If you get up at a very different hour, everything is different.*

During summers from the mid-1950s through the mid-1960s the Turner family would pack up and drive to Cape Cod for a few weeks' vacation. Walking the beaches, seeing shells wash up and then become bleached by the sun, affected Turner. His later *Beach* and *Shore* pieces are this sun-bleached white. While color change is part of a natural process, the shells are odd because this is not their normal color. Mutations occur. Processes continue.

Turner's pots can also vary similarly. Some types he makes in only one color; others exist in two or three different versions. The color gives a similar form different character. The three colors Turner tends to use are white, red, or blue-black. While the colors relate to a location like "Beach," they also are associated with day and night, birth and death, and materials like charcoal or dirt. They refer to change, too. Obviously the same color in bright sunlight is different than at dusk. Turner uses the color of his pots to make an analogy.

While hiking among the rocks that lined the shore, Turner contemplated how in seeing a piece of something one senses that it is part of something much larger. He learned from studying the ordinary, the commonplace: a mushroom growing at the base of a tree could reveal much about light sources and change.

A mushroom coming up through the grass was carrying its past with it. The twig or branch that had covered it became nudged from below as the mushroom grew. Within two days the twig was suspended in air by the mushroom. I saw something visually and it told me about a change in time. What I saw today was foreshadowed three days before it could happen.

When he attaches a rectangle of clay to the side of one of his pots so it sits like a rock perched on edge in a canyon, Turner is creating that tension, that question, that foreshadowing of change as one moment leads into the next.

For Turner, there is a commonality in geometry that negates scale and yet allows a multitude of scales. He observes such things, then often photographs what he wants to remember. It's usually the details he's after.

The picture in one of my slides from a trip to Nova Scotia in 1968 is a tree which has grown around a rock and up to get the sun. The rock describes the tree because it formed it. The tree describes the rock because it is unchanged. They begin to give each other identity. That's not cultural, it's natural history.

I was observing the way a tree comes out of the ground or trees make noise when you touch them and they touch each other. In the summer they begin to rub. It was the natural world I was responsive to; the way things grew, to rocks, to textures. Why were they this way? The idea of change and time and very different timelessness. This is the way things work and this was very important.

He came to the idea of putting shapes together when he spied a stack of logs, seeing them as units, thinking you could put single logs together or units of four logs together and either would create an order. *[The logs] were geometric, amazing forms. I hadn't seen them that way before. On the beach in Nova Scotia, pebble after pebble after pebble together made a mountain of*

pebbles. It's the natural way things new and old build and disintegrate, inevitable, the natural way. That life includes death is a common experience when you're involved with making, searching.

Late in 1974, Turner made the first of his *Beach* pieces, from observations and ideas that had been fermenting as a result of his summer trips to Cape Cod and Nova Scotia. Aspects of these pieces had appeared in earlier work, especially in a 1972 *Shore* pot.

I did those [Shores] at Penland. [I was] influenced by the membranes on the beach, where things breathe and have a softness. The Shore *pieces emphasized the lower cylinder supporting a cone on top, rather than being two separate forms. The* Beach *pieces were a larger symmetrical form going up from a base that was wider at the top, really flowing from bottom up.*

These are his subtlest, simplest pieces of the seventies. Because these *Beach* pieces rely on form, there are few lines incised or clay shapes applied to the surfaces. The gentle swellings, the places where Turner pushes in the clay with his finger from the outside, or pushes out on the clay from the inside, need to be seen, uninterrupted by details. They should be felt as they are seen, or sensed, because the protrusions and projections recall the push/pull of breathing. The vessel walls carry a motion that reflects the simplicity of the beach with waves sweeping over it, of water flowing free and retreating back, pulled by the gravity of the tides. Small indentations and a few marks suggest the signatures little animals leave as they move over the sand.

White clay is a beach. Weathered whiteness, bleaching by the sun, things like bone thrown up on the beach, membranes, objects in shells that are soft like amoebas. Those things are life forms that live under the sand. The water comes up and retreats, and a hole forms where this thing pops up and breathes. Its soft shape, versus hard shell, protecting the soft life that's inside it.

The top edge of a vessel, where the eye can move from outer to inner, rim to idea, form to space, is a critical juncture in much of his work. *They are white shapes of the beach or beach edge . . . where water hits rocks, meets the sand. The edge is important as an idea where things meet because it defines where each affects the other and brings out some quality you'd not have known about the other.* As a transition point from solid to void, it provides a moment of decision, the question being whether to continue looking or to separate from the weight of the vessel and venture on. Some pots open wide and seem to force the eye out, others are narrower and draw the eye back in. The edge is also a line crossed to enter the pot, not just exit. But during the throwing process it is the last part of the pot to take shape, so it must be the culmination of the form. There is a circularity here, a kind of endlessness and ambiguity. As such the edge is a pivotal point of engagement for Turner, and he continually explores its possibilities.

Turner made a lot of *Beach* pieces, working particularly on the development of a sense of movement and rhythm. *Each piece came up and completed itself at the top with an openness and sense [that] it had its own life. The subtle volumes grew as though they were finding something. I use porcelain-type clay, not a white clay. It has other materials in it that prevent it from being almost glass at top temperatures. [From] the first one, I began to sandblast the white glaze [to] get the dried effect of things on the beach, the sense of time, of elements working on something. It was important when you get up close and feel the subtlety. The subtler it is, the more you can discover the form in light and shadow.*

White Jar-Small (Early Beach), 1974, the first piece of this type, is fluid in form, carrying a sense of motion in its shape, as though one edge could slowly propel the pot forward. *Beach*, 1976,

is marked more by bumping up against things. Both are evolutions of *Circle-Circle*, with rising upper chambers taller than the lower ones. They are as soft as Turner's geometry gets and recall the church at Taos Pueblo that inspired him with its worn, rounded form. *They are closer to the human form, the subtle curves of the human body as one moves down its torso. I left the inside not affected by sanding and weathering so it is slightly cool and to get the iridescence of shells on the beach with their insides protected from the elements. The difference between inside and out is important.* There is little variation in the white glaze, except where it has been worn thin by sandblasting around the rings; hence the glaze is more of the whole. But the thinning areas are critical, making the glaze feel more intrinsic and more revealing of the effects of time, similar to the slight unevenness of the bleaching shells.

As a group, these white vessels are the most purely abstract of the 1970s works because they rely so minimally on specifics. Their purity makes visible and predominant Turner's skillful shaping of his vessels. White is the absence of color. Organisms that developed in water, where life began, were elemental. Many creatures that inhabit the shore have no viscera: they are solely skin, only membrane, except for the core that is inside pushing out. The human torso is likewise a swelling shape that can be abstracted. The *Beach* vessels embody, rather poetically, the development of life.

The critical thing is the shape, as a form around space and how it exists. I don't know how one arrives at form (a deeper word than shape) independent of examination and observation of what other people had done over the years. In your paintings and sculpture you build up something. It is more than taste, something that is a response to what you see that makes aesthetic sense to you. It is the way things seemed to be formed and changed in nature; the gravel, the clouds.

THE GEOMETRIC BOWLS EVOLVE

While vessels tied to a specific place were seminal, Turner didn't give up on those that were more general, developing new types of geometric bowls in the 1970s and continuing to make those derived from types begun in the late sixties. In September of 1972 Turner went to Penland for a workshop. His charge was typical of the period: make whatever he wanted.

I did a Circle-Circle, *which developed into a white* Shore *piece, but in this case it was made of dark clay. My fingers were moving inside the base and they went through. Suddenly the piece had this organic sense of an animal or organism moving inside in some kind of way that was pushing out. It was from years before seeing a bowl in Mexico where a turtle was protruding from a groove. This altered the bowl from just being a bowl of roundness and verticality. The circle going around, together with the finger movement pushing from inside, made a cross. The organic animal sense of movement has been retained from then on, stretching the inside space to become a force equal to the space outside.*

The relationship gives the pot wall the quality of a "membrane," as he says. Rather than something solid and unyielding, the clay wall retains the idea and memory of something porous, a natural material that breathes and changes and records change in its form.

This is all part of the Quaker sense that you can rely on internal needs to find identity which is personal and cultural and it comes out at particular times when there are connections. I was searching for something like that, which was not external but was of itself impor-

tant. That happened with that little piece. The hand, almost by surprise, matched things I had seen in other cultures. The organic was affecting what was abstract and a geometric shape.

Another vessel from the early 1970s, called *Red Bowl*, brought together a number of different elements and geometries. A three-part variation on *Circle-Square*, it was also called a *Low Square*, in a 1976 pot, and in the 1980s and 1990s evolved into a taller version called *High Square*. The *High Square* gets more organic as your eye moves up from the base. The pots are eight to eighteen inches high. Most are glazed red; few are blue-black, resembling the color of cooled ash.

The pots recall the Neolithic Japanese forms of the Jomon period in the combination of volumes.[51] The *Red Bowl* form is a wondrous, slightly awkward balancing act. It begins with a small, almost spherical base, clearly married with a line to a cylindrical center that swells up and gradually out to the third part, a larger cylinder. This top section is pushed out further into a square opening. The tripartite form is much larger at the top, resisting gravity. The rim is usually cut with a clean edge that may shift up a notch or down a bit as a corner is turned, but otherwise is flat. The eye seems to move faster around the cut edge because of the smoothness, whereas by contrast, it lingers over the interruptions made by fingers on a hand-formed edge. The strong sliced feeling of this wide edge makes a dramatic rim from which the eye falls precipitously, as if it has suddenly plunged into an open chasm. The contrast intensifies the feeling of motion and the experience of the pot as a whole.

Light falls clearly to the base inside, illuminating any marks that are present, but the middle section is usually hidden in shadows. The eye is drawn to the bottom by the light. Then the viewer must visually explore the walls to move up and out of the confines. There are crevices, places on the outside and inside where clay bits accumulate and are trapped in the glaze, or where the push or pull of the vessel wall adds to the sway. Smaller forces have moved with or against the walls, leaving imprints that tell that something has happened, something was here.

You are looking way down into a pool or river, a little world way down on the inside. With the Low Square, *the bowl was so open you could see the outside form and look across and see the inside, referencing both in and out, the yin/yang at once.*

In *Red Bowl* one feels the power of a kind of mounting energy in the form as it grows higher and higher, as though something explosive, like a volcano, could occur here. A different but equally valuable analogy is to the walls of a canyon in the Southwest where birds have built nests in crevices, which are like those of the pot, and where weeds grow; where one imagines a goat ambling along a path with a man alongside. All are Turneresque connections among natural forms, natural forces, and man.

The hand shaping the square at the rim both gently and surely interacts with the thrown cylinder. One never senses an overworking, but rather feels the give and take with the clay and the wheel, a Turner strength. Action and reaction is a basic scientific premise. Touching Turner's finger marks in the clay is an experience of intimacy. To move from this relatively small sensation to the idea of volcanic eruption is another conceptual shift in scale.

Something internal makes the hand move like grass curving over. The grass has a structure, [it's] not just a flat form. Things are pliable and are affected by the mind. All these things build on your own experiences. If I do something, it's going to get response. I don't know what it is, because the conditions differ from moment to moment. The mind changes, altering form, and form reflects those changes, which become part of the changes themselves.

Turner continued to make the dome pots during the seventies, working out a globe shape that is essentially a cylindrical dome. The globed *Domes* developed from an emphasis on a type of place; they are also about the probability of that one point, and hence place, occurring over and over again, across time throughout different societies, anywhere around the planet. The subject, a dome, is a man-made architectural form that often covers a place of religious significance. By adding natural marks and basic human gestures, coloring the container so that it responds as a natural material, Turner is synthesizing, making whole.

The first time I picked up that globe form, it made its own shape. I knew that was a shape that should be. It had an inevitability about it, a sense of going around. I didn't alter it again but returned to another way of contesting the organic. I began to challenge how to use my strong sense of geometry that was implied in the piece, but in another way, and that was by line, by drawing. I began to make a vertical line from the top, which is what the pot is really about. I went vertical and horizontal, finding where the form of the piece, the vertical cylinder, started to move into a dome, which is very indeterminate, ambiguously catching the place.

The juncture where horizontal and vertical meet is a means of locating oneself on the earth, a concept basic to any culture that is calculating a fixed position in terms of ground and space. Whether using complex instruments or a thumb in the air, people consider the place where the vertical crosses the horizontal, where perpendiculars meet, as a way to mark a point.

Once Turner established this position on these pots, he used it as a way to locate other things, making visible the idea of a responsive action. *I slashed, and then pushed in. Then I pushed in further. I think it is presenting the clay with an action or motion that permits the clay to express itself in response to that action or motion. When you look across the valley, there is a crevice with shadows that is out of the rain. That's where something happens because animals go there, or people. All things are invited. It has inevitable possibilities. Any one thing affects what was there before it came. These things came out in 1980 from my trip to Africa in 1972.*

With these pots, the issue of locating one's place on the globe isn't solely a matter of orientation, it's also the place where one is and perhaps where one belongs, if only at that moment.

The *Globe* and *Dome* pots are usually red, that earthy red of the desert Southwest. The black wouldn't work, because it absorbs too much light and rarely creates shadows. The white-glazed pieces have much less going on than Turner wanted on the surface of these works. Dark flecks and charred flashings occur in the red glaze, as the result of accidents of the kiln, though some aspects of the flecking and charring might not be so accidental. Turner, from instinct and observation, knows where to place a piece in his kiln to ensure that some of this will occur during firing. *Accident is part of an inevitable possibility being presented. The danger is whether you will have decoration. I have a horror of just plain decoration. I hope what works here is fundamentally a wrapping.*

The dark spots add shadows to the pots, making a visual recession, a variation on the recession caused by a physical action such as a caved-in side, and a way Turner can unite figure and ground. Since Turner's paint is glaze, a material that on firing becomes intrinsic with the surface to which it is applied, the glaze becomes a breathable skin, not decoration on the surface. The glaze spots, both painterly and sculptural like a mole on an arm or a pitted surface on a brick, are one with the pot. It is as though the glaze layer is a geological stratum in the earth.

Throughout the seventies Turner also continued to produce the *Dome* with a square opening, or the *Circle-Square,* adding things he had discovered.

There is something fundamental in the transition of lower volume to upper. In the sweep up, just where the circle gives over to the square defies certainty. So that shape is present yet cannot be captured. . . . I still like the ambiguity. I can't capture the silhouette or volume in terms of dimension. What changes in the volume is where it starts and how it . . . springs up supported by the form. The transition is very organic. I'll make a piece and be dissatisfied and keep altering it until it has that vitality. The word vitality is very important. The Circle-Square is involved in a search for that vitality between the circle and square as they express themselves in a pot. It needs to reflect the softness and sensuous character of clay when it's moving and soft and being formed and forming itself. The way you're pulling and it is making itself square is intriguing. It's forming itself in response to what I do.

Turner gave the name *Prisco* (after his friend and colleague at Alfred, Mario Prisco) to a very large *Circle-Square* that Prisco had bought. Executed in 1970, this variation is characterized by the movement of drawings inside and of indentations making slight changes on the exterior, like mysterious evidence of habitation. There is also active linear exploration of the area where the lower and upper walls meet, a cliff edge where forms change. The bottom chamber is roundish verging on square, the top chamber very square. Turner did several of this type, intrigued by their larger size and the bottom chamber's shape, how it started as a circle and slowly began to change.

While the vessel sculptures preoccupied Turner during the seventies, he did continue to do some functional pottery: *I was doing functional work to use what I had done in the vessels, advancing the casseroles to include what I saw of nature.* The casseroles, in particular, were still compelling as a kind of disciplined geometry. The bottom of the newest version was a two-cone form. The lower cone was more fluid, with a smaller bottom that moved out to connect with the top cone. It was about ten inches wide by two inches tall, broad and wide, larger at the rim than at the base. The cover, a cone also, was larger than the base. Hence the three cones gradually advanced in size from bottom to top. Turner incised some lines in them, to emphasize the geometry. He held the casserole sideways from the inside, and poured glaze, blue over a tawny base, over the handle and pot so the glaze flowed downward like a waterfall. When it was upright, the waterfall was horizontal, a watery horizon line.

THE SOUTHWEST AND NATIVE AMERICAN INFLUENCE

The Turners' regular summer visits to the Southwest continued throughout this period. By the end of the 1970s his connection to Native American cultures and its landscape became as consequential to his work as that of Africa. In 1973 the couple visited the pueblos of Acoma and Taos, as well as places that had been inhabited by ancient people in prehistory, including Canyon de Chelly. Acoma, which is said to be the oldest continuously inhabited place in the Americas, sits high on a mesa and seems defined by its relationship to the sky. The canyons offered examples of ancient geology as well as habitation by humans and animals. Canyon de Chelly, for example, is both giant and intimate in a strange way. The canyon walls are huge, with a nearly sheer vertical drop that meets the floor or horizontal plane dramatically. *Down in the canyon, walking across the floor with water flowing, plants growing, and a few people living there, there is an intimacy. Herds of goats and Navajo dwellings dot trails in the walls that were created by streams gouging them over the*

years. When you touch the rock, the walls have very soft curves like curves in the body, and then there are sudden cuts, the result of events that occurred.

Other canyons like Hovenweep, where rock formations were used by the Native Americans as habitations, and Chaco Canyon, which is not as deep as Canyon de Chelly, were impressive. Structures were built here using the formations of the earth and rock, significant structures like pueblo-type buildings and ceremonial structures and secret places for religious ceremonies. They are beautiful containers of space.

In 1978 the Turners bought a house in Santa Fe, because they visited the area frequently, but even more because they happened on the home and loved it. It is an adobe, made of the earth, in the old section of town. The living room is round inside, with round walls and a squared roof, like the inside of a *Circle-Square* pot. It is small: a living room, kitchen, tiny studio, and bedroom. The furnishings are more rustic and colorful than they were in Alfred, but still modest.

Sue Turner used oriental rugs in Alfred, and some Native American ones in Santa Fe. "I'm nuts about textiles," she says. "None is a family rug. We've worn them out. I started buying in the fifties. Bob doesn't object to them. The Navajo ones are the most exciting because they belong where they are and we are. When you get them on site, there is something wonderful."

A sheer cliff wall at the Canyon de Chelly National Monument in Chinle, Arizona, 1973.

She often explains their furnishings with such phrases as, "This chair was Mother Turner's from Monroe Place," or "Remember when we bought this rug in Greece?" The objects, whatever they are, carry associations and histories that are retold. The couple remains very aware of their personal and familial past.

The thick walls of the Santa Fe home keep the rooms cool. Open windows catch the breezes. The Turners live much more out-of-doors here, in the bright light and open air. The studio is just big enough to permit throwing a pot and drying it. The kiln is outside. Turner tacks all manner of things on the walls—a postcard of a Navajo blanket, invitations for exhibitions, scientific and archaeological information—anything that interests him enough to want to look at it awhile. Some clippings have yellowed with age.

For years the couple drove back and forth between Santa Fe and Alfred, spending winter and summers in Alfred, a bit of spring and fall in Santa Fe. The contrast between the two places, they both said, was good for them. "Santa Fe is enlivening," said Sue Turner in 1996. "Home is Alfred."

I make a few pots here, but I never really figured out how to work here.

It's a strange mixture. I do love all this stuff, the landscape and the rock garden and going out into the pueblos. It's a polar difference from the East Coast greenery, the Alfred snugness and the small hills. We often drive out, three days each way. You get into snow a few hours from here, from the expanse of dryness. It looks different. It smells different.

The sky in Alfred is more intimate. You're among hills that give it definition. You're

encompassed. When snow is on the ground in Alfred, it emphasizes the geometric lines of rocks and trees in rows. The sky varies in colors that are all part of the landscape. In the West it is a tremendous expanse of sky. It smells different, because everything is freer. The air doesn't reflect the sense of fog and other things.

The couple has spent much of their time familiarizing themselves with the place and slowly coming to know the Native American people and their ways, never imposing, always waiting, listening, observing. The Turners felt close to Maria Martinez, the seminal Navajo potter credited with reviving the Native American pottery tradition in the Southwest. Her pueblo, San Ildefonso, was not far from their home. Turner has great respect for the way she gave herself to her people, because she believed it was her responsibility.

Driving to her village one passed a holy place, the Black Mesa, an unusual black rock formation in the middle of scrub and desert. It stands alone in a huge expanse of flat land, a wide circle that slopes dramatically up, ending with another smaller circular plane. It is distinctively different from regular mountain formations, this majestic plateau with its face raised to the sun. A few animals climb its craggy sides and the birds swoop in to rest, pointing their beaks toward the huge, open sky.

Turner researched this mesa and others in geological, archaeological, and scientific literature. He also studied the related history and rituals in the Native American tradition. Over the years the couple learned where and when certain ceremonies would take place. If allowed, they witnessed and participated in them.

I think I start out with a very sympathetic approach. If it's important to them, it's important to me, so I can find out about it. I know that they know things I don't that are important. At the Santo Domingo Pueblo, something happens when you stay there even to watch dance for hours. You feel it. It's an internal focus that comes out in dance. You use that focus. You build that focus. It's hard work. People who live there go up on the roofs to watch. They accept and welcome tourists who, in a sense, want to become a part of it. If you're quiet and observant you can begin to feel part of it. Taos is a different ceremony and different language.

Turner likes to tell the stories of their rituals. He explains the "Deer Dance": *On the same evening each January in firelight, the deer and other animals show up for the ceremonial dance before returning to the hills. In the morning, as the sun strikes a spot on the far western mountain, a caller lights a fire to call the deer down from the hills for the dance, a ceremony in thanks for giving their life to be your food.*

The Turners visited some old, now abandoned, Native American compounds in the nearby mountains, spending days exploring. Homes cut into the rocks look like miles and miles of rectangular boxes that from a distance seem to emerge in relief from the walls of the canyons. Rectangular slots are cut to form windows. Some façades have fallen away, exposing simple chambers inside. One wonders about the level of civilization the people must have reached with such homogenous living conditions.

The community had five thousand rooms with two thousand people occupying them and a huge stream running through. An outcropping looks like a huge animal. The geometry, you can look in so many directions and see it is different. . . . The spiritual underpinnings of these people are part of their lives. It seems it's the same for me. They are always saying they are of the earth, the way Anglos aren't. It's a sacredness that's always with them that makes me think of native Africans. They feel part of something bigger than they are.

ALFRED UNIVERSITY

In 1966 Bob Turner became a full-time teacher at Alfred. By 1971, William Parry was chairman of the Foundation Program, Val Cushing headed Major Studies, Turner led Graduate Studies, and Ted Randall would serve two more years as chairman of the department; together these four were essentially running the school. Under their direction Alfred became established as the East Coast school for students who wanted to become ceramic artists.

Turner was a respected, well-known, and innovative teacher. He was not interested in developing skills, but rather in art-based intelligence. He would ask students to make something ugly one day, then blindfold them the next and take them outside so they would hone their sensitivities to nature. In critiques, students would often have to wait quite a while to get answers to their questions, as Turner would be contemplating all the ramifications.

Sue Turner said, "They called him Rocket Bob. I never knew exactly what it meant. His slowness in response to questions?"

According to Val Cushing, Turner's "way of responding is not just correct, it is metaphorical. So you get an answer, but must think. He may answer a question with a question. It is a peaceful way of responding. He has a lovely sense of humor. There are always smiles. The way he teaches is very laid back. He never tells people what to do. He is on the side of making this an experience for the student where they have to solve things. It's a more complex way of teaching."[52]

Wayne Higby, who was also close to Turner-the-professor, recalled: "Bob kept things moving along. He's not a person who suffers fools. But he's very tolerant. He can be firm, but never feels the need to be right. He knew when he was right. He talks around ideas. His style is more oblique, which relates to his work. He is trying to find the blue note. It's a bit like visiting the Delphi Oracle, going to visit Bob."[53]

I always liked to get involved with [the students] and know what they were doing. I gave them a lot of space, differently from Wayne who is very provocative and very certain about things.

Bill Parry identified strong connections between the way Turner taught and his personal character: "I happened to see him with a group of students outside Harder Hall. They had paper bags and were to close their eyes and put their fingers in and experience the form, to realize it in some other way than by vision. He is not a critical person, but he has critical mechanisms. He would talk to students and they'd be mystified. He is more interested in the idea, not in the reading of it and telling you what he thinks. It is indirect, but no less [penetrating]. The students want to know about him still."[54]

Turner didn't discuss his own work in class, preferring to show what was important to him through the art of others. *I'd talk about other people's work and early Native American work, beautiful, simple bowls, with black marks or checks moving across the pot.*

As a result of the faculty's stewardship, Alfred's identity moved with the times. Alfred is still known for its interdisciplinary program and excellence in teaching ceramic artists. *We were accepting more and more students who were into art, sculpture, and painting in the graduate school in particular, and they were having a tremendously opening effect. A great group of students came in 1974–76–78, bringing inquisitive ideas and skills and the ability to see.*

Turner characteristically can only remember a few students, mentioning George Johnson and John Gill, with his cubist-oriented pottery. What is certain is that the students were fully versed in

all aspects of fine art and craft, unafraid of taking chances and developing independent styles. Asked whether he had an influence in his teaching at Alfred, Turner responds Turneresquely: *I hear so. I feel close to students. I guess they remembered my attitude and approach, much more than any words.*

While his slowness was appropriate to his teaching style, his need to build consensus was a problem when Turner was named acting chairman of the division in 1969–70, during a Randall leave-of-absence, and then held the position again in 1974–76 after Cushing resigned to go back to full-time teaching. Sue Turner said her husband tried desperately to avoid taking on the acting chairmanship. At first he told them no. Then he felt it was his turn, his obligation.

"His style of listening and acting and not acting was also his administrative style," recalls Cushing. "Ted Randall was not like that. Faculty meetings changed [with Bob]. They became more like Quaker meetings where they seek a consensus. People talk and keep talking until it is resolved and somehow together they come to a solution."[55]

It usually took an excruciatingly long time for that to happen. Happily, in the spring of 1976, a replacement was finally found for acting chairman Turner. "A letter of intent was sent to Anthony Hepburn at Lanchester Polytechnic in England," wrote Bernstein. "He would assume his duties on 1 September 1976."[56] Turner put it this way: *I asked Tony, 'Would you like to be head of our division?' And he said, 'Yup.'*

Hepburn was a conceptual ceramic artist and contextualist who was also well known as a theorist, writing a regular column for *Craft Horizons*. When he took over, Turner began assessing where he was going. The years were catching up with him: he was sixty-five. In his spare life-style, the luxury of time was critical. During 1977–79 he taught half time and only worked with first- and second-year graduate students. He wanted the other half of his salary to be available to bring visiting artists to Alfred. As a result, Ruth Duckworth, whose sculptural abstractions took many scales, and Betty Woodman, who invested historical ceramic styles in contemporary pots, spent time on campus and brought another viewpoint to the students' artistic development.

Outside the classroom, faculty members weren't much involved in each other's art. All seemed to relish independence and rarely visited one another's studios. Each had a strong artistic identity: Cushing's nature-based functional forms and Higby's landscape vessels were very different from a Turner pot with its opposing simplicity and complexity. Each became well known for their style and was supportive of the others.

THE *AKAN* AND ITS PROGENY

During the eighteen months that Turner taught part time, he secluded himself in his studio and made another major body of work. His first *Akan* sculpture, a seminal type, appeared in unnamed form in 1976. In 1979 he began exploring the genre in depth and deemed it a type. Named after the people who inhabit the Ashanti area, the *Akan* is basically formed of a cone on the bottom with a cylinder on top. There are three variations, *Akan*, *Ife*, and *Oshogbo*, titled for villages by the Niger River.

The first of that type, the Akan, *I made in the winter of 1979. . . . The* Oshogbo *and* Ife *I made within a month after. The* Akan *is essentially two parts. I put them together and they remain much as they were before I joined them. They do affect each other in the making. . . . They define each other by their differences, whether one springs or sets on the other.*

The cylinder is narrow and much taller than wide. It sits as a chimney on the cone below. Having established that relationship, I used two parallel clay bars having a dimensional thickness, as something from another place that could join the separate cone and cylinder, literally and physically in a taut relationship. They join that lower form and go to the upper form. The bars define that pot, that sculpture, by the way they sit and move up.

While the vessels are constructed of two geometric shapes, these shapes are not of Greek regularity, but are off-center enough to seem animated by something, whether it be the wind or some animistic force. The walls swell and recede. Marks in the surface range from those one sees in nature to human signs. Turner thinks of them as canyon walls.

The bars Turner speaks of are cut by hand into uneven rectangles. They vary in size. On the earlier *Akans*, these bars are usually gutsy, thick, and long. On the first *Akan*, two of these thick bars reach the rim. One is draped over and, like a waterfall, flows in. On another early pot, the bars are placed vertically to bridge the two basic shapes, like those African mends. These seem to slither on the pot moving upward, like ritual snakes. On yet another, the bars lift off the surface unattached for a bit and jut out from the cone and cylinder. They recall an animal's tail seen around a corner or a bird, seen with space behind it, perched on a canyon niche. Some of the bars are narrow, maybe one-quarter inch wide by one inch long. These have a delicacy and are attached to the vessel walls at an angle, gracefully joining one part of the pot to the next, like a dancing line.

The bars also act as markers, providing a way for the viewer to imagine distance, scale, and proportion as the mind's eye shifts from seeing the vessels as pots to landscapes. The bars are another element, countering with their expressive placement the geometry of the cone and cylinder. They add the motion of natural forces like gravity and the postures of living organisms.

The *Akans* are glazed blue-black, the denseness of which gives the pots a depth and intensity. The rim of the cylinder is usually sliced but not cleanly, so textures and fissures mar the edge, giving it a more natural feel. *The top is where you walk around. Little bits and pieces have fallen there.*

[The Akan*] has a lot to do with being in high places and looking down.*

They started out as storage jars. The inevitable possibility was to have something sitting in between two cylinders. I had been making pieces closer in dimension of one piece on top of the other. For some reason I moved on.

I've done more since the first ones, and there is a much greater sense of fluidity. I'm using softer clay and [am] letting them adjust one to the other more and more. There are alterations in . . . the width. They take on a greater sense of the environment.

I like them. There is a tautness and strictness about them.

The *Ife* pots, which clearly evolved out of these *Akans*, are made of a similar cone-cylinder-bar body, but something new is added at the rim of the pot. First the rim is squared off, and then two clay rectangles are attached to the rim on opposite sides, extending the cylinder. The rectangles partially enclose the space so the opening becomes more like a slot, narrowed. Rather than cutting or shaping the top of the vessel to make an opening in the thrown forms, Turner modeled these assembled pieces. This new way of making an opening allowed him to extend the pot into space, treating the top as a plateau where something could occur. Across the rectangular slot Turner placed another shape. A primitive tool or key form, it visually finishes off the curves of the pot with a flat curve, acting in some ways like a stopper and grounding the pot.

The Ife [is made of] a tall cylinder. You look down into a deep, deep space, without seeing the bottom. Walking around the canyons, there are places where you can look up and down. I did that in the pot. I cut [one piece] off the wheel and hand-pushed it through [the opening] and looked down, and the light was coming through. That is close to what happens in the canyon. Something made an opening or something around the corner is open so you see light coming from somewhere that does not explain itself.

These pots are about place, their location being the canyons and the niches in them places where people lived. Dimension and scale as they relate to place are critical, conveying a sense of being there inside this deep hole in the earth.

Another thing. About [this time of the first Ife] Sue and I went abroad with a college group [to] Greece. I remember some old Greek pots. I remember one with this base, which was cylindrical, moving up to a flat roof cover and extending up as two cylindrical shapes, like arms or horns. I was thinking of that extension vertically, that chimney form.

The space between those horns, the negative space, is also a shape, something Turner considered the space between the two rectangular extensions on the *Ife*. Turner creates a sense of direction, up, down, around, that is tied to the earth. It is physical, based on actually moving around the pot. A column shape was attached to the side of an *Ife* and fell off and broke. Turner reattached its segmented form so it followed the contours of the vessel. He saw it as a family of objects because it consisted of parts of a whole. He thought of the pieces as people or animals trying to make their way up the cylinder or canyon wall, adding elements that could be used to tell a little story, an imagined narrative.

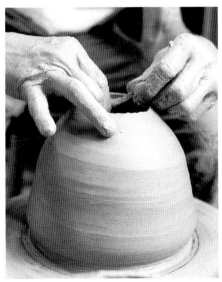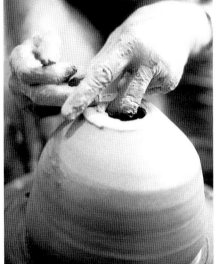

PAGES 115–19: The throwing and assembly process from start to finish, 2002.

The *Ife* has almost a human demeanor, like an African woodcarving. But at the same time the idea of a chimney and a Native American dwelling come forward, intimated by a particular profile or perspective. Such metaphorical associations shift as one sees these pots from above, from straight on or below, from one side or another. On one, the rectangle of applied clay seems like one of those rods supporting and linking the pueblo dwellings. A nub of clay could be a vestigial handle or a rock forming a niche. Turner is a master at making shapes loaded with inferences and allusions.

The Black Ife *[works] reflect the ritual places of Africa. The* Ife *red reflects the red earth of the canyon. I like making indentations and scratching areas and adding bits of clay. These are like a place where you walk along on the desert floor. The* White Ife *was a dead white and then*

I rubbed them so the oil of my hands soaked into edges and got the pieces warm looking there, like the sun was hitting them.

The form implies exploration within it, to find what it's about with its cone and cylinder. It's also a mountainside and then two cliffs that face each other, as partners or in opposition. The air comes through the sides, like you are on a cliff and feel the air on one side and it's cooler and at the same time [you] look down inside to the depth, which has no bottom. It's kind of a chimney and a well. It's a canyon. It's kind of a womb, dark and warmer down there. Gravity is there, joining those two shapes. It tethers them. The Ife *has its own identity, its own being. It has its parts and they work together because it doesn't fall apart. So [the* Ife*] talks about gravity and wind and warmth and parts clinging to sides. It is complex in its parts and very simple after all.*

It is curious that Turner's first *Ife* lay unfinished on the floor in his studio for a while. The artist wasn't sure whether it was right or whether he could take it anywhere. A graduate student, George Johnson, came to visit Turner and pointed to it as interesting. Turner took another long look and began reworking the piece. Sometimes it takes the distance of an outsider to identify and discern things that elude the person more familiar with a work.

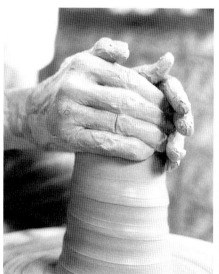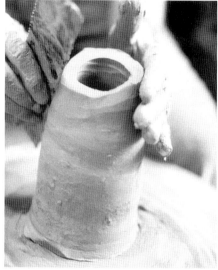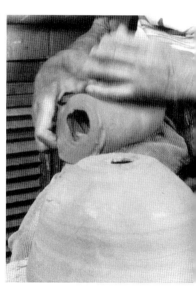

The third type of these *Akan* pots to emerge, *Oshogbo*, has a different structure rising from the rim. It evolved from *Form with Two Prongs*, a pot with two rectangular prongs opposite each other extending up from the opening. Turner made four or five of these in 1970, but discontinued them because he liked the prongs, not the pot.

In the *Oshogbo* the prongs are part of a larger element and are integrated into the cone/cylinder/bar pot of the *Akan* and *Ife*, obviously a form he thought was successful. On top of the two prongs a third horizontal member is balanced, making an open rectangular space below. This gives the familiar vessel form a completely different personality.

The prong construction recalls a rudimentary structure made of posts and lintels. Its location on the top of the *Oshogbo* immediately makes one think of shrines in the mountains of Greece, the kivas of Southwestern pueblos, altars in Africa, prehistoric structures at Stonehenge, or their kin. The pot seems to be about something happening in the open air, up high, a relationship between heaven and earth. The spiritual implications are strong.

The Oshogbo *[type pots] reflect the desert area, with pillars that stand everywhere. Monument Valley has these massive forms that auto companies use in their ads. They stick out [like] chimneys too. Chimney is a way to describe vertical shapes, shapes that resist weather.*

I'm a slow learner. I saw [the pillars] in 1940, but I never thought about that columns-in-desert–chimney connection until these pieces.

The columnar structures are made of rough coils of clay, flattened at the ends to attach the parts together. In various *Oshogbo*, bars of clay wrap around the columns at the base and middle and emerge from inside the pot. The touch of the hand and sense of the handmade permeate these elements; hence there is the strong link to preindustrial cultures. All these pieces are the red color of the desert or sunset or rock.

One thing permits another to happen. One column is up. It permits a horizontal column to wrap around it. It doesn't give security, but gives a sense of joining. I've never been sure of rightness of a form, but the strapping on this work is right.

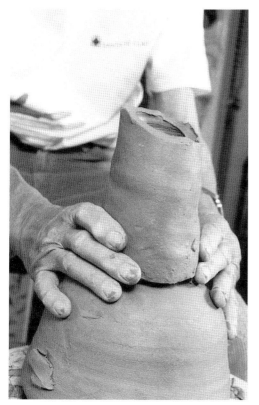

Along with the sense that he was getting somewhere with his pots in the 1970s came a new rhythm of work. When he was a production potter, making functional wares throughout the fifties, the emphasis was on making one pot after another. These new vessels required a cycle. Turner's was about twenty-one days: seven to eight days of making, all kinds of time spent looking at each piece, a week of glazing, and then start again. The period of looking has always been critical. Pieces may sit in the studio for months, with Turner getting to know them. Sometimes he'll take the piece back to his work area immediately, reworking it to get it right. Other pieces he'll just look and look at, until he comes to a decision. The drying table usually has a shelf full of pots in process. Covered in plastic, they stand in wait.

I could throw one in 20–25 minutes, then come back. I'll look at it in the light and, if it is wrong, I'll do something more. I'll start altering it. I'll push it. One-third I put aside and don't think about. They are the ones I kind of like, but I don't have any idea why I'm so close to them. They just sit around and become kind of meaningless, then someone begins to love one by giving it the right light and it begins to look like the reason I kept it.

I make some things and I'm not sure if they may be saved. I put plastic over them to [keep them] damp, so I can work on them again. I come back and see something I've missed. One of the pieces I liked the most in Philadelphia [at the Helen Drutt show in 1996] I had stopped before in absolute disgust. I knew I couldn't finish it. I threw things on and tore them off. I left it and was about to throw it away and that turned out to be one of the pieces I liked the most. It has a gesture. It's defying gravity. And quite a lot of joining goes on as incidentals in its totality. And some opposing things wrap around and there is a hesitation. It was composed in three stages of development upward. The first is the hill, from which the others come. It changes into a square form by the time the interior emerges into the light, with some reinforcement of moving upward and moving around.

Recently, over the last seven or eight years, Turner hasn't felt the need to keep a three-week cycle. *I just finish when I have to, when I can, when the piece is ready.*

He generally comes up with the abstract conception for a piece first, then begins throwing. Because process is so crucial to how he works, Turner rarely draws a specific piece before he makes it. He uses drawing to work through ideas, of what, for instance, a pot wrapped in a strap of disproportionate size might look like and how the draping of the strap would affect things. In a series of little drawings he studied issues of scale, mass, and space, trying to figure out what a massive pot could carry.

In 1980, on Turner's retirement, a retrospective exhibition of his work occurred at Alfred. Higby organized the show that spring in the Fosdick-Nelson Gallery. The curatorial process was rather informal. Turner brought over a lot of pots and the two of them got to work.

I had over one hundred pieces. I laid them out in a long, long line. Wayne went through and took out a piece and said, "That's not what you do," figuring out what I do. One piece that was not what I do was the Form with Two Prongs. *It was closer to China than Africa.*

Wayne was instrumental in organizing the show. It started with my student work and then the ashtray and the large form. It had examples I thought were important. I'm sorry there was no catalogue.

 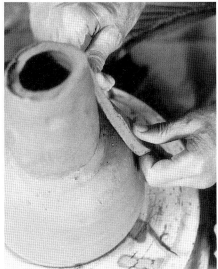 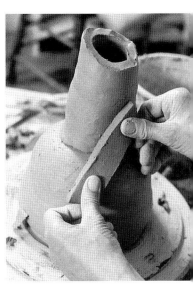

Wayne laid the show out so you could see the threads that go right on through. That's when I realized that little ashtray [with the crab foot] was one of the first works about ambiguity, and I began to understand that Chekhov helped and being very quiet and looking and observing had been there very long too.

It was an important exhibit for the perspective it provided Turner on the development of his mature work. Connections between functional pieces and vessels were clear, identifying Turner's strong, intuitive sense of form. While the mature work was made of altered geometry, both had the thrown form at their core and a slightly oversized scale. Whether reference was being made to canyons or casseroles didn't matter. The early work carried intimations of the later work. The transition between the two appeared to be easy, rather than the difficult and emotional time it actually was.

The retrospective also brought Turner acclaim for his vessels by people he considered discerning. *Helen [Drutt] and Alice [Westphal] saw it and liked the work. Then Alice said, 'Let's start regular exhibitions.' I got a lot of positive response. Ted Randall came through and he said, 'This is not only a good show. This is a great show.'*

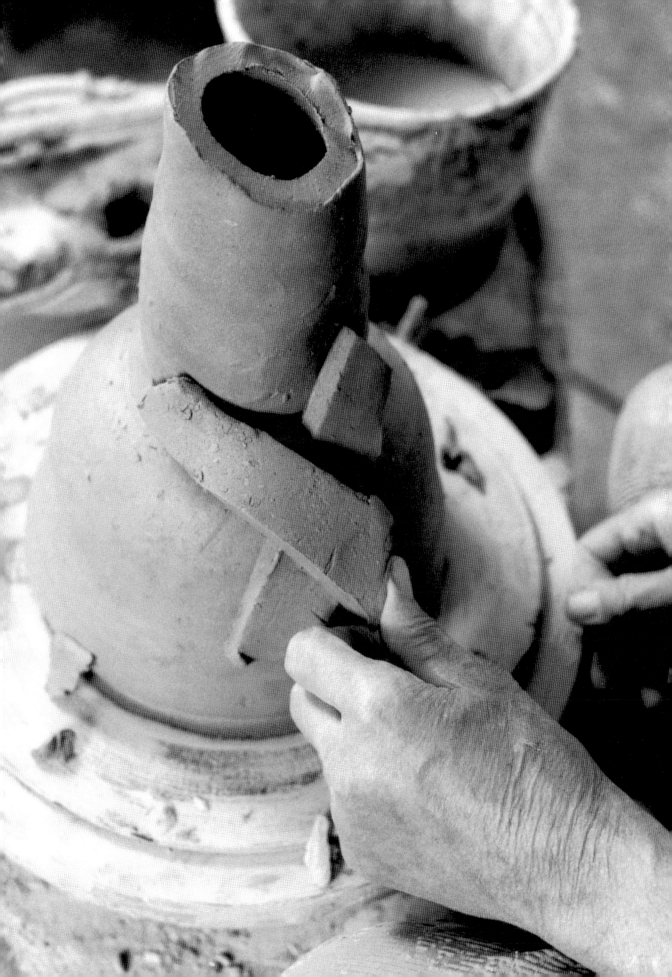

THE ART WORLD AFTER ALFRED

Retirement from teaching at Alfred afforded Bob Turner a few luxuries; he had more time to work, and he could work without interruption. But, as an educator, he still chose to punctuate his years with seasons dedicated to workshops and the fraternal stimulation of ceramicists who gathered at Anderson Ranch outside Aspen, Colorado, and the broader colony of artists who summered together on Maine's Deer Isle at Haystack Mountain School of Crafts, as well as in rural North Carolina at Penland. Through the eighties and nineties and even at age eighty-nine, in 2002, he still taught an occasional workshop.

These three schools were in nonurban locations, places where one could escape from the pressures of normal lives to commune with nature and make art. The opportunity to get to know someone like Turner or Voulkos, to study their working processes, and to speak with them about their ideas, attracted working artists. For a Turner or Wayne Higby the chance to work with peers they normally didn't see, as well as to experience different disciplines, like dance, was enriching. Both Turner and Higby served on the board at Haystack in 1985–86, helping to keep it going. At Anderson Ranch, Turner spent time with Paul Soldner, Ron Nagle, and Ken Price. They mainly socialized, enjoying each other's company, and didn't indulge in many deep discussions of ceramic issues.

Each of the venues brought Turner different challenges. *At Anderson Ranch it's much more the breadth of being in art, while Penland was more crafts-based. At Anderson you were more aware there was a separate focus in photography and painting and sculpture. This was an art center. It produced an awareness of the sense of context. Haystack was somewhere in between. I introduced the same approach of investigation, of trying things out, of making assumptions that whatever you do as a student, you haven't done before.*

Turner had begun participating in workshops during the 1960s to supplement his income and see what was going on in other communities. Certain of these visits ended up having significance for his pots. *When I do workshops or a talk, it's trying to clarify what I'm talking about. Maybe it's making it too linear. I don't go linear. I can't write well, because I'm not linear. I lose my trend or where I am trying to get to because I'm not linear. I did a workshop in Toronto where I forgot my slides. I liked it better without slides. I could refer, not to what the slides were saying, but to what I felt about what I was doing. The group could pass the* Oshogbo *around and feel it as I was talking about the smooth or the gritty or the interruptions, all the things you see in the sculpture, landscape and places. It permitted something to come out that was hidden behind the slides. It's all about connections, seeing connections.*

In 1976, on the tenth anniversary of the first Supermud Conference at which Turner had been embarrassed when his functional pot flopped in front of the other presenters, Voulkos, Don Reitz, and Rudy Autio—the same four—were asked to do a reprise. Turner saw clearly what had happened in his work over the decade.

It was the first time I felt good. I could make shapes I felt really close to. I knew Pete [Voulkos] liked them. I remember those distinctly. They were good people. There were real exchanges, real tests, real expressing in front of people what it was you were trying to do and finding it didn't inhibit. It meant that everything you did counted. If you erased it, that you erased it counted. It had a truthful spontaneity. The danger of that is that you become a megalomaniac.

Turner developed a way of teaching in these situations that threw people off balance. *I'd intro-*

duce people to things they would not have thought about with their hands. It's trying to find another window for people they hadn't been looking out. It has to do with perception.

He sought a mix of students for his classes, some who had very little ceramic education, others who might have finished a graduate program, so that if he had them work together on a piece the results would be more unexpected. He eventually gave up teaching in other venues beyond the three main ones. *I began to be skeptical of some other workshops. They became exercises in: How do you do it? How do you fire that? What glaze do you put on that? None of that is relevant to basic art. You are trying to know by doing, by exposing what you already know, to what you might not know, in front of a lot of people. It's to expose one's person. Everyone who starts with clay, and continues, and uses it, does it a little bit different than someone else. So it's a very personal journey, and people pick things up from it. And people begin to get rid of the 'how tos' after a while.*

While Turner became more selective about teaching after retiring, his exhibition schedule went in the opposite direction. He showed his work regularly in particular galleries and was included in many museum and nonprofit exhibitions. By the end of the 1970s things were generally changing for the better for ceramic artists because museums and galleries were finally taking their work seriously. There was a shift in the way ceramics were being perceived, sold, and accepted in the world outside the studio. The "vessel" aesthetic emphasizing the pot as container of ideas had taken hold. Art dealer Alice Westphal curated a show at the Evanston Art Center in 1977 titled "The Ceramic Vessel as Metaphor," in which Turner, Voulkos, Higby, and Richard DeVore participated. In 1978 Turner became part of Westphal's stable of artists at the Exhibit A Gallery in Chicago. After his retrospective at Alfred in 1980 he also joined the Helen Drutt Gallery in Philadelphia. Showing regularly with the two provided an affirmation for Turner that he was doing something of value.

Alice had the kind of eye of someone who looked and looked and looked and tied it with other things I was doing and made a philosophical statement of what I was about. It was recognition of the importance of the accumulated sense of the thing, that these were important enough for people to spend time with and see what I was trying to put in, after all these years. She had other people I respected like Bohnert, Voulkos, and DeVore. When Alice said, 'I'm returning this one,' it made me think about whether that piece worked.

Helen continues to be very supportive in a different way, loyal and insightful, sensing when I need a show, keeping after museums to exhibit the work, and encouraging them to buy. She is very attentive to a number of people whom she shows, giving her support to their energies. It's a very personal, almost family situation there.

The exhibitions also provided a critical milieu where the work could be discussed, reviewed, and collected. Contemporary ceramics became accepted as a medium for ideas and a new market level was established by such galleries. While prices are hardly what a painting or sculpture of similar quality would command, at least the clay objects were valued for their importance as works of art. Both dealers sold many of the vessels in their shows to major collectors and museums.

Turner has also exhibited in other galleries such as Joanne Rapp in Scottsdale, Okun in St. Louis, Bellas Artes in Santa Fe, and Dorothy Weiss in San Francisco. Revolution: A Gallery Project in Ferndale, Michigan, is currently one of his steady dealers.

A few museums have been significant in building public understanding of Turner's art. In 1978–79 Turner was included by curators Margie Hughto and Garth Clark in the Everson

Museum's groundbreaking exhibition "A Century of Ceramics in the U.S., 1878–1978," a huge survey that traveled to other museums around the country.

Like all anthologies it was very generalized. It was important because it confirmed my existence, what I do. You never really know what you do, until you have shows and maybe one piece sells here and there.

From 1980 to 1985 he had sculptures in group exhibitions at the Renwick Gallery of the Smithsonian Institution in Washington, D.C., the museum at the University of Wisconsin, the Nelson-Atkins Museum in Kansas City, and the Museum of Fine Arts, Boston. The Boston show in 1984 included work by eight ceramic artists that revealed the variety and breath of the contemporary ceramics movement.

A 1984 exhibit at the Milwaukee Art Museum of "Modern Master Ceramics," which included Turner along with Picasso, Miro, and Voulkos, proved interesting. It provided a chance for Turner to see his work alongside that of master artists. Rather than comparing himself, he looked at each artist's success in ceramics. *I am always affected by Picasso's work, the way he can bring something rather strong into anything he tries. His work was quite simple. Miro's work in clay [on the other hand] was tremendously strong because of the surprise combination of sculpture and painterly concerns and something like innocence in the abrupt way he introduces things. I didn't think their work interfered with what I wanted to do. It was an interesting insertion into the possibilities of clay.*

After his Alfred University retrospective, Turner was the subject of a second one-person retrospective museum exhibition organized by Gerald Nordland at the Milwaukee Art Museum in 1985. Nordland was a recognized scholar who had done other major exhibitions, which brought an increased significance to this show of ceramic art. Forty-two pieces were included, from a covered baking dish of 1956 to an early *Dome*, *Circle-Square*, *Beach*, *Ashanti*, *Akan*, *Ife*, and *Oshogbo* types; the survey concluded with *Canyon de Chelly* pieces that had been completed the previous year.

The main essay in the catalogue, by University of Wisconsin philosopher Kenneth Westphal, explained the work more in descriptive and scientific terms than in art historical contexts. Nordland's chronology at the end of the catalogue is revealing. He isolated key experiences, feelings, and ideas, establishing turning points and setting up some connections between the artist's life and his art. The show traveled to the Carnegie Institute, the University Art Collections of Arizona State University, and the Krannert Art Museum of the University of Illinois.

NEW WORK OF THE 1980s AND 1990s

Bob Turner turned seventy years old in 1983, but age did nothing to slow his creativity. The generative ferment of the late 1960s and seventies continued into his work of the 1980s and nineties. Seven new pot types appeared.

The first *Canyon de Chelly* pot, begun in 1982, was finished in 1983. Related to the *Akan* sculptures with its two distinct parts, the *de Chelly* was built of a lower cone or dome form and a tall upper cylinder/chimney. This type ranges from eight inches to about eighteen inches in height. Because the two parts are almost the same size, the proportions are different from those of the *Akans*. The new proportions allowed Turner to suggest different scales.

The name evokes Turner's associations with the canyon, not a desire to represent physical likeness, though the sheerness of the way the walls meet the bottom recalls the place. He uses the canyon as an icon of ancient places that demonstrate geological time and preserve, even if cryptically, human habitation.

In 1966 when I traveled to Canyon de Chelly the first time, I was utterly amazed at the monumentality of the place and the way in which human beings used it as an environment, keeping goats and sheep safe on the canyon floor, moving up, using hand holes in the cliffs, finding they could climb to a height where they might live. The rock formations that they used and niches they found in the rocks formed their cliff dwellings. The dimension and geology and human habitation [is in the pots]. Geology is not just history. The people who come along and make life inside history are dependent on natural earth, the rock, sky, water. It's that interaction of elements. . . . The canyon was a cut form, cut long ago by the river with all stages of development. Time and place: little events took place because that is where they could occur.

There are splits in some pots. These really twirl.

I did them into the late eighties. They had different dimensions, like I was manipulating tiny or larger canyons. They do suggest some scale and size by the way things happen on the pot and in these spaces. It is in the metaphor of color dripping down and staining the rocks.

The *de Chelly* have surfaces sandblasted to a burnished finish, as in the *Beach* and *Shore* types. The rims are cut smoothly with a few little bobbles, so that they seem to be an edge worn clean. Interruptions in the walls are minimal; hence when changes occur, they seem stronger and more disturbing. Often shifts imply a rupture. A large tear at the rim or fold of clay in the bottom cone seems to be the result of a major movement in that place. Turner doesn't apply a strap or mend to the surface, but rather uses the clay of the pot itself, which he stretches or pulls in place, to bring the torn sections back together. Hence the fissures and cuts seem to be self-healing, like the earth after a rupture. But the scars are always visible.

Turner calls this *visible evidence of a change in time. Something one time was not there at all. The wall carved by water. The wall was determined by the material moving next to it. It could have been shaggy smooth or serrated rough. As the iron manganese comes down the wall it describes a visual effect, a movement inside me. I don't know where it will come out. Those things are moving oneself and therefore one's work.*

The *de Chelly* pieces reveal a way Turner relays time and, in turn, timelessness. The immediacy of time elapsing, of change, is depicted by these actions of something rupturing, something flowing, some transformation being imminent. Geological time is recalled by a shape similar to a rock formation or a canyon eons in the making or the color red of the desert earth, a geologic material. *I call this type* de Chelly *from the effect of the canyon on me. It comes from the color and the gravity, looking up and then down. From the base the way things meet and from the top the way water comes down, the way things reflect gravity at different levels. Glaze reflects that. It moves downward. I can make dark places that I see in the canyon where there is a turn or curve, by sandblasting. It has to do with texture and gravelly red. There is not much African in these.*

Most of the *de Chelly* pots are the red of the canyon with an extremely subtle flow of glaze moving from top to bottom, moving naturally with gravity. The glaze runs off the ruptures and is funneled into some areas where it leaves a thicker deposit of color. In some places the pigment turns the black of the magnesium, creating a dark space against the red light, recalling the way shadows

deepen crevices. Turner creates the feeling of how canyons and rock walls look as they change in geological time.

Of a *de Chelly* from 1984/1988 he wrote about the specific incidents and forces that he imagined in the form of the pot: *about gravity, natural events, perhaps violent intrusions that leave the Canyon marked but intact. . . . On valley floor between stream and massive wall, Navajo with their goats and tiny wood post fences.*

Turner also began conflating types. A *Shore* (white *de Chelly*) of 1984 brings the momentary and elementary changes of matter as it is shaped and carried by water into a fusion with a geological formation formed over millennia. An amazing vessel, so hard and yet velvety soft, fresh and yet old, it alludes in its walls to creation over vast ranges of time.

The next year Turner made another kind of coalescence with a black *de Chelly.* The black of the African fires absorbs the light so there are little of the two-dimensional contrasts of the red. This black one is harder, taller, and more forceful than the prior white version. *With the dark I hardly sandblast. I may touch it here or there. . . . Sometimes I hit a certain part; it will bring out the way I see reflection.*

At the join of the cone and cylinder in this black *de Chelly*, a podlike form seems to have broken through and then grown. Just above, there is a similar shape pushing from the inside out. Is this a mutating form? Is it a cell-form from the water, a big bug carved on the pillar of an African shrine, a sheep climbing the side of a cliff? Or is it a bird that just swooped down from a tree to protect its own space, landing back on its branch, something birds do in the canyons or Africa. Species share purposes whatever their geography. By making cross-cultural references and creating mixed breeds, Turner is developing genetic, biological, social, and physical links that harmonize existence.

After this series of *de Chelly* vessels, the discoveries were less frequent because Turner was working through what he had learned. For a few years he made pots that were variations on types he had already begun. In the early 1980s he did one with a key shape at the top. *I've never done another like that. It's a key form, hammer form that goes back to people who made hammers to alter something else. It sits there and fills the space. The wind blows through here when it is cold. The [place] has a lot to do with air and wind and space.*

Then in 1989 he became involved in a new series he called *Form,* doing five versions. They were not about any particular place or time, but were generally formalist works about their own making. The fluidity with which he composed the vessels belies the complexity of the thinking that went into them.

Form I and *Form II* take an existing type into a hybrid direction, marrying three different orders. *Form I* is a variation of a *Circle-Square*, *Low Square,* and *Ife*, glazed the charcoal or "cinder color," as he had begun calling it. *It emphasizes a breakthrough in the lower bell-like form, a physical breakthrough, with the underbody almost coming through the earth and stone.*

While his description makes the accidental breakthrough sound like it is visible and strong, the juncture of the lower, earthbound form to the square is abrupt and barely smoothed over, the lower form almost seeming to be wrapped in clay like a sheet pulled over a body. Columns from the *Ife*, from the desert, move out from the squared top and rim. But these columns are set horizontally, not vertically, visually pushing the vessel down, holding it to the earth while it wants to rise. The opening is large so you can see inside, where these columns are adhered crudely. Yet they appear tight and controlled from the outside. It is a stout and grounded form.

Turner had long ago learned to heed what appear to be mistakes. Speaking of an earlier *Dome* piece he said: *That little place up on top near the opening, I thought I needed to have a square up there. So I put one there, and it wasn't right. It just looked added. It looked thought out and unconvincing, and I tore it off and that's what it provided me. The tearing is what I needed. So that mistake gave me something. How do you know you need it? It works or it doesn't work.* [57]

Turner only made a few of *Form I*, then went on to *Form II*, which is extremely ambiguous. Composed of a dome with a high squared top and various *Ife* parts, it had a different purpose for Turner. Beneath a globe base sweeping up to the rim an area is made square by slabs of clay adhered to the inside, shaping the outside, and rising above the edge. Turner wanted to see if this thicker wall would resolve something that was troubling him—the feeling that before pieces were just stuck on top.

The top section being a squared form of wide dimensions (rather than the narrow cylinder of the *Ife*) definitely changes the relationship of protrusions at the rim. Because they are more integrated into the wall shape, they seem less pieces put there than pieces that are part of the clay composition. These slabs of clay at the top are held there, balanced, integrated into the pot, but still defying gravity because they couldn't really stay in place on, say, a mountaintop. This raises the question of a conflict between something working formally in a vessel that is not possible in the real world; part of the tenuous, sometimes contradictory relationship Turner makes between a physical manifestation and the idea. The wider opening is not the narrow mountain pass or tribal-like head of the *Ife*. These *Form IIs*, in black or red, are more abstract and heterogeneous, more indefinable than the other *Forms*.

While Turner was contemplating where to take these thoughts in *Form III*, he made *Form IV*, a *High Square*, where the rim has been cut into on opposite sides to form handles. He calls it *Basket*, though the only seeming reference to weaving is the handle made of lengths of extruded clay wrapped around a section of the pot in a random but bracing manner. The title *Basket* suggests a link to utility, a reference that is only one more metaphor, one more connection to the idea of function; but this time the reference is essential. The object is a sign of something lost, referring to the great African and Native American traditions of basketmaking that have been compromised.

The pot has to do with another kind of physicality; the conceptual experience of knowing without holding, the sensuality experienced by the mind's eye. Rather than lifting it by embracing the pot all around, one uses the handles to lift and carry the vessel. This puts the viewer at more of a distance from the pot. A line scored horizontally around the vessel in the area of transition between the middle and top form gives the pot equilibrium, the balancing point of a horizon.

By the time Turner got to *Form III* he understood that these pots were about height and moving upward.

Something moves upward, almost like a cloud on the base's shoulders. It has a great deal to do with gravity. Throwing clay you are moving up, circling with energy. Growth moves upward. It has vertical movement, spiraling upward in opposition to gravity, a little off center. It's getting shaky. It's enclosing space inside.

Form III and *Form V* are similar to each other. Both have a lower cylindrical form that keeps growing, making a tall columnar shape that teeters back and forth, almost shifting direction. The shape doesn't refer to either Africa or the Southwest, but its glaze is the African cinder black. The germination of *Form V* is a typical Turner sequence:

In 1990 I made a piece and set it aside. It never completed itself. I didn't know what it was. I brought it out for some reason and made a cover for it and it didn't need a cover, so I put the piece in the kiln. Some of it fell apart. I patched it together and kept it. I made a slightly larger one and then the largest ones, of which I've made two. This is Form V, *which had things on it, protuberances. I then began to call it* Onitsha.

Onitsha is a place in Nigeria. After I made these I realized I knew where they came from: a slide from 1972 [taken in Onitsha] of an object passed from father to son. It's about horns and rams. The horn has a spiral. The horn is their symbol of the growth of their culture and hence was for their survival. The piece goes up in stages, and in that has the sense of the canyon. I never think of this gesture of reaching up except in the mountains, finding locations in stages. It's the way the Greeks knew how to place their temples for the spiritual. In Priene in Turkey, you climb up to a level on this mountain until it is a kind of leveling off at a height and behind it is a cliff, that continues on up. You have a sense of a raised place that is throne-like. You look out over the valley. You look down and out and around. It's a wonderful spot to put a temple.

Generally, the protuberances on an *Onitsha* sculpture include some familiar shapes and some new ones. The profile of the vessel is irregular with many small ins and outs like a canyon wall or a mud-wasp nest, providing Turner with different perching places, for rocks on edge, resting creatures, and arched structures where the light passes through.

While these vessels are as elemental as the *Beach* and *Shore*, they are harder, rocklike. They don't have that sense of coming into being, but seem geologically ancient, fixed by moving the expressive identity of his material from earth to clay to rock. Turner is portraying an essential geological process.

The consistent cylindrical shape makes the *Onitsha* seem taller than the *Akan*s, for instance, which have wider, more grounded bottoms. The *Onitsha* seem more precarious as a result, like skyscrapers about to bend over near the top.

A column in the desert that moved up and stone that's teetering, the sense of certainty and uncertainty combined. It's just a dance. All these [forms] are about space where canyons are, with movement of air through them. Rocks hang on. It has to do with heights and promontories and cliff forms, behind the created channel of space and wind.

Turner moved from the *Onitsha*, which deal with being tall and up high, to the next series that are about the opposite: huge scale and weight. The *Owerri* were begun in 1994 and examine the behavior of mass, conveying the weightiness of things of the earth. The name refers to a village in Nigeria not far from the Mbari shrine.

Owerri *is a tall piece that's been squashed down. The sense of scale is big, of mass versus mass, different events occurring as masses meet. I was looking this morning at photos of these immense places where different events had occurred, powerfully grinding surfaces, and moving things over long periods of time. Huge slabs of things, ground beneath great masses of rocks, cube forms run down with gray and black shapes of manganese. They don't fit tight against the ground. One edge meets the ground at ground level, another doesn't. It is a very delicate variation in edge. In* Owerri *a major interest was the contest, or incorporation of mass and delicacy. The little shadows emphasize the immense bulk above. There is always the question of how movement in other rocks and water formed them.*

Bob Turner and Bill Parry (**RIGHT**) in Alfred, New York, 1999.

126

The base of the *Owerri* pot is a broad cone but not a deep one. It is only one-fifth of the pot, at most, joined rather quickly to a cylinder that forms the remainder. The cone provides a stable bottom like the broad foot of an elephant, supporting the much greater mass of the cylinder. The balance seems right.

The *Owerri* sculptures are usually black, which increases their visual weight. Their measurements are revealing: there is little difference between height and width. *Owerri II*, for example, is 16 1/4 inches high and 15 1/2 inches wide. Each vessel is almost as wide at the base as it is high, so the proportions emphasize its horizontality. From pot to pot, within a particular type and beyond, Turner rarely repeats exact measurements, but keeps them similar. Balancing and shifting, he is always exploring differences.

Though the *Owerri* is a big pot, the vessel form is not ungainly because of the skillful way Turner's thrown form shifts from the base up. But the attachments to the pot add a sense of lumpishness, of forces at odds, shifting and breaking out of the earth.

A thick, crude, long bar, which Turner calls an arm because of its size, clings around the middle of *Owerri*, making a shape like a raised road built around a mountain, precariously located on the outside. The thick awkwardness of the arm gives it a feeling of a mass that barely hangs on, because of its weight; it is tenuously suspended, the opposite of a stable pot. Turner earlier called such applied shapes "bars." This one he named "arm," because it circles the entire circumference of the pot and embraces it, physically. One feels a passion in that embrace. Maybe that is what keeps the arm attached. This ripped arm is like the tree that grew around the rock. These two contrary forces are going around and weighted down.

With the Owerri, *I can't use my hand. I have to put my arm around it, like having a huge snake arm finding its own way around the form, in its own rhythm. There is something about the scale: It's too big and you can't see where you started when you're ending as it goes around. It's always round space. The scale is much bigger than a person's body. Still, the scale is not that big when you think of the space stations. There are so many dimensions out there [in the universe].*

In the Owerri, *the strap arm is like a canyon's natural formations, like the petroglyphs the Indians make on surfaces. That has an overarching sense of drama and contrast. Mass, nature, man, woman, working with it, bringing their own symbols and the relationship of the symbol to the mass of things, that is important.*

Turner has only done a few *Owerri* pots. His struggle to realize a piece is more clearly visible in this type, because the contrast of pot and arm is such a critical hinge. If the arm is attached too low or too high, if it's too thick or not crude enough, the piece can't work.

Bill Parry remembers being invited by Turner to work with him on one of these sculptures. "Bob was making a work that was bigger than those he was used to making. In his puzzlement he talked about the difficulty in making decisions about an element stuck on the thrown piece. I couldn't appreciate the depth of his uncertainty about it. . . . He is involved in understanding something that is scientific, without being scientific himself."[58]

The inelegantness of this arm indicates Turner's willingness to strike a different kind of balance where precariousness and discomfort are primary. He began attaching these thick chunks of sliced clay to other types too, particularly the new *Ashanti* sculpture he made. Rather than circling the vessel, the applied pieces cling vertically to the lower sides, as odd rectangular slabs that seem vulnerable.

Direction, once again, is significant. The vertical or upright piece has deep ties to human presence. While these slabs have little articulation and don't seem to be metaphors for the human form, one of their primary functions is to carry the intentionality of a human act. They are clinging marks that focus on a moment by implying change—that they might slip off. Tenuous though their visual bond is, the actual bond made in firing is fast. Turner contradicts the harmony of natural forces— weight, mass, and gravity—with the awkwardness of these clinging slabs and by taking them out of context, from different places and times, creates a disturbing beauty. *I'm trying to have different kinds of things meet. Massive strength and the way rocks sit on top and water flows down.*

That he allows this kind of forceful and unresolved tension into the work at this later stage in his life and work suggests release. Turner seems more and more able to relinquish control in his art to instinct, to circumstances, and to the material. While he would say he isn't sure about anything, that maybe it is this or that or just trying something different, that attitude and approach brought him to this point; he is so sensually aware, spiritually deep, and intellectually informed that he doesn't need to be sure. The sculptures seem almost to be leading him.

CONTINUED EVOLUTION

For Bob Turner daily life at the age of eighty-three was not much different than at sixty-three. The house at Alfred Station continued to captivate him. As he looked from the front door up the hill, he began recounting his pleasures:

This is the field I love. There are a bunch of deer out there. We don't kill deer. But I realized the people who did it here were not doing it for sport. They depended on deer as meat.

It is wonderful here in the summer. I've lived in Alfred forty-five years. I never thought much about it. It's not changed much. It still retains a lot of its traditions and people knowing each other. You'll never have malls and things like that.

I love where we live, partly in contrast to Santa Fe. The two places meet to talk about one another, that's true in the pots. Santa Fe is clearer. There are so many different worlds there.

Now I try to split my day in half, half writing letters and doing errands, and half in the shop. It's good, so many things come up I have to do in the mornings. I take the car down into the valley where it isn't sloped. I run a couple of miles in a half hour. I run and then I walk and stretch. I like that kind of isolated thing, being alone, doing something. It's a very good feeling. I put screws on my sneakers for running in the snow.

An accumulation of all the years filled the house. A shelf of pottery that circled the walls of the study displayed work Turner had acquired by trading with students and artists. *In the sixties I made things that were available if faculty wanted them or students or friends. A collector from Toronto would come down in the sixties and say, 'Can you make me this thing for flowers or for the table?' He died fifteen years ago and had arranged for me to get his collection. I donated it to Alfred.*

Other shelves had work Turner collected from the pueblos, and from Japan and Korea. Knowing these objects were present was all he needed from them. Rugs, paintings, and photographs by artists whom the Turners have known covered the walls of the living room, dining room, and den. Though their children are adults, their bedrooms remained much as they always had been. The family has grown: the Turners have six grandchildren. Neither children nor grandchildren live in the area any

The Turner family in Alfred, 1995. **FROM TOP LEFT**: Rosalind and her husband Howard Zuses, Rob and his wife Karen Turner, John and his wife Brier Turner. **SEATED, SECOND ROW:** Benjamin Zuses; John Thomas Turner, son of John and Brier; Sue Turner; Robert Turner; Rachel Zuses; Elizabeth Zuses. **SEATED ON THE LAWN:** Brier Turner, daughter of John and Brier; Joseph Turner, son of Rob and Karen.

longer, but in their reciprocal descriptions of each other, the manner of their closeness, is apparent.

John has a woodworking shop where he builds cabinets; he remodels kitchens, loves to cook. Rob is into archaeology and works as an artist in Santa Fe; he illustrated the Oxford Edition of Dante's Divine Comedy. He's very sensitive, very psychic. Rosalind makes cakes, has a new graduate degree in psychology, and is socially concerned. All three families are congenial and well loved.

Rob Turner has also become the family's curator of his father's pottery. "I have his pots all around my place. I like watching him work and then having them [the pots] around. I like carrying them around and remembering what he taught me of the evanescence of relationships. You have to be with people and with pots and touch and feel and sometimes they get hurt like the rest of us. It all seems positive and sacred, the hurt and not hurt. There is this constant embrace of life."[59]

Social activism is a family tradition in which the elder Turner continued to participate. But most of his time was spent in his studio. He had enlarged it and had more space than ever to work. "I remember Bob's studio when it was one small part of what it is right now," explained Val Cushing, an admirer of Turner's parsimony. "He got enough money to enlarge it and used a local contractor. That happened only a few years ago. For the previous thirty-five years he worked in a space many might find inadequate or handicapping."[60]

The added area, with views out into the landscape, allowed Turner more working space and a storage room/gallery for his art. The large room contained an assortment of pieces Turner had saved. Rarely were they the best of a particular style or period, just the ones he didn't sell. Hardly prolific, he only made between twelve and eighteen of the vessel sculptures a year.

But he could look through the deep shelves crammed with dusty pieces and study the chronology of his art. That first lute-shaped bowl was there, and the ashtray with a crab foot. Some of those sublime double-cylinder casseroles seemed even more classically controlled, in retrospect. And the prescience of the first caved-in dome piece became obvious, seeing it so many years later. Vessels Turner was studying stood together on a large wooden table in the middle, ones that were obviously successful with a new one he needed to absorb.

In February 1994, the most recent of his pot types was introduced in an exhibition at Revolution: A Gallery Project in Ferndale, Michigan. Called *Jar (with Stone)* or *Jar (with Lid)*, it seemed radical for Turner at first. The pot has an *Ashanti* bottom, but the cover is different, flat rather than conical. The handle consists of two ribs of clay attached all the way from one edge of the cover to another, crisscrossing at the middle and bisecting the circular form.

Turner found a stone that he positioned on the cover. A worn stone, a river stone, he says he just picked it up somewhere. A found object and natural form, it doesn't seem out of place, more a curiosity, until one moves to the conceptual level. Thinking of it as a boulder on top of the Black Mesa or as a rock in a Japanese garden begins to explain it.

The arching arms over that space make it like a plaza. I found the stone. I liked the color and texture, and it just seemed invited into that space. The handle allowed space, space through which you could enter the piece. There was no point, but this was space formed by the lid that was a platform for activity.

It [the lid space] reminds me of de Chirico because of his big spaces and the sense of empti-

ness: that you could walk around there and look at the towering columns and walk within the mass of clay. The flat platform refers to the horizontality of where we live and where we work. The arching reminds me of things immemorial. It's a joined thing, as well as one of those things with continuous movement. The stone was almost like an egg. To lift the lid, one had to remove and hold the stone, the act of holding a direct connection between pot, person, and place.

Turner made a few more of these jars, but left off the stones. Drawing on the side of one jar, he outlined an image that had the sense of stones piling up to the point where they defied gravity. The drawing began at a big depression in the clay body made from the outside. The conceptual pile of stones, located at a point where the wall is actually collapsed, could be seen as an action and reaction of two improbable forces or as a thought about what happens from the pressure of the weight of the stones on a canyon wall. It is an invitation to meditate on these natural relationships.

While Turner continued to make new work that is part of existing series, the beginnings of another pot type stayed moist under a plastic cover in his studio. Though he has been working on these new sculptures since 1996, the vessels remain unresolved.

I have done several over the last couple years. I've started them and then put them away and keep coming back to them. It's like someone having hiccups that won't stop.

I have ideas about thrown pieces that either come off the table or ground at slight angles: a series of three or four cylinders at odd angles, looking like they might fall over if you move them around. It's as though they're circling around you with the top cylinder, and there is a flat side hiding the interiors. It is something that has twisting growth. They are similar to falling upwards, and it has to do with dance.

Rather than the applied forms creating the tension, the forms that make up the vessel itself would carry a dissonance by their position, alignment, and movement in relation one to the next, "falling upward." Over and over Turner balances the physical baseness of clay with the physically implausible, in a way making manifest the spiritual.

Usually my work is setting up conflicts and resolving them, finding ways of things meeting, oppositions and connections. I think the excitement in art spills into expectations of positive openings in human relationships. That attitude is critical to a Quaker, opening up where things are, where things work and that things can be resolved.

OLD AGE

The Turners had achieved an idyllic life-style in Alfred, which they still enjoyed after his retirement, but by October 1998, they felt it was time to make changes. The Alfred house was sold in order to buy a simple cottage in a Quaker retirement community in Maryland, closer to their daughter Rosalind and Sue Turner's sisters. While they were both still in good health, the recurrent problems of older age made the isolation of Alfred difficult. By June of 1999, they had moved to Sandy Spring, Maryland. The boys retained part of the Alfred property, where John Turner hopes to build a small place. The old kiln stayed. Much of the art, both Turner's pots and those he collected, was given to friends and colleagues.

The Turners did this for each other, as they have so much else during their years together. They were preparing for the uncertainties of the future. "There's a lot more you need to let up on, at least a little, when you're into your eighties," said Sue Turner.

Rob Turner looked back at his father's working life and assessed it: "He was able to construct a kingdom that allowed for his strengths to be productive. He could be ambitious without being brutal. He has the capacity to dream around the sides of something so you get the three-dimensional and four-dimensional sense of what's going on, instead of taking things on face value. He has had this right for a long time."[61]

Leaving Alfred and settling into Sandy Spring took a long time for the Turners, over a year of unpacking and adjustments. The new place is small, but Turner set up a studio in his garage and bought a new kiln which he shares with students at the Quaker school near the house. Their life is very busy: Quaker meetings, doctors appointments, exhibition openings, all manner of activities seemed to keep Turner from making pots. In the summer of 2002, this was still the case. Turner says he'll get back to his ceramics when he has more time. He talked of ideas, lots of them yet to be explored, but also discussed the last pots he had made before he moved in 1998. They weren't given any specific titles, just a continuation of the hybrid *Form* series. Sort of *Akan*, mixed with *Shore*, pieces mixed with the bottoms of *Circle-Square*, these hybrids are emergent forms, like the bulge that the elbow of a baby still in the womb might create on its mother's stomach. The white glaze in this context seems pure, like the white of the skin before sun, smoke, and age change it. While the ring marks from the wheel may peak out from under the glaze, for the most part the pieces seemed to have happened, not to have been thrown. The junctures where forms were combined flow without any evidence of the act of physical connection. It is as though the parts grew together, as a flower on a stem. Remarkable for their naturalness, for the surprising sense that there was no human intervention in the making of these vessels, these are perhaps Turner's last pots. They encompass all that is necessary.

ACHIEVING WHOLENESS

While rhetoric can get in the way of simply sensing what Bob Turner has achieved with his ceramics, a central question remains to be discussed. Has Bob Turner given wholeness to this cosmos of pieces he has brought together? In the end, this is crucial to knowing what he has wrought.

Wholeness doesn't mean omitting inconsistencies, incompleteness, and random confluences. As Turner shows us over and over, it is precisely such occurrences where, for example, the color of the African fire burns over the membrane of an amoebic form, that a correspondence—of form and surface, form and content, form and experience—emerges. Through the conflation of these scattered elements, he connects the endless line of creation.

The classical and Renaissance belief in harmony, order, and balance between all the parts is an antecedent. But so is the mannerist, baroque, and expressionist faith in emotion, disorder, and instability. And so are certain core values of the traditional Chinese, Japanese, African, and Native American aesthetics. Yet culture is not the sole source. Scientific observations inform Turner's artistic decisions, as do the spiritual and political. While the vessels are discrete wholes, much that is uncontrolled, that is up to the fates, the spirits, is always present.

One thing Turner uses to bring these variables together is the force of the wheel, its centering motion that is ever present, even in pieces made of separate parts. This physical motion, rather than the intellectual act, is primary. The natural origins of his materials, the observations of pre-conscious occurrences in nature and nature's relationship with human beings, are also near the center,

but after the felt experience of the wheel's pull. Man and his technology are controlling and shaping. His use of chance allows nature its power and place.

Aesthetic decisions are crucial. That there are many fronts and backs to a Turner vessel means the pot must be perceived in the round to be known. That the inside and outside are sensed, whether or not they can be completely seen, and are of a unified piece, is completing. Plane and line, as well as intrinsic and applied color, are among the painterly concerns he explores. Sculpture and pottery parameters are also seamlessly integrated into the finished vessel. The pots are usually of a size that a person can put arms around, to physically embrace this constellation of ideas. The vessel tradition is the structure within which he works, and so reference to the container is seminal.

Judgments about the relative importance of one medium versus another, or one idea or one artist, are not a part of his awareness. His work is based in a nonhierarchical discourse grounded in multiplicity. He isn't appropriating other cultures' symbols, nor acting as a cultural imperialist, but is seeking a migration of meaning, a unity, to bring wholeness through his work.

Content comes from everywhere and anything, from the homes in which Turner grew up to his sense of kinship with Native Americans and the feel of the clay. Local color is an abstract sign of place, which may not be the same place as that signified by the title. Color—white, black, or red— is based in nature, how light affects the perception of color. His signs are multivariant to include much disparate information.

The pots begin with the roundness or solidity of the earth as their base and end with an opening to the sky, uniting man and planet: ground, flesh, and space. He makes his vessels whole through his philosophy of inclusion and how he acts upon it. Turner's Quaker belief in the oneness of all things is the soul of his art. *The things that have mattered to me I have integrated. I can look back at a pot and say that's what I was thinking or feeling at that time.*

The art historian Meyer Schapiro explained an artist's need "to make whole," in a number of ways. It is based, he wrote, on "a conception of the world as law-bound in the relation of simple, elementary components, yet open and unbounded and contingent as a whole." [62] Also, ". . . concepts of unity rest on an ideal of perception, which may be compared with a mystic's experience of the oneness of the world or of God, a feeling of the pervasiveness of a single spiritual note or of an absolute consistency of diverse things." [63]

A similar search for wholeness is Turner's hope for all people, but he does not specify a path for this quest. The sculptures simply demonstrate ways to it. In this age of a shrinking planet and expanding universe, his hope hardly appears reactionary, but rather visionary.

In his 1982 essay, "Born Remembering," Turner explained why achieving wholeness was what he was seeking with his art: *Our identity with the universe is as close as I can get to what we're talking about: who we are; what we can discover from exposing our sensibilities, from being vulnerable, from being quiet and letting things speak back to us. It is not identity in its isolated sense, but identity in its joining sense. One hopes that one doesn't miss entirely the natural world and its order. We can get close to wholeness. Philosophers such as Jacob Needleman say that perhaps the wholeness of nature can never be seen by human beings who are not themselves whole. Only through wholeness can we understand. Understanding the natural order isn't the accumulation of facts; it is an understanding derived from thought and feelings together. For me, this is the true inner sense of form.* [64]

And the inner form is the light within that connects us all.

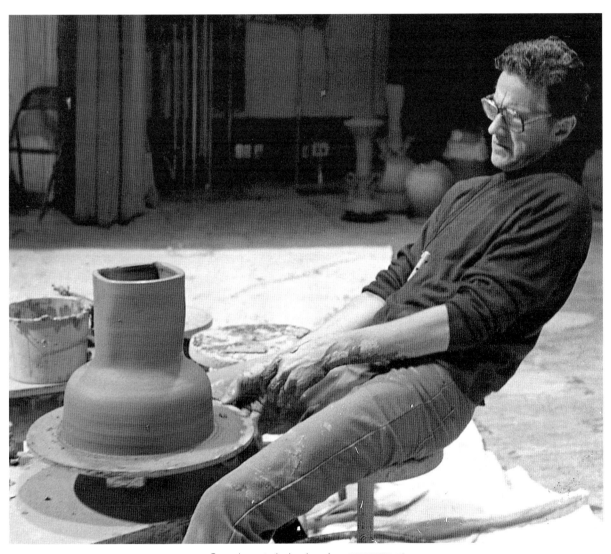

Turner demonstrating how he makes a *CIRCLE-SQUARE* pot
at the second Supermud Conference in 1976.

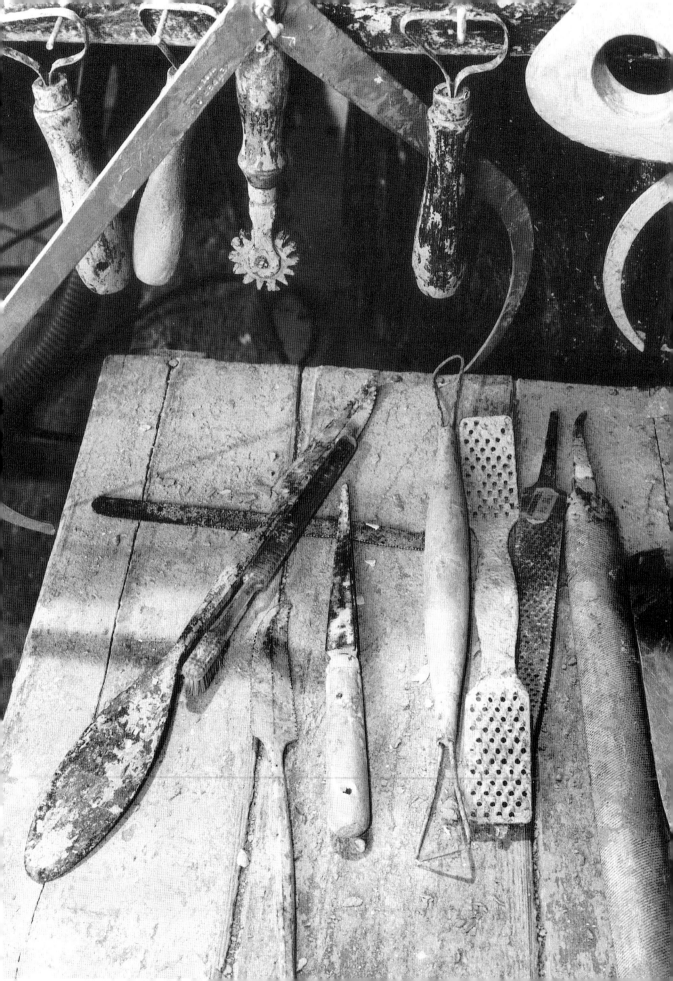

TURNER IN CONTEXT

Tony Hepburn

A winding dirt road leads to Robert Turner's studio, a barn set on a hillside overlooking a valley. Nature dominates. A fragment of a remote house can be seen, but it is the meadows, shrubs, and trees that form the landscape. Though the barn has been altered, one still senses its original function, even after Turner's presence of some forty-six years. Its history over the last four decades parallels that of the pots which have been made there. A massive table stands stoutly by a window with a view of the valley. Turner's freshly thrown pots are grouped, awaiting decisions. On misty days the scene resembles a Morandi painting. Everywhere are traces and clues of thoughts interrupted, of an unspoken need to suspend judgment at a particular moment in time, when to go further would feel rehearsed. Some pots—dried but still unfired—gather dust; perhaps that is their destiny. Another table holds unused strips of clay from the previous day, briefly important but now scattered and forgotten, yet somehow purposeful, like a Twombly drawing.

Some of the more important works of art of this century have been generated at this studio. The fact that Robert Turner makes pots would seem to jeopardize this lofty claim, but a quotation from George Kubler provides a context that supports the assertion:

> Let us suppose that the idea of art can be expanded to embrace the whole range of man-made things, including all tools and writing in addition to the useless, beautiful, and poetic things of the world. By this view of the universe, man-made things simply coincide with the history of art. It then becomes an urgent requirement to devise better ways of considering everything man has made. . . . We are discovering, little by little, all over again, that what a thing means is not more important than what it is . . . that to neglect either meaning or being, either essence or existence, deforms our comprehension of both.[1]

Among the many reasons why little is known about Turner is the fact that his work defies easy clarification, even when viewed or discussed in detail—and therein lives its power. I would contend that the very difficulty of being definitive about the work has caused many to balk at putting pen to paper. The work certainly lays no claim to modernism or post-modernism. It does not look "new" and therefore might even be considered "un-American." So, what is its context? To locate the work solely in the field of ceramics would refute Kubler's position and ignore the profound cultural

and spiritual aspects of Turner's work. It would also overlook the visionary scope of the artist's achievement. While making no claim to being definitive, this essay will attempt to provide clues to what makes Turner's life and work important. However, I would further suggest that if one could simply have "faith" in a Turner pot, true rewards would be gained.

NONBEING

Cultures around the world and throughout time have consistently sought to attain the clarity of the centered self, a search embracing such apparently diverse thinking as Buddhism and the deconstructive theories of Jacques Derrida. Turner, too, embarked on his own search for a center.

In a symposium at the Cranbrook Academy of Art, in May 1994, Turner addressed the issue when fielding questions concerning the unconscious and conscious:

> I am doing what we perhaps are all doing—searching, hunting. . . . This search has a deep meaning and significance, and the finding is in the process, not necessarily in the result of it. The more nonbeing a person can take into that process, the more power that is brought in, . . . a power that attains a quality and ties with the universe. . . . Getting rid of ourselves in a way, getting rid of the aggressive, assertive need to find out what it is out there that we are really hunting for, searching for—that is the universal system, and I am trying to move into that.[2]

In her book *Art and Soul: Notes on Creating*, Audrey Flack, in her conversation with the painter Philip Guston, echoes this idea of getting outside the self to a place of nonbeing. The painter says, "When you're in the studio painting, there are a lot of people in there with you. Your teachers, friends, painters from history, critics . . . one by one, if you're really painting, they walk out. And if you're really painting, *you* walk out."[3]

Turner's art and life is a balancing act between the sublime and the pragmatic. His is a perception of life that can focus equally on the "needs" of the evolving pot and on the changing seasons outside the studio window. Many years ago Turner showed me a remark from the poet Stanley Kunitz that reflects his own position on many things: "A badly made work of art falls apart. It only takes a few years for most of the energy to leak out. Anything pretentious is full of lies. . . . One must not strive for too mechanical a perfection. The creative mind is always ready for the operations of chance. It wants to sweep into the constellation of the artwork as much as it can of the loose, floating matters that it encounters."

This desire to encompass influences on a vast open-minded scale may explain why Turner's mature work began relatively late in life; it took that long to grasp the state of nonbeing and to capture it in his work.

ALFRED UNIVERSITY AND BLACK MOUNTAIN COLLEGE

Turner was thirty-three years old when ceramics became an important part of his life. World War II was over, he and his wife Sue were raising two children, and practical questions of survival loomed—monetary, aesthetic, and spiritual survival. Turner had heard of an opening at Alfred University, in Alfred, New York, and considered the possibility of making pots and teaching there. Turner, who had studied painting, found that the process of throwing pots on a pottery wheel was

complete in itself and fully sustained his aesthetic needs. (In an interesting parallel, the young Peter Voulkos, in Montana, rejected painting for almost the same reasons.) Among Turner's teachers at Alfred were Daniel Rhodes and Charles Harder, both avid readers with a philosophical orientation. However, the thrust of the school was toward technical proficiency rather than conceptual development or experimentation. Turner's peers were there for very practical reasons. The discipline required to make a well-made pot was analogous to that required by a man of conscience and firm beliefs. Turner, a Quaker and conscientious objector in World War II, was such a man.

In 1949, Turner was invited to set up a ceramics studio at Black Mountain College in North Carolina. It is unclear why this invitation was extended, given the experimental focus of the school, but possibly it was due to an appreciation of Paul Valéry's paean to ceramics, "On the Pre-eminent Dignity of the Arts by Fire." Valéry wrote,

> Among all the arts, I know none more hazardous, none less certain of the outcome, and consequently more noble, than those which call for the use of fire. . . . Fire, their essential agent, is also their greatest enemy. . . . All the fire workers' admirable vigilance and all the foresight learned from experience . . . still leaves immense scope for the noble element of uncertainty. They can never abolish chance. Risk remains the dominating and, as it were, the sanctifying element of this great art.[4]

If one interest pervaded Black Mountain during Turner's residency, it was an interest in chance. The chance inherent in ceramics, and investigations into chance by other Black Mountain residents (notably, dancer Merce Cunningham and musicians John Cage and David Tudor), generated questions about the nature of improvisation that have been central to Turner's thinking ever since.

In 1951, Turner returned to the Alfred area. He and Sue now had a third child. The Cold War era, with its attendant anxieties, and the proliferation of weapons of mass destruction led Turner to conclude that the isolation of Alfred and Allegany County was, by definition, protective. The countryside had its own beauty—soft green summers that gave way to brutally cold winters. The impressions left by fall colors and the intense gravity of snow would later find an important place in Turner's work. The terrain and climate, which Turner enjoyed, can make life difficult and inhospitable. Over half a century later, Allegany remains one of the nation's poorest counties per capita. Although no quick money could be made there, it captured the essence of survival. This rawness, or primeval quality, attracted Turner to Alfred and, later, to West Africa and to the Southwestern United States.

During Turner's hiatus in North Carolina, the influential British potter Bernard Leach visited Alfred for three weeks, bringing his quasi-oriental philosophies to the department. The significance of the visit was to introduce Charles Harder, then the dean, to the creative possibilities and social value of the individual, isolated potter working quietly in his studio with the products of his labors, which found their way to the tables of society. *The Alfred University Handbook, 1946–47*, outlines a course structure "that applies modern craftsmanship to the old apprenticeship system and present-day production methods. These can be achieved through training in the 'Hand Arts' geared to sound production principles which will offer gainful employment."

In this same year (1951), Turner opened his studio, or "shop" (as he still calls it), next to his house and installed a gas kiln. Gas-fired kilns produce ware of a specific character that falls somewhere between the highly controlled oxidized electric kilns used in Europe and the more ritualized

wood firings of the Far East. Slowly, Turner learned about and came to admire the poetic but precise work of Europeans like Lucie Rie and Hans Coper, but was equally drawn to the austere beauty of Japanese Bizen ware and the apparent freedom of Rosanjin, a restaurateur, bon vivant, and potter. Turner was mining the middle ground, discovering what it meant to make pots in rural America in the middle of the twentieth century. His first pots were functional: casseroles, bowls, and vases. They fulfilled the needs of a people eager to integrate handmade works into their lives, as they were surrounded by mass-produced products and a growing efficiency mantra.

Turner's proximity and aesthetic compatibility with the ceramics program at Alfred University eventually led to a teaching position in 1958, where he taught until his retirement as Professor Emeritus in 1979. During this period, dialogue with faculty and students about the issues inherent in the field of ceramics, in particular, and in art, in general, satisfied his need to question all things and provided an outlet for his generosity of spirit. Teaching fulfilled Turner's desire to share his internal world with the world at large and to recycle that dialogue back into the private workings of his studio.

My firsthand perceptions of Turner as a teacher began when Harder Hall, the new home of the Division of Art and Design of Alfred University, was dedicated in 1973. Its larger open spaces, with few walls or doors, gave ready access to workings, critiques, and demonstrations in the studios. It was here that I observed a unique throwing class of Turner's. Two students worked at a single potter's wheel, throwing the *same* pot, each responding to the other's rhythms. By forcing his students to cope with another's energy and dispense with "the self," Turner hoped to give each student a window onto nonbeing. This highly unusual approach underscored Turner's notion of a greater whole and appealed to his interest in the universal.

Alfred is isolated and remote. It is also permeated by Puritanical roots and is a stronghold of Latter-day Saints, Mennonites, and others. In the winter months there is a positively Dickensian air to the community. Not surprisingly, the Alfred ceramic tradition is equally austere, in spite of having drawn faculty from a variety of regions. Function, simplicity, and stoneware were synonymous with Alfred. Turner's pots in the fifties and sixties reflected this aesthetic until he sought broader and more complex possibilities. His search for the answers required travel beyond the boundaries of Allegany County and eventually led him to West Africa, the Southwest, Greece, and other sites from which he was to later draw inspiration.

"JOINING IN"

There seems to be nothing in which Robert Turner is not interested. Given the range of his curiosity, why would he choose pots as a way of synthesizing an aesthetic response to the world? Other artists go to great lengths to explain the human condition, be it with a wall-length canvas or a two-story sculpture. How can a modest-sized handmade pot thrown from four pounds of clay possibly exist on an equal plane with such works in embodying the mysteries of human existence and the fragility of life? Here it becomes important to state the obvious: pots have been made by hand for twenty-five thousand years. Of this time-worn output, eight thousand pots have been documented. In almost all cases the hands of the maker are in evidence, revealing direct contact between the maker and the material—unlike, say, painting and sculpture, where traditionally the markings of a brush or chisel may be seen, but no direct trace of the human touch is visible.

Turner exploits this primariness to signal his presence, and so the sense of the moment remains with the piece. Further, pots have been made on pottery wheels for almost four thousand years, but only in this century has the wheel become a personalized idiosyncratic tool. One of the many changes in Turner's work from the mid-sixties to the early seventies can be attributed to his rethinking of the pottery wheel's potential as a source of energy to be consciously harnessed. This source of energy, called "centrifugal force," is the same force astronomers use to explain why planets do not fall into the sun. The initial momentum is started by Turner's foot: as the leg swings, momentum builds, and his hands begin to slap the moistened clay. There is synchronicity as the pot begins to form. His work requires opposing forces—centrifuge and gravity—pushing in and out, up and down. Turner acts as a mediator between these forces.

For Turner, to make a pot without a wheel would be to neglect this latent energy. His wheel and the spinning clay are part of a continuum Turner subconsciously connects with the rising and setting of the sun, the movement of clouds, the rotation of the planets. Deriving inspiration from this level of consciousness, how could the work not address the human condition? Turner once said, "You can do so much when you have so little to begin with."[5] It is as if he is starting with a mere lump of clay and tapping into a greater stream of consciousness. As the sculptor Barry Flanagan noted, "The work is always going on; with proper physical circumstances and the visceral invitation one simply joins in and makes the work."

One could speculate that all wheel-made pots engage these forces, but what I am suggesting is that Turner's frame of mind or state of being during these processes ultimately imbues his work with qualities that allow us to sense the intensity he feels when he "joins in" and makes the work. Practicing this particular sense of being has been his life's work.

An essential characteristic of clay is that it is malleable in one state and rocklike in another. Turner "joins in" at various moments between these two states, when the degree of resistance is right—an instinct that could be triggered by a passing breeze, a distant memory, or a note of music. This sense of rightness is both phenomenological and spiritual, involving what Turner calls the "inner forces" and the simple atmospheric hardening of the clay. Turner exploits the minutiae in the sequence. Throwing is followed by prodding and poking from the inside toward the outside and vice versa. As moisture leaves the clay, its resistance changes. The hand can no longer mold it easily; typically, Turner needs other tools. At this stage, he uses a knife. He might carve clay strips from new clay to add to the pot or draw lines, the blade's edges making fine incisions or cutting scarlike fissures. When Turner says that the lines "find their way around and up the pots,"[6] he is referring to a will or volition, independent of his own, that the pot and energy surrounding its creation have. This echoes a thought expressed by Paul Klee: "Take a line for a walk."

Once the pot is thrown and shaped, it is set on a shelf to dry. The bone-dry pot awaits the fire in stillness, with the potential of change hanging in the air. After the pots are fired, the results are examined. All that was pliable has now become stonelike, but Turner's instinct to "join in" has not diminished. The degree of resistance of fired clay simply requires other tools. He sometimes relies on a hammer, but more often he reaches for a sandblaster, which he uses to erode the surface. In Turner's mind, this process "speeds up nature." He sandblasts in the way the sea erodes the land. Sandblasting changes the way light plays on the surface of the pot—a sheen becomes matte, and the eye of the viewer is slowed. It pauses. The pot becomes tranquil.

The ceramic forming and firing processes are extremely complex, and Turner takes neither of

these for granted. Accidents are welcomed with some relief, for they briefly shift the weight of responsibility. Extremes are embraced, if they work. When the base of a pot is blown out during the firing process, Turner has, on occasion, glued the fragments back together with apparent delight, and with little attempt to disguise the "flaw," this being yet another way of joining in.

ACHIEVING "RIGHTNESS," INTERPRETING SCALE

Turner's functional pots of the sixties were lean and controlled. It seems as though their ability to move from the studio to the marketplace defined their being. In some ways they were anonymous, availing themselves of the mantra of the times concerning "the unknown craftsman." They were designed but functional and, in Turner's own thinking, were quite definitely not art. He had embraced Greek ideals via the Bauhaus-trained potter Marguerite Wildenhain and understood the Bauhaus principles and considered the notion of "timeless perfection." What seemed to be missing was the moment: "My pottery had begun as comments on what I saw in the history of ceramics and it became comments on what I see through experience, an internal response."[7] Turner struggled through what must have been a painful period, "a desert." Yet self-referentiality and looking inward were insufficient for guiding his struggle toward resolution.

Turner in Santa Fe, 2002.

Turner's decision to travel not only gave him new sources of inspiration but enabled him to cease thinking of a profile as the dominant aesthetic consideration. He made studies of pots composed of two or three distinct volumes rather than the traditional foot-belly-shoulder-rim combination. He reexamined sequences to consider gravity, tension, and weight. In the end he declared that the pot "told him what to do." This deconstruction of the pot shapes he had relied on left Turner with a form that became a new setting, or "host," for further explorations. The setting was a gathering place for Turner's interests. During his travels, Turner sought to create a bridge between his observations and their potential application in the studio. Until this time, there had been a controlled, one-to-one correspondence between function and finished piece, or between the initial inspiration and the finished piece. His jars were designed to hold a pound of sugar; his casseroles, to serve five people. Even one of Turner's more adventurous pieces drew its shape more or less directly from the scale and form of a lute. Moving beyond this one-to-one correspondence meant embracing wider possibilities, even tentative and uncertain avenues, a method Turner continues to explore to this day.

Turner began his new explorations by drawing on analogies in architectural placement, landscapes, and historical markers as applied to certain parts and functions of his pots. He observed a precariously placed temple on a hillside in Greece and wondered about the placement of handles on his casseroles. A pictograph high on a rock face in New Mexico caused him to speculate on the placement of lines on the vertical planes of his pots.

What intrigues Turner to this day is how large-scale images and structures he encounters in his travels may eventually be transformed by adapting them to the scale of his pots. This traveling, observing, and searching would become Turner's modus operandi. It was in no way strategic but rather the fruit of being willing to really look at the world. A statement by German philosopher Martin Heidegger anticipates Turner's new-found position: "Questioning is then no longer merely a preliminary step that is surmounted on the way to the answer, and thus to knowing; rather

questioning itself becomes the highest form of knowing."[8] Turner questions existence, space relations, and more. He might ask, "Why is that rock there?" or, "What kind of space is created between those two dancers?" or even, "How and why do we feel a resistance when we are near a wall or a building?"[9] His probing allows him to focus his attention on the scene at hand. Sometimes an image, lasting only a moment, would often remain with him for months or years, and ultimately find its way into his work. As jazz legend Miles Davis put it, a musician "pulls from the subliminal knowledge to achieve rightness."[10] In this same nonlinear progression, a plastic artist arrives at an image. Turner makes musical analogies in his own aspirations, talking frequently of looking for the "blue note." In jazz terms this means altering traditional musical scales and tempo. Turner's "scales" are the four or five dominant forms that he has employed in this journey.

The ability to allow visual images from anywhere and on any scale to enter the intimate domain of the artist's pottery-making involves particularly agile and reactive leaps. To see one's work as part of the universe as we know it (or don't know it) requires a frame of mind that can move seamlessly from apparently incompatible visual phenomena to spirituality, and from the pragmatic to the esoteric. In order for this to work, Turner has to see his pots, in the process of their "speaking" to him, as different things at different times. What I am suggesting is that, at times, as his memory travels to things observed and as he works to impart to the pot his impressions of that place, that event, that feeling, the pot ceases to be a pot. Three quotations from Turner's article "Born Remembering" reinforce this observation:

> I'm thinking of a pot I made . . . a simple open bowl . . . below the rim there is a place where you put your hand to pick it up. Your hand strikes something there: a little pushing-out form, an addition like a little rock . . . just a little place where turtles emerge from the rock. In the world where the turtle, the snake, the bird, and the insects live, if there is a crevice, something is bound to emerge from it. There is such a crevice between the upper and lower parts of the pot. That is a natural place in the joining of two separate things—two strata, the split of two rocks, where a rock meets the earth. It's a protected place—the place of the turtle, the place of joining—where you put a handle.

> I was at the rim of an old, extinct volcano in El Salvador. . . . You examine a place and find unexpected objects that give size and scale to that immense center. This is a bowl like all bowls. The crater is just a big, big bowl. After you've seen that, all bowls are different.

> I think of this pot [part of the *Dome* series] as something I can be inside of. I can be at the bottom looking up, or at the rim looking down. . . . Move near the walls, and you almost feel the containment.[11]

This flexing of scale and its effect on the decisions made in forming and working is a clue to understanding the artist's work in general. What we are seeing when we look at a Turner pot is in fact many things, and they are never stable. A scratched line can suggest a trail left by an insect; a white glazed surface can make reference to a stone or a shell made smooth by the ocean. This shift requires that the viewers allow their own knowledge of the world to enter the work so that their own creative imaginations forge links, enabling them to change conceptual channels with ease. In this way we are drawn in and come to "know" the pot intimately. This is how Turner achieves his desire for universality. However, for this to occur, viewers must be willing and able to "join in."

For varied and complex reasons, the Turners chose to visit Africa. Their instinctive feeling was that in Africa, as in the American Southwest, one could find images and forces at work that had been lost in European cultures. Their inclinations were in no way nostalgic. On the contrary, the Turners believed, and still believe, that these forces—spiritual and ritualistic—continue to be present in many cultures, including their own. The forces are buried but still capable of surfacing, as happens in Turner's pots.

The axiomatic belief that returning to one's roots can inspire a deeper understanding of one's culture takes an unusual turn in Turner's case. His roots were not geographic so much as mythic. This view defines the difference between Turner and, say, Picasso. Picasso essentially appropriated the images rendered in African sculpture, recognizing their visual power and seeing alternatives to the European way of representing the human figure. Turner, on the other hand, responded to a way of life and to the making of artifacts as an essential aspect of the survival of a culture. He admires Anasazi pottery for the same qualities.

Suzi Gablik in her 1995 book, *Conversations Before the End of Time*, writes of Ellen Dissanayake, whose book, *Homo Aestheticus* (1992), can help us understand Turner's visit to Africa:

> She argues that human societies throughout history have always displayed some form of behavior that can be called "art," and that this behavior fulfills a fundamental biological and evolutionary need. In societies other than our own, according to Dissanayake, this behavior plays an integral part in daily social life, and functions as a communal activity, whereas "the dominant idea about art in our culture, ever since the idea of 'art' itself arose in the eighteenth century, has been that it is superfluous—an ornament or enhancement, pleasant enough but hardly necessary." Dissanayake feels that by idealizing aesthetic experience and assigning it only to certain culturally sanctioned objects, our modern view of art controverts its biological and evolutionary significance. It is only by discovering the biological origin of this intrinsic human imperative to make art that we will truly come to understand what art means for human life and what its future might be.[12]

Turner, who had once been a "functional potter" whose work flowed easily into a domestic role in the world, was looking to a world where the notion of function existed on a nonverbal plane. The things that caught Turner's attention in Africa and would later find their way into his pots were combinations or hybrids of aesthetic and functional needs. In a "painted village" on the outskirts of Onitsha, Nigeria, the architecture is principally mud, adobe, and tin formed by hands and primitive tools. This architecture is loose, uneven, and flowing. The walls, buildings, and shrines are elaborately painted. The signs and symbols applied to the buildings attempt geometry and are clearly painted with precision. Turner noted a circular dwelling in a village in Nigeria, "the roof of which is a core of grass matting. It ends in a hole on the top where the smoke goes out. An old, broken pot sits on the top of that hole—black and charred."[13] It was in West Africa that Turner had found a core or center: he saw geometry trying to find its relationship to the nongeometric, the poetic transcending the functional, and ambiguity and necessity coexisting side by side. He discovered there a belief that the relationship between animals, trees, space, and people (i.e., the "animals" of society) is nebulous, yet on another level seamless.

Turner returned from Africa with various cognitive and subliminal ideas churning in his mind. The experience confirmed some of his earlier beliefs and ambitions, namely, that the artist can still

function in an integrated way in Western culture; that pots, by virtue of their portability, contextuality, and domesticity, serve the viewer or the owner in a way that painting and sculpture, no matter how established their traditions, cannot; that the mere suggestion of function links objects with life's daily necessities, and that this is achieved without necessarily relinquishing their potential simultaneous embodiment of the spiritual and universal. Turner also considered formalistic issues. Like his pots, the architectural solutions to human needs he had observed relied on simple materials and their submission to gravity; they were built with an eye toward how the architecture met the plane of the earth. Concern about this relationship was of particular interest to him and is explored in the *Ashanti* and *Ife* series. Turner contemplated this architecture with no substructure or foundation, with its reliance on the earth beneath to support the walls, and found it analogous to the pot on a surface—whether a table, shelf, or hearth. This empiricism led him to consider the gestalt of the structure, as if the building could be picked up and examined from beneath. In Turner's work, the first inch from the supporting surface (the table and/or base) establishes the posture of the pot. The broken pot sitting atop the hole in the roof provided Turner with an issue that sustains him to this day: the nature of transition between one, somewhat geometric, form and another. On the one hand, the architecture fulfills a necessity, and, on the other, it is a functional addition, though at the risk of visual incongruity.

Sketches on Turner's desk in his Alfred studio, 1996.

These observations became hypothetical games that Turner found tantalizing. The theoretical construct that is loosely conceivable but to which any successful solution is circumspect fascinated him. He stated it thus: "I wanted to get back to something which was a universal through geometry. I wanted to use geometry. And clay, of course, is organic, so it immediately allows for the abstract geometric cylinder and cube. It provides the means of improvising on that space between how they [the cylinder and the cube] join, how I achieved the transition from the circle to the square—a sense of something that was uncertain. . . . Was the square springing from the cylinder or was it resting on it? . . . It's almost like presenting yourself with something well known and being surprised at the problem you presented yourself with."[14]

Ceramics is essentially a unitary medium determined by the proportions of the human body. The brick is determined by the span of the hand; the thrown pot, by the size and strength of the hand, the length of the arm, and, ultimately, the unit of the kiln. To exceed these limitations, artists and architects have used assembly techniques, principally stacking, piling, and joining. Notable examples are the early works of Peter Voulkos, such as *Gallas Rock* (1960), and, more recently, Anthony Gormley's *Brick Man* and *Field*. Turner's post-African pieces employed similar techniques with distinctly different motives: the aim was not to achieve great sculptural presence but simply (or not so simply) to investigate various kinds of transitions—from circle to square, from wide to narrow, and vice versa.

Prior to his African experience, Turner's pots were essentially one-piece pots, with the exception of covered jars. Once the conceptual crossover was made, he began to make larger intuitive leaps. While working, he saw comparisons between the function of a pot lid and the grass roof of the circular home. The circular-roof reference is generalized in the *Ashanti* series, from 1975, and persists in *Jar* (*with Stone*), two decades later. A small, carefully selected stone rests on the flat lid of the jar.

As Turner sees it, all three elements are movable, even interchangeable, challenging fixed notions of composition, function, and placement. Other series of works—specifically *Akan*, *Oshogbo*, and *Canyon de Chelly*—have shared characteristics with similar inspired leaps: a wide ground-hugging base tapering to a small opening, with a second thrown form placed on top. Turner does not take measurements but joins the two parts while the clay is wet, conditions that immediately demand improvisation and response. The dance begins. The transition between the parts may be smooth or obvious; the parts may be joined from the inside (leaving protruding humps) or from the outside. Once the overall form is established, the dialogue slowly moves to the surface. Still, Turner remains aware of the interior, and is "always thinking of the other side. . . . What's happening on the other side or what's going to the other side, and what does it invite? The play on memory is constant—the unconscious memory of landscapes and the way things move and catch and fall, the up and down, the kind of place where they put a Greek temple on a hill. I remember a building in Turkey at a wonderful height on a precipice behind a bluff; you look out over a place that used to be a river. I think of its place and how intuitively I want to deal with it. So it brings memories, and then you deal with those memories." [15]

With his complex backdrop of memories and images in place, Turner begins work. Yet it should be clear how nonlinear his work process is. In Turner's own words, "Chance is very much a part of it. I think of the pot as a small box in which I am finding all kinds of things that are bigger than it. What does it need? It has to be thrown off balance so that it can move. There has to be something happening that opposes us other than this symmetrical event. I can very well remember my hand going out . . . and grabbing something, not knowing what it was. I couldn't form what it needed. When I do form what is needed, it doesn't work. . . . When I think I know what it needs, I'm not up to what it really needs. I have to find that thing that's unexpected. And it surprises me and does something that is beyond what I could have expected. I only know that it means something." [16]

Among the series of ground-hugging pieces, the *Ife* series stands apart as the only works with a device that rests on the top edge of the pot and protrudes down into an unseen interior. A concern for the unseen, expressed in the almost-closed form, has been with pottery from its beginnings. Turner further expands on the conceptual and sensory possibilities. In his own words: "What I put was a key which can be removed, a key matching [the pot's] axis. . . . The long tongue, or key, stretches down to explore the interior. That will also give balance, so that it acts as a plumb. It forms a link with that deep space. After it was made, it had the look of a hammer form, something used as a tool. . . . Everything that is used relates to needs, human relations, to the environment, to the surroundings, and to the universe." [17]

This recurring insistence that the pots function in relation to the world, like "a hammer . . . to the environment," dominates Turner's thinking and creative processes. A word he frequently uses is "connectedness," which he defined in a lecture at Anderson Ranch in 1989:

> In using our capacity to perceive connections, thus, we alter the sense of our world, our reality. . . . Making connections is the magic gift of metaphor—with a large bird above me I am walking in the sky. . . . So it can't be about this or that. No, it is about ambiguity, not fuzziness, but the multiple possibilities of a word or a line, the way shapes or people meet to take this beyond our mind-set, to transport us to unforeseen openings so we don't carry ourselves with us all the time and get in our own way. [18]

The disciplined development in Turner's work, between *Early Dome* (1970) and *Canyon III* (1997), is remarkable. He has found, within all the self-imposed limitations, a way to communicate the complexities of the human spirit and to plumb the depths of the natural landscape. And Turner's work continues to surprise. In the most recent pots, although the "host" pot looks familiar, the ratio between it and the additions has changed. The appendages are three times as thick as the walls of the pot, threatening it in some ways. In *Jar* (1994), two large slabs are affixed vertically and come close to directly referencing rock formations. They are as literal as any Turner works I have seen. The fact that the host is a covered jar (like a granary) establishes the much sought-after ambiguity. The light drawing/scratching suggests both boulders, on the one hand, and marks left by a small creature crossing soft sand, on the other. The glaze is the color of sandstone and has been sandblasted—another reference to eroded landscape. One lifts the heavy lid, and the piece then looks exactly like what it is: a pot.

Within his tight framework, Turner also stretches scale. One senses that *Owerri II* (1995) is the largest pot Turner has made. It conveys a feeling of reaching for limits. At only sixteen-and-a-half inches high, its sense of mass and size reaches beyond its numeric dimensions. Interestingly, the host form seems linked to *Landscape*, made thirty-two years earlier, although the mood is distinctly different. Hulking bands of clay appear to embrace the body of the pot like floppy arms. Other lumps of clay look as though they were hurriedly brought in to give support to these arms—the pragmatic endorsing the metaphor. The base of the piece, possibly sanded epoxy, looks like lava. The glaze is metallic and black, establishing an unusual sense of visual weight. In spite of looking somewhat familiar, *Owerri II* stands apart. It has drama. Was it a new beginning? Its urgency is suggestive of the excitement of the unknown.

RISING ABOVE PERCEPTION

As we manipulate, we touch and feel; as we look, we see; as we listen, we hear. The hand moves . . . the eye attends and reports the consequence of what is done. . . . In an emphatic artist-aesthetic experience, the relation is so close that it controls simultaneously both the doing and perception. Such vital intimacy of connection cannot be had if only hand and eye are engaged. When they are not, both of them act as organs of the whole being, there is but a mechanical sequence of sense and movement, as if in walking that is automatic. . . . The artist is in the process of completing at every stage of his work. He must at each point retain and sum up what has gone before, as a whole and with reference to the whole to come, the series of doings in the rhythm of experience give variety and movement. They save the work from monotony and useless repetitions. An object is peculiarly and dominantly aesthetic when the factors that determine anything that can be called an experience are lifted *above the threshold of perception* [italics added] and are made manifest for their own sake.[19]

When John Dewey wrote these words in 1934 he could not have anticipated the coming strategists in the guise of Warhol, Judd, Koons, et al. However, his dissection of a certain kind of creative process is one that Turner understands and one in which he excels. It is simply one of the claims to quality of his work. One is lifted "above the threshold of perception." Turner takes us on a journey with no destination in mind. To paraphrase Marcel Proust, he is seeking truth in perpetual uncertainty.

Throughout the late nineteen seventies and early eighties, various contemporary and historic investigations surrounding the nonfunctional pot were vigorously critiqued. A philosophical and practical context was sought. Ceramics, already marginalized, became more so. Hence the bigger picture was rarely addressed, and Turner was somewhat inappropriately categorized. Not only is Turner's role in the history of American ceramics significant but he has like-minded souls in other creative arenas as well.

So much art is simply a conduit for debate. Turner's work vehemently resists that, continuously pushing the viewer back, should he attempt to search for clarification. His work achieves one of the higher goals of art: it resides in the known while transcending cultural and contextual barriers. The secret may be found in one of Turner's suspicions "that the hand may tell more than the eye."[20] This statement is telling and hints at the limitations of even this book.

Turner tells of an occasion when, on his way to give a lecture, he discovered that he had forgotten his slides. He did, however, have two of his pots with him. It was these he handed to the audience to pass around as he talked. The response was significant. While most people had *thought* they were familiar with his work, their understanding and appreciation moved to another level once they were able to handle the actual pieces.

Michael Brenson, in an article entitled "Please Do Not Touch Culture," further elucidates this point. "The sculpture that I am concerned with seeks a communion with the hand and holds the promise of an encounter between it and the hand that will release something essential yet hidden in both. Should the knowledge of the eye and mind be considered intrinsically superior to the knowledge of the hand? . . . What I am asking for here, most of all, is respect for the memory of the hand. A sculpture [or pot] that has been a resting place for the hand is remembered differently than a work that has only been seen and analyzed."[21]

Turner's mature work grew naturally out of the making of functional pots, where touch was not only necessary but in many ways a factor, along with the ergonomic experience, in the determination of quality. For Turner this is still the case. The relationship of the work to the body (his body) is one way to negotiate understanding. Most of the pots Turner has made in the last twenty years, although no specific function is referenced, have ergonomic qualities that create a "bridge" from the work to the viewer. For example, the *Akan*, *Shore*, *Ife*, and *Oshogbo* series have "necks" which invite the hand to explore. The *Dome* series can be carried and examined by grasping the rim, with the hand entering from the top. Hence, although the function in these pieces is oblique, they still communicate a sense of common physical knowledge, a necessary aspect for Turner's constant balancing act between the pragmatic and the mysterious or obscure.

Touching was characteristic of preindustrial societies, which sought to maintain an intimate personal relationship with their environment. Now, for the most part, we are only able to touch at length that which we own. Owning a work of art enables us to spend time with it and thus repeatedly find fresh insights, deeper meanings. In Turner's case, this process would include exploration of the pieces through the sense of touch. Turner's work, then, functions on many levels. It beckons us to join in, invites us to reach beyond the visual, alters scale, offers haptic impressions, and thus, at its best, takes us beyond the physical plane to a state of nonbeing. We can ask for no more.

Turner outside the front door of the Santa Fe house, 2002.

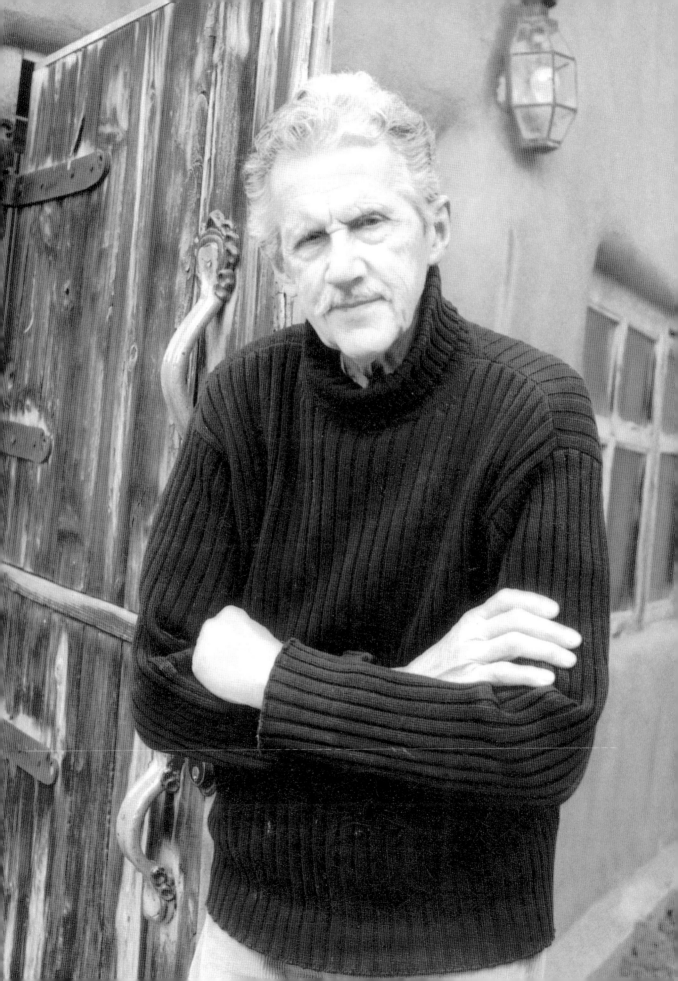

ROBERT TURNER: A CONSIDERED ART Marsha Miro

1. Alice Westphal, statement for exhibition at Exhibit A, Chicago, October 1987.

2. Unless otherwise cited, all quotations from Robert and Sue Turner occurred in a long series of interviews, meetings, and telephone conversations with the author beginning in Alfred, New York, March 13–14, 1996; in Santa Fe, N.M., May 6–7, 1996; and in Bloomfield Hills, Mich., May 3, 1997. The telephone conversations have continued from April 1996 through July 2002. Excerpts from statements by Robert Turner are styled in italic type to facilitate identification by the reader.

3. Henry Turner, "Skyland Farm," self-published, Highland Park, Fla., 1944, pp. 43–45.

4. Ibid., inscription on overleaf, dated August 1945.

5. Telephone interview by author of James Turner, August 1997.

6. Richard Polsky, oral history with Robert Turner for the Columbia University Oral History Research Office as part of the American Craftspeople Oral History Project, September 13, 1985, p. 16. In order to make Turner's quotations clearer, material from the oral history and Turner interviews with the author of this essay have, on occasion, been merged. Turner said things to the author similar to those recorded in the oral history. Whenever a quotation is excerpted from the oral history, quotation marks around italicized text are used to signal the reader.

7. Ibid., p. 13.

8. Interview by author of Rob Turner in Sante Fe, N. Mex., May 7, 1996, and by telephone, October 1997.

9. Polsky, p. 21.

10. Turner personal papers dated 1939, p. 1.

11. Ibid., pp. 1, 2.

12. Polsky, "Oral History," p. 29.

13. Melvin Bernstein, *Art and Design at Alfred* (Philadelphia: The Art Alliance Press, 1986), pp. 125–26.

14. Elaine Levin, *The History of American Ceramics* (New York: Harry N. Abrams, Inc., 1998), pp. 166–67.

15. Polsky, "Oral History," p. 44.

16. Ibid., p. 44.

17. Roy Nuse, letter to Robert Turner, April 18, 1946, p. 1.

18. Bernstein, p. 119.

19. Ibid., p. 122.

20. Polsky, "Oral History," p. 47.

21. Ibid., pp. 49, 51.

22. Robert Turner, letter to Elizabeth Stephens, March 10, 1983, p. 5.

23. Sue Turner, from a historical research paper on the origins of their land done for personal use, dated 1952.

24. Sue Turner, descriptive information in letter form provided for a possible exhibition.

25. Ibid.

26. Polsky, "Oral History," p. 56.

27. Entire quotation from interview by author of Val Cushing in Alfred, N.Y., March 12, 1996.

28. Polsky, "Oral History," p. 53.

29. Entire quotation from interview by author of Val Cushing, Alfred, N.Y., March 12, 1996.

30. Interview by author of Wayne Higby, Alfred, N.Y., March 13, 1996.

31. "Seven Ceramic Artists Each Acknowledge Five Sources of Inspiration," catalogue for Alfred University exhibition, 1993, p. 41.

32. Polsky, "Oral History," p. 55.

33. Notes made by Robert Turner for a lecture at Anderson Ranch Arts Center, 1989.

34. Interview by author of Val Cushing, April 15, 1996.

35. Bernstein, p. 177.

36. Interview by author of Rob Turner in Sante Fe, N. Mex., May 7, 1996, and by telephone, October 1997.

37. "Seven Ceramic Artists Each Acknowledge Five Sources of Inspiration," catalogue for the Alfred University exhibition, 1993, p. 43.

38. Garth Clark, *American Ceramics: 1876 to the Present* (New York: Abbeville Press, 1987), p. 171.

39. Polsky, "Oral History," p. 72.

40. Karen Tsujimoto, *The Art of Peter Voulkos* (Tokyo: Kodansha International, 1995), p. 113.

41. Polsky, "Oral History," p. 76.

42. Ibid., p. 57.

43. Ibid., pp. 58, 59.

44. Interview by Helen Drutt of artist for chronology.

45. Interview by author of Wayne Higby in Alfred, N.Y., March 13, 1996.

46. Interview by Helen Drutt of artist for chronology.

47. Interview by author of Val Cushing in Alfred, N.Y., April 15, 1996.

48. Jean Laude, *African Art of the Dogon* (New York: Viking Press, 1973).

49. Interview by author of Wayne Higby, March 13, 1996.

50. Interview by author of Mario Prisco in Alfred, N.Y., March 13, 1996.

51. Kenneth Westphal and Gerald Nordland, *Robert Turner, A Potter's Retrospective* (Milwaukee: Milwaukee Art Museum, 1985), p. 6.

52. Interview by author of Val Cushing, March 12, 1996.

53. Interview by author of Wayne Higby, March 13, 1996.

54. Interview by author of Bill Parry, March 13, 1996.

55. Interview by author of Val Cushing, March 12, 1996.

56. Bernstein, p. 233.

57. Notes mode by Robert Turner for a lecture at Anderson Ranch Arts Center, 1989.

58. Interview by author of Bill Parry, March 13, 1996.

59. Interview by author of Rob Turner in Santa Fe, N. Mex., May 7, 1996, and by telephone, October 1997.

60. Interview by author of Val Cushing, March 12, 1996.

61. Interview by author of Rob Turner.

62. Meyer Schapiro, *Theory and Philosophy of Art: Style, Artist, and Society* (New York: George Braziller, 1994), p. 32.

63. Ibid, p. 48.

64. Robert Turner, "Born Remembering," *The Studio Potter*, vol. 10, number 2 (June 1982), p. 12.

TURNER IN CONTEXT

Tony Hepburn

1. George Kubler, *The Shape of Time* (New Haven, Conn., and London: Yale University Press, 1962).

2. Turner at symposium "Chance, Intuition, and Improvisation," May 1, 1994, Cranbrook Academy of Art, Bloomfield Hills, Mich.

3. Audrey Flack, *Art and Soul: Notes on Creating* (New York: E. P. Dutton, reissue 1991).

4. Paul Valéry, "On the Pre-eminent Dignity of the Arts by Fire." N.C.E.C.A. Journal.

5. Turner in conversation with author.

6. Turner in conversation with author.

7. Turner in conversation with Helen Drutt.

8. Martin Heidegger, as quoted by Wendy Steiner in *The Scandal of Pleasure* (Chicago, Ill.: University of Chicago Press, paper 1995).

9. Robert Turner, "Born Remembering," The *Studio Potter*, vol. 10, number 2.

10. Turner on Miles Davis in conversation with author.

11. Turner, "Born Remembering."

12. Suzi Gablik, *Conversations Before the End of Time* (London: Thames & Hudson, 1995), pp. 38–39.

13. Turner, "Born Remembering."

14. Turner in conversation with author.

15. Turner in conversation with author.

16. Cranbrook symposium, May 1994.

17. Turner, "Born Remembering."

18. Notes made by Turner for a lecture at Anderson Ranch Arts Center, 1989.

19. John Dewey, *Art as Experience* (New York: Putman, 1934), pp. 49–50.

20. Turner in conversation with author.

21. Michael Brenson, "Please Do Not Touch Culture," *Sculpture Magazine*. May 1995.

1913 Born July 22, 1913, Port Washington, N.Y., to Quaker parents, Charlotte (Chapman) Turner and Henry Chandlee Turner. Father founded and directed the Turner Construction Company. Fourth child, four siblings.

1931 Graduates Brooklyn Friends School; childhood spent in Brooklyn, N.Y.

1932 Graduates from George School, a Quaker preparatory school, Bucks County, Pa.

1932–36 Attends Swarthmore College, Swarthmore, Pa. Receives B.A. degree; majored in economics.

1936–41 Studies painting at Pennsylvania Academy of Fine Arts, Philadelphia, with Henry McCarter, Francis Speight, and Daniel Garber. Interested in portraiture.

1938 Marries Sue Leggett Thomas of Sandy Spring, Md., whom he had met at Swarthmore College; resides in Wallingford, Pa.

1939 Receives Cresson Traveling Scholarship in Painting from Pennsylvania Academy of Fine Arts; summer travel in Europe, especially Italy, studying Renaissance and Giotto. Leaves Europe in haste because of outbreak of World War II. Returns to live in Swarthmore, Pa., where Sue is assistant to Dean of Women, Swarthmore College.

1939–41 Attends Barnes Foundation, Merion, Pa. Lectures delivered by Albert Barnes and Violetta de Mazia; Bertrand Russell delivers lecture series in the fall of 1940.

c. 1940 Journeys to New York to study work of Stuart Davis, the cubists, Picasso, Cézanne. Also interested in Renoir, El Greco, Velasquez.

1940 Receives second Cresson Scholarship from Pennsylvania Academy of Fine Arts; travels to American museums, the Southwest, and Mexico, where he discovers David A. Siqueiros and his work.

1942–46 As a Quaker and conscientious objector, assigned to Civilian Public Service in forestry conservation, Big Flats, N.Y. Volunteers to do service at Training School for Mentally Deficient, in Pownal, Me. (1944–46).

1944 Birth of son, John.

1946–49 Enrolls in New York State College of Ceramics, Alfred University, Alfred, N.Y., starting in fall 1946. Receives MFA from Alfred University in Industrial Ceramic Design, 1949. Studies under Marian Fosdick, Daniel Rhodes, and Charles Harder. Ted Randall and Joan Jockwig Pearson were fellow candidates for the MFA degree in 1949. Fellow students include David Weinrib, Ken Uyemara, Warren Gilbertson, Winslow Anderson, Susan Peterson, Alex Giampetro, Jane Van Alstyne, Bill Parry, Bacia Stepnero.

Works in his final semester in Daniel Rhodes's home studio.

1947 Birth of son, Robert.

First acceptance in Ceramic National Exhibition, Syracuse, N.Y. Exhibits footed stoneware ashtray, organic/abstract form.

1948 Serves as administrative head of the International Service Seminar under the American Friends Service Committee at Frances Shimer College, Rockford, Ill.

Awarded Honorable Mention, Ceramic National Exhibition, Syracuse, N.Y.

1949 Awarded prize, Wichita Decorative Arts Exhibition, Wichita, Kans., for *Large Bowl*, illustrated in catalogue.

1949–51 Initiates pottery program at Black Mountain College, N.C. Starts own pottery. Begins to draw from community of ideas in dance, science, literature, and social governance. Meets musician John Cage, color theorist and painter Josef Albers, Paul Goodman, dancer Merce Cunningham, dancer Katie Litz, weaver Trude Guermonprez; becomes friends with abstract painter Theodoros Stamos, art critic Clement Greenberg, émigré mathematician Max Dehn; and establishes lasting

relationships with teacher and poet M. C. Richards, painter Joe Fiore, and physicist Natasha Goldowski Renner.

1950 Birth of daughter, Rosalind.

1950–52 Exhibits at Bertha Shaefer Gallery, NYC, during residency at Black Mountain College.

1951 Moves his family to a farm in Alfred Station, N.Y. Establishes independent studio. Joins faculty, summer program, Alfred University. American potters Isabel Dobson, Louis Mendez, and Karen Karnes were present.

Awarded prize, Ceramic National Exhibition, Syracuse, N.Y.

1952 *Garden Bowl* (with one foot) wins a purchase award at the Los Angeles Fair Association exhibition and is eventually acquired by Los Angeles County Museum of Art.

1952–58 Lives as a studio potter, making stoneware bowls, jars, candleholders.

1953 Solo exhibition at America House, NYC.

"Potter of the Year," Philadelphia Art Alliance, Philadelphia, Pa.

1954 Exhibits functional pottery in solo exhibition at Memorial Art Gallery, Rochester, N.Y.

Awarded prize, Ceramic National Exhibition, Syracuse, N.Y.

Japanese ceramist Kitaoji Rosanjin lectures at Alfred University, N.Y., and donates work.

1955 Awarded Silver Medal, International Ceramics Exposition, Palais Miramor, Cannes, France. (Gold Medal awarded to Peter Voulkos.)

1956 Solo exhibition at Bonniers, NYC. Exhibits functional pottery.

1957 Visiting Professor of Ceramics, University of Wisconsin, Madison, Wis.

1958 Elected Craftsman-Trustee of American Crafts Council, N.Y.

1958–79 Joins faculty at Alfred University as special instructor in pottery and sculpture. Becomes full-time faculty member in 1966. Serves as acting head of Art Department in 1969–70 and as head in 1974–76. ("Numerous people over the years were important to me: students in the MFA program at Alfred included Ken Price 1959–60, Richard Shaw, David Shaner, and Frank Stokes. David Shaner and Norm Schulman assisted me in my studio.")

1959 In serving as juror for national exhibitions, meets many fellow artists including painter Richard Diebenkorn and weaver Ed Rossbach.

Member of Technical Advisory Committee for USIA in organizing European exhibitions.

1960 Augments teaching with ceramic workshops and seminars; participates in approximately six per year; locations include Banff, Canada; Aspen, Colo.; and Montreal, Canada.

1960–65 During this period, feels "rich in people and places" and begins to question direction of own work; teaching becomes catalyst to examine work further. Already actively protesting war in Vietnam, uses part of a year's leave from teaching to reexamine his pottery. "My pottery had begun as comments on what I saw in the history of ceramics, and it became comments on what I see through experience, an internal response."

1961 Solo exhibition in art festival at Wallingford Art Center, Pa.

1962 Awarded Silver Medal at Third International Congress of Contemporary Ceramics, Prague, Czechoslovakia.

Juror, "Young Americans," Museum of Contemporary Crafts, NYC.

1963 Solo exhibition at Cortland State College, NY.

Serves as technical expert and designer in Ilobosco, El Salvador, under State Department's Agency for International Development, where he meets Sam Maloof and his wife Alfreda ("Freda"), also program consultants in El Salvador.

Juror, Tiffany Fellowships, N.Y. Excited by "first real contact with West Coast artists." Noted Jerry Rothman's work and awarded prize to Jim Melchert for *Leg Pot I*.

1965–66 On leave from Alfred faculty, concentrates on studio work.

Travels to New Mexico with Sam and Alfreda Maloof, who had taught in pueblos; visits native sites and churches.

Travels to California, meets West Coast artists Jim Melchert, John Mason, Jun Kaneko, Henry Takemoto, Jerry Rothman, and Peter Voulkos in their studios.

1966 Awarded prize for stoneware storage jar at the 24th Ceramic National, Everson Museum of Art, Syracuse, N.Y.

Participates in first Supermud Conference at Pennsylvania State University. Demonstrates with Peter Voulkos, Rudy Autio, Don Reitz.

1968 Exhibits stoneware jar at 25th Ceramic National Exhibition, Everson Museum of Art, Syracuse, N.Y.

1969–72 Exhibits in "Objects: USA," which debuts at National Collection of Fine Arts, Smithsonian Institution, Washington, D.C. (travels internationally).

1969–74 Teaches summer sessions at Penland School of Crafts, N.C., which he recalls as "a truly watershed time," in part due to interaction with dancer/teacher Carolyn Bilderback.

Returns to teaching at Alfred University.

1970 Solo exhibition at Lycoming College, Williamsport, Pa.

Exhibits five pots in "Ceramics '70 plus Woven Forms," Everson Museum of Art, Syracuse, N.Y.

1970–73 As member of Fine Arts Visiting Committee reviews program of Rhode Island School of Design, 1970, 1971.

As member of Visiting Committee makes recommendations on the studio program of the Fine Arts Department of Swarthmore College, 1973.

1971–72 During sabbatical leave, travels to Africa with Sue, hoping to discover culture beyond Europe and Orient. Primarily visits Nigeria and Ghana, focusing on animism, myth, and beliefs carried by sculpture. Starts private library on African culture, reading Chinua Achebe, Warren M. Robbins, M. Ulli Beier, Peter Sarpong, and Herbert M. Cole.

1972 With Jeff Schlanger and Peter Voulkos, invited to be juror at Ceramic National Exhibition, which resumes its quarter-century history after a year's hiatus. When three meet at Everson Museum of Art, Syracuse, N.Y., they reject all the entries. "I felt the absence of the power of strong conviction to match the depth of the Vietnam despair, at least in what the slides presented to us. It was sad. The decision was royally condemned at the time."

During visit to Southwest, develops passionate interest in Mimbres pottery. Turner struck by ability of potters to incorporate cosmic sense of their culture in eight-inch bowl. Early pueblo attitudes reinforce animism seen in Africa.

Elected titular member of the Académie Internationale de la Céramique. (International Academy of Ceramics/IAC), Geneva, Switzerland.

1972 Travels to New Mexico, visiting Canyon de Chelly, Acoma, and Taos. Notes that landscape surfaces record time and human activity; this recognition informs his future works.

Solo exhibition at Wallingford Art Center, Pa.

1973 Receives Chancellor's Award for Excellence in Teaching, Alfred University, State University of New York.

Solo exhibition at Alberta College of Art, Calgary, Canada.

1973–74 Begins *Ashanti* forms, adopting name of Nigerian culture group for this series.

Makes a brief visit to Athens, Crete, and Samos with son Rob.

1976 Participates in 10th Supermud Conference at Pennsylvania State University, working again with Voulkos, Autio, and Reitz.

"Soup Tureens 1976," invitational and juried group exhibition in honor of the United States Bicentennial, Campbell Museum, Camden, N.J.

"Masters in Ceramic Art," group exhibition at Everson Museum of Art, Syracuse, N.Y.

"Works in Clay," group exhibition at Art Gallery, University of Akron, Oh.

"Approaches to Function. Three artists: Anne Currier, John Glick and Robert Turner," Gallery of American Ceramics, Evanston, Ill.

"Masterworks—Autio, Reitz, Turner, Voulkos," Pennsylvania State University, Pa.

"Alfred Faculty in Clay," SUNY College at Plattsburg, N.Y.

1977 Solo exhibition at Greenwich House Pottery, NYC.

Solo exhibition at Yaw Gallery, Birmingham, Ala.

"The Ceramic Vessel as Metaphor," group exhibition at Evanston Art Center, Evanston, Ill.

Invitational Show—Creative Arts Workshop, New Haven, Conn.

Elected Fellow of American Craft Council, NYC.

1978 Exhibits functional work and *Dome*, in solo exhibition at Florence Duhl Gallery, NYC.

Group exhibition at Potato Gallery, Sun Valley Center, Idaho.

Joins Exhibit A Gallery, Evanston, Ill., which relocates to Chicago.

Joins Board of Managers, Oakwood School, a Quaker school, Poughkeepsie, N.Y.

Elected Honorary Member of the National Council on Education in the Ceramic Arts.

Acquires home in Santa Fe, N. Mex.

Begins to divide time between Alfred, N.Y, and Santa Fe, N. Mex.

1978–79 "DeVore, Duckworth, Turner, Voulkos," Exhibit A, Chicago, Ill.

"Language of Clay—10 Artists," group exhibition at Burchfield Center, Buffalo, N.Y.

1979 Continues to draw on fertile experience of 1972 trip to Africa; develops *Oshogbo*, *Ife*, and *Akan* forms.

Exhibits *Circle-Square* in "A Century of Ceramics in the United States 1878–1978," group exhibition at Everson Museum of Art, Syracuse, N.Y. (traveled).

Retires as Professor Emeritus, Department of Art and Design, New York State College of Ceramics, Alfred University.

1980s Joins faculty at Anderson Ranch Center, Aspen, Co., summer workshops. Meets Ron Nagle, who is on faculty at same time, along with Paul Soldner, Ken Price, and Jim Dine.

1980 Retrospective solo exhibition at Fosdick-Nelson Gallery, Alfred University, N.Y. Exhibits pieces from *Ife*, *Akan*, and *Oshogbo* series for first time.

Exhibits in "Robert L. Pfannebecker Collection: A Selection of Contemporary American Crafts," Moore College of Art, Philadelphia, Pa.

First solo exhibition at Helen Drutt Gallery, Philadelphia, Pa.

1981 Joins Haystack Mountain School of Crafts, Deer Isle, Me. Chairman of the Board of Directors, 1985–86.

Solo exhibition at Okun-Thomas Gallery, St. Louis, Mo.

"American Porcelain: New Expressions in an Ancient Art," Renwick Gallery, Smithsonian Institution, Washington, D.C. (travels throughout United States and Asia).

"Contemporary Ceramics: A Response to Wedgwood," Museum of the Philadelphia Civic Center, Philadelphia, Pa. Exhibits *White Ife*.

"Centering on Contemporary Clay," The Joan Mannheimer Collection, Museum of Art, University of Iowa, Iowa City. Exhibits *Akan*.

Solo exhibition at Exhibit A, Chicago, Ill.

1983 Solo exhibition at University of Wisconsin, Eau Claire, Wis.

Solo exhibition at Dorry Gates Gallery, Kansas City, Mo.

"Ceramic Echoes," Nelson-Atkins Museum of Fine Arts, Kansas City, Mo.

"Who's Afraid of American Pottery?," Dienst Beeldende Kunst, Museum Het Kruithuis, The Netherlands. Participating artists include Christina Bertoni, William Daley, Richard DeVore, Robert Forman, Andrea Gill, Graham Marks, Randyll Miseph, Ron Nagle, Betty Woodman.

1984 Travels to Hawaii. Visits Haleakala, a volcanic crater. Presents lectures and workshops on Oahu and Maui.

"Modern Master Ceramics," Milwaukee Art Museum, Wis., featured with artists Picasso, Vlaminck, DeVore, Duckworth, Mason, Voulkos,

"Directions in Contemporary American Ceramics," Museum of Fine Arts, Boston, Mass. Participating artists include Laura Andreson, Robert Arneson, Rudy Autio, Walter Darby Bannard, Anthony Caro, Stephen DeStaebler, Friedel Dzubas, Viola Frey, Wayne Higby, Margie Hughto, Jun Kaneko, Richard Shaw, Rudolf Staffel, Betty Woodman.

"A Passionate Vision: Contemporary Ceramics from the Daniel Jacobs Collection," DeCordova and Dana Museum, Lincoln, Mass.

1985 Solo exhibition at Exhibit A, Chicago, Ill.

"Robert Turner: A Potter's Retrospective," Milwaukee Art Museum, Wisconsin. Organized by Gerald Nordland. Show traveled to Carnegie Museum of Art, Pittsburgh, Pa.; Krannert Art Museum, Champaign, Ill.; Arizona State University Museum of Art, Tempe, Ariz.

"Dillingham, Turner, Wood, Woodman," University Art Gallery, New Mexico State University, Las Cruces.

"American Clay Artists: Philadelphia 1985," The Clay Studio, Port of History Museum, Philadelphia, Pa.

"Pottery Questions II," Bacardi Art Gallery, Miami, Fla. Broward Community College, Fort Lauderdale, Fla.

"Surface, Function and Shape: Selections from the Earl Millard Collection," University Art Gallery, Southern Illinois University, Edwardsville, Ill.

1986 Solo exhibition at Helen Drutt Gallery, Philadelphia, Pa.

"Craft Today: Poetry of the Physical," American Craft Museum, New York, N.Y. (traveled).

"Contemporary Crafts: A Concept in Flux," Society for Arts and Crafts, Pittsburgh, PA; Crafts Showroom, NYC.

"Contemporary Arts: An Expanding View," Monmouth Museum of New Jersey, and Squibb Gallery, Princeton, N.J. Exhibits *Akan*.

"Architecture of the Vessel," Bevier Gallery, Rochester Institute of Technology, N.Y. Exhibits large *Canyon de Chelly.*

1987 "The Ritual Vessel," Twining Gallery, NYC.

Garth Clark Gallery, NYC. Exhibits with Karen Karnes.

Dorothy Weiss Gallery, San Francisco, Calif.

Receives Honorary Doctor of Fine Arts from Swarthmore College.

1989 Solo exhibition at Helen Drutt Gallery, NYC.

1990 Solo exhibition at Bellas Artes Gallery, Santa Fe, N. Mex.

Solo exhibition at Earlham College, Richmond, Ind.

Hill Gallery, Birmingham, Mich. Exhibits with DeVore and Price.

Group exhibition at Greenberg Gallery, St. Louis, Mo.

1991 Solo exhibition at Dorothy Weiss Gallery, San Francisco, Calif.

Group exhibition at Kanazawa Culture Hall Gallery, Kanazawa City, Japan.

1992 Solo exhibition at Nora Eccles Harrison Museum of Fine Arts, Utah State University, Logan, Ut.

1993 Two-person exhibition, Joanne Rapp Gallery, Scottsdale, Ariz.

"Beyond Tradition—Ceramic Art in New Mexico," Santa Fe Fine Art Museum. Turner, one of five artists included; exhibits ten works.

"Local Clay Samples," Tower Fine Arts Gallery, SUNY College, Brockport, N.Y. Exhibits *Canyon I.*

"Clay 1993: A National Survey," William Traver Gallery, Seattle, Wash.

Awarded Gold Medal, American Craft Council; ceremony held in Chicago, Ill.

"American Craft Council Gold Medal Recipients 1975–1993," Charles A. Wustum Museum of Fine Arts, Racine, Wis.

1994 Solo exhibition at Okun Gallery, Santa Fe, N. Mex.

Commemorative Exhibition (group exhibit), The Clay Studio, Philadelphia, Pa.

Solo exhibition at Revolution: A Gallery Project (now known as Revolution Gallery), Ferndale, Detroit, Mich.

Participates with Tony Hepburn and Jim Melchert in Symposium: "Chance, Intuition, and Improvisation," May 1, 1994, Cranbrook Academy of Art, Bloomfield Hills, Mich.

1996 Solo exhibition at Helen Drutt Gallery, Philadelphia, Pa.

1997 Solo exhibition at Revolution: A Gallery Project, Ferndale, Mich.

"White," group exhibition at Center Galleries, Center for Creative Studies, College of Art and Design, Detroit, Mich.

1998 "NCECA Honors and Fellows Exhibition," Modern Art Museum, Fort Worth, Tex. Exhibits *Owerri III.*

1999 Moves with Sue to Sandy Spring, Md.

Retrospective exhibition at Helen Drutt: Philadelphia.

Solo exhibition at Joanne Rapp Gallery, Scottsdale, Ariz.

"Clay Traditions: Texas Educators and Their Teachers," Dallas Museum of Art, Tex. Exhibits *Canyon III.*

"Contemporary Clay: Master Teachers/Master Students," The Fine Art Center Galleries, Bowling Green State University, Oh.

"Choice From America: Modern American Ceramics," Organized by Museum Het Kruithuis, held at Den Hague, The Netherlands. Exhibits *Shoreline*, *High Square*, *Oshogbo*, and *Akan V.*

Works exhibited at SOFA New York by Helen Drutt: Philadelphia, Pa.

2000 Solo exhibition at Revolution Gallery (name changed), Ferndale, Mich.

"Color and Fire: Defining Moments in Studio Ceramics, 1950–2000," Los Angeles County Museum of Art (traveled). Exhibits *White Ife.*

"Regis Masters Series," Northern Clay Center, Minneapolis, Minn.

2001 Solo exhibition at Newark Academy, Livingston, N.J.; delivers lecture.

"Crafts at the Turn of the Millennium: Selections from Helen Drutt: Philadelphia," Monmouth Museum of Art, Lincroft, N.J. Exhibits *Canyon de Chelly.*

"Poetics of Clay, an International Perspective," Art Alliance, Philadelphia, Pa.; Museum of Art and Design, Helsinki, Finland. Exhibits *Niger* and *Canyon de Chelly.*

2002 Solo exhibition at Helen Drutt: Philadelphia, Pa.

Solo Exhibition: "Robert Turner: 2002 Heilman Artist, Selected Works," List Gallery, Swarthmore College, Swarthmore, Pa. Delivers Heilman Lecture.

"Contemporary American Ceramics, 1950–1990: A Survey of American Objects and Vessels," Aichi Prefectural Museum in Nagoya and Museum of Contemporary Art in Kyoto (traveled).

"Crafting a Legacy: Selections from the Contemporary American Crafts Collection," Philadelphia Museum of Art, Pa. Exhibits *Covered Jar* (1995), *Covered Jar* (1964–65).

Works exhibited at SOFA Chicago by Helen Drutt: Philadelphia, Pa.

"Ceramic Masterworks: 1962–2002," Modern Gallery, Philadelphia, in cooperation with Helen Drutt: Philadelphia.

INDEX

Italicized numbers indicate a photographic image.

ACKNOWLEDGMENTS

All the right people worked with us on this book. Our editors Janet Koplos and Tish O'Connor were sensitive to our commitment to Bob Turner and his work, yet distant enough to help us focus the content on that which was significant for this artist's monograph. Barry Lancet, our editor at Kodansha, understood the importance of Turner to contemporary American ceramics and was certain from the beginning that this beautiful publication would prove it. Heeding the unassuming nature of Bob Turner, Kazuhiko Miki designed an elegantly simple book that brings out the monumentality and humility of a Turner pot. Marc Lancet was our sounding board and creative title writer, pulling together many disparate ideas with his clear solutions. Keith Learmonth and Judith Ravin protected us from our mistakes.

Paul Kotula, director of Revolution Gallery in Ferndale, Michigan, and Sandra Schemske, assistant director, spent many hours organizing the photography and supplying information. Their intern, Jerlyn Jareunpoon, was of great assistance. Working overtime in the heat of the summer of 2002, Tim Thayer took the remaining necessary photographs, adding his superb images to the large inventory of fine photography from which the pictures in the book were chosen. Sam Maloof was generous enough to lend us personal pictures he took of the Turners over his many years of friendship.

Bob and Sue Turner and their family were always available to answer questions and unravel the complexities of their lives, particularly things not normally formalized in words. And to our spouses, Pauline Hepburn and Jeffrey Miro, and our children, we offer our deep appreciation for their support. Finally, we want to thank the Cranbrook Academy of Art, that fervent crucible of art activity, for bringing us all together.

Tony Hepburn
Marsha Miro

■ ■ ■

The generosity and the encouragement of all who truly have created this book is very moving. I am most grateful to each person. My thanks are far from perfunctory.

First, I thank Tom Simons, a close friend in Santa Fe, who, following an exhibit of my work there in 1994, proposed and, with enthusiasm, pursued a plan for a book.

This proposal was supported by scholar and gallery director Helen Drutt, who sensed an as yet untold story. I am most grateful for her organization of the chronology and for her tireless and cheerful support over the years.

Tony Hepburn's unhesitating willingness to write an essay on my ceramic work gave me a needed purpose and confidence to proceed. For a period of time our studios were on adjacent hillsides. He had raised penetrating questions about the work, and his sense of it would make a link with my thinking and with underlying issues of art. Tony has remained a source of nourishment, and his work a source of excitement.

In 1994, Marsha Miro chaired a panel at the Cranbrook Academy of Art in Bloomfield Hills, Michigan, on "Chance, Intuition, and Improvisation," which was inspired by an exhibit of the ceramics of Tony Hepburn, Jim Melchert, and myself at Revolution Gallery. The good fortune of her eventual choice as biographer is abundantly clear to me. For the perception, curiosity, understanding,

and clarity with complexity, as well as the expressiveness, wholeness of image, and caring attentiveness, I give my lasting thanks to her.

I am enormously grateful to Janet Koplos for her unstinting support. That she was willing to join as editor gave the assurance of a critical eye and mind. I am highly appreciative of the professional skill, focus, and experience she brought and the time she gave.

The photography provided by John White commenced in Santa Fe during an exhibit at the Okun Gallery, coinciding with the start of the writing for the book in 1994. He generously continued the work he began in Santa Fe by traveling to my studio in Alfred Station, New York, and to the Helen Drutt Gallery in Philadelphia, at times lugging his heavy equipment up city steps. The three locations provided a broad overview of various works covering some thirty years. His mastery shows in the subdued but dramatic image of each piece.

I also extend my appreciation to the other superb photographers whom I feel honored to have worked with: Brian Oglesbee and Steve Myers, who were available at crucial times when my studio was in Alfred; likewise to Tim Thayer. And I am indebted to Laurie Snyder and John Wood, a longtime friend and former colleague, for their sensitive images.

Also, my ongoing gratitude to Revolution Gallery, a venue that has been constantly thoughtful of my pieces, under the quiet guidance of Paul Kotula and his staff, notably Sandra Schemske, who so faithfully and expertly handled the photo images.

Alice Westphal, the owner and director of Exhibit A in the 1970s and 1980s, has my boundless gratitude. Her eye, vision, belief, and friendship were reliable in the development of my work during this time. Likewise to Gerald Nordland, then Director of the Milwaukee Museum of Art, who mounted a retrospective exhibit of my work and with whom conversations meant so much.

To Jennifer Esperanza for her recent, remarkable photographs, a special thanks.

And last, I dedicate my efforts to Sue.

Robert Turner

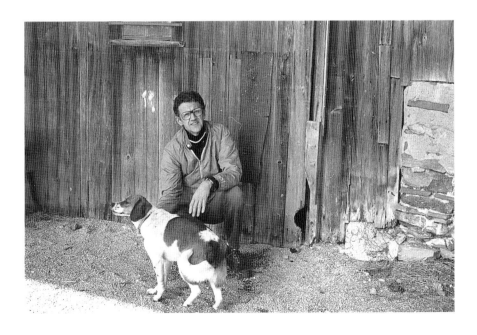

PHOTO CREDITS

John White	pp. 1, 8–9, 20–47, 48 (bottom), 49–51, 54
Tim Thayer	pp. 4–5, 10, 12–13, 16, 17, 52, 53
Laurie Snyder and John Wood	pp. 6, 7, 11, 14, 134
John Wood	pp. 79, 82, 83, 84, 85 (top three), 86
Jennifer Esperanza	pp. 15, 115–19, 140, 147
Brian Oglesbee	pp. 48 (top), 55, 56, 81
Steve Myers	pp. 18, 19

■ ■ ■

The majority of photographs on the color pages of this book were generously supplied and annotated by Revolution Gallery in Ferndale, Michigan.

Additional photographs were supplied by Les Mertz pp. 2–3, American Images p. 70, Edward DuPuy p. 73, Paul O'Hara p. 133, and Harland Snodgrass p. 159.

The photograph on page 73 is used courtesy of North Carolina State Archives (Black Mountain College Project).

Permission to reproduce the Rosanjin piece on page 81 was granted by the Schein-Joseph International Museum of Ceramics, New York State College of Ceramics at Alfred University, Alfred, New York. The work was donated to the museum by the artist.

Sam Maloof graciously supplied the photographs used on pages 88 and 89.

作陶家　ロバート・ターナー
ROBERT TURNER

2003年4月18日　第1刷発行

著　者	マーシャ・ミロ／トニー・ヘップバーン
発行者	畑野文夫
発行所	講談社インターナショナル株式会社
	〒112-8652　東京都文京区音羽1-17-14
	電話　03-3944-6493（編集部）
	03-3944-6492（営業部・業務部）
	ホームページ　http://www.kodansha-intl.co.jp
印刷所	大日本印刷株式会社
製本所	牧製本印刷株式会社

落丁本・乱丁本は購入書店名を明記のうえ、小社業務部宛にお送りください。送料小社負担にてお取替えします。なお、この本についてのお問い合わせは、編集部宛にお願いいたします。本書の無断複写（コピー）、転載は著作権法の例外を除き、禁じられています。

定価はカバーに表示してあります。